Outsiders

Compiled by Steve Lazarides
Art by people

This isn't a manual for an art movement. For a start I can't stand genres: I used to share a flat with a music journalist who was always trying to drum them up. Most importantly, though, it's got to be said that this is a very subjective book. Like the Lazarides Gallery itself, it's just a collection of work I admire. It's organised not by artist but in three sections; [out, in and other].

Partly this book is called *Outsiders* because a considerable proportion of the artists included choose to display their work in the very public domain of the street (or actually, in several cases, the countryside). But equally they're Outsiders because they've made their name without taking the traditional path via, and I don't think it's unfair to label it thus, the established gallery system. Many haven't had any formal art training – even Jonathan Yeo, whose portraits regularly feature establishment figures, is entirely self-taught. Some, like Antony Micallef, landed on my desk. But most – for instance, Invader or Faile – I first approached after seeing their work in – or on – their chosen medium of the 'outside' world.

These artists' greatest claim to the tag of 'Outsiders', however, is that while they've regularly been accused of 'not being art' they've ended up gracing museums and major art galleries.

As crazy as it may seem that a painting can be derided as such – 'not art' – many column inches pertaining to these artists have centred around this debate. If certain critics and powerful individuals deem a work not to be art, it somehow isn't. Indeed, certain major contemporary artists have been far more supportive of the people in this book than any critic, and I include those commentators from the liberal and style press as much as the right-wing newspapers. Even the familiar language used on our websites has aroused suspicion. Since our founding ten years ago, we seem to have broken all sorts of rules, but only really because we didn't know what the rules actually were, and weren't entirely sure that they applied to us anyway. The only maxim we've ever really worked under, and I mean this as modestly as it can be, is 'do we like the work?'.

I'm less inclined to be humble about the fact that the success the Outsiders artists currently enjoy is a genuinely populist phenomenon. From the start our buyers have ranged from landed gentry to teenagers (and for the latter, this is the first time it's been acceptable to be 'an artist' – they can look up to "that Jamie Hewlett"). We've always encouraged visitors to simply come and see the art, and the last thing I want is for them to feel at all nervous around the work, or that they don't have the credentials to be there. All they have in common is a personality that's drawn to the new and isn't swayed by orthodoxy. We've always been very conscious, too, of having

different levels at which people buy stuff – they can purchase books for 20 pounds, a screen print for a hundred, or a painting for thousands.

Also, when I try to think why people come to our gallery, I imagine it's mostly down to other contemporary art being quite personal and also rather intimidating. Moreover, I believe it's because people want to be excited and entertained, which is maybe something they've missed out on in the age of white boxes, polished concrete flooring, and private views serving thin-stemmed glasses of Prosecco where it's all as much about commodity as the work, with hardly any sense of occasion. To be frank I know little about Andy Warhol, but I'm certain that when he put something on it was an event. Which is surely one of the reasons he remains fascinating.

Though the internet, of course, has played a huge part. What other museum is open twenty-four hours a day, seven days a week with no entry fee? All the Outsiders artists have well-maintained websites and a considerable internet presence in general. Blu's *Muto* video, for example, boasts just under 2,440,000 hits on youtube at the time of writing. What other artists have that kind of reach?

Hob-nobbing and money may be fun, but the Outsiders artists aren't producing their work just so a millionaire can put it up in his Swiss chalet. They do it to communicate their message. Some of these artists travel the world exposing their work and ploughing the money they gain from selling pieces back into even more ambitious projects. This purity of purpose is easy to admire.

Mostly though I would like to think the art we show is so popular right now because people enjoy it – and its messages, even if they don't agree with them. It goes without saying that we live in highly politicised times and that doesn't get addressed a great deal by culture. The majority of the Outsiders work is very accessible in regards to comprehension – you don't need a degree in art history to understand it, the same way any idea isn't necessarily any less powerful if not communicated in a complex manner.

And as such, I should let the pictures speak for themselves.

Steve Lazarides, London, 2008.

Out

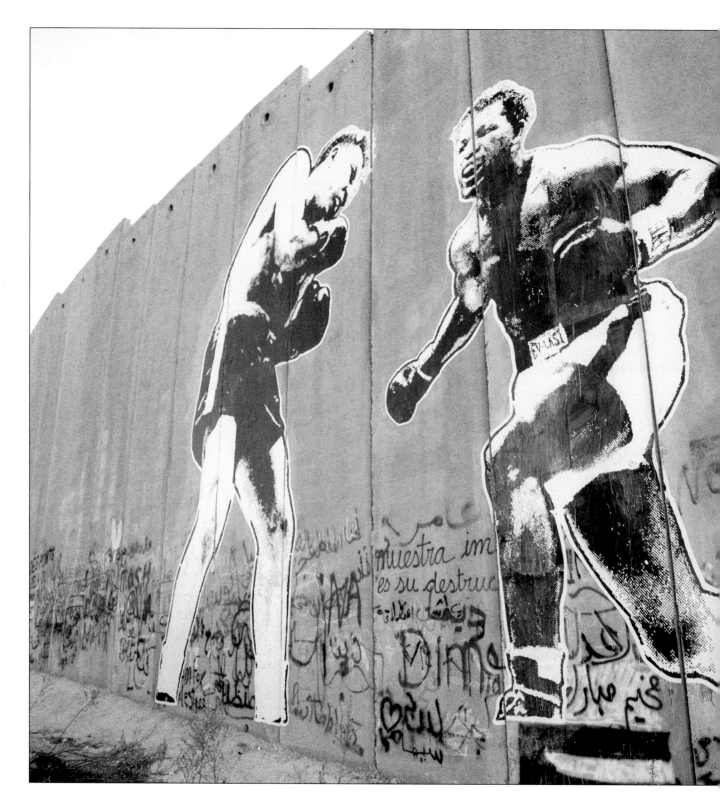

Palestine

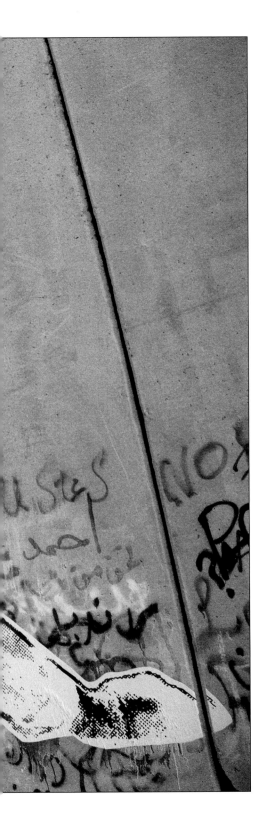

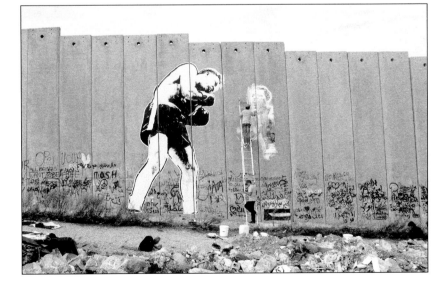

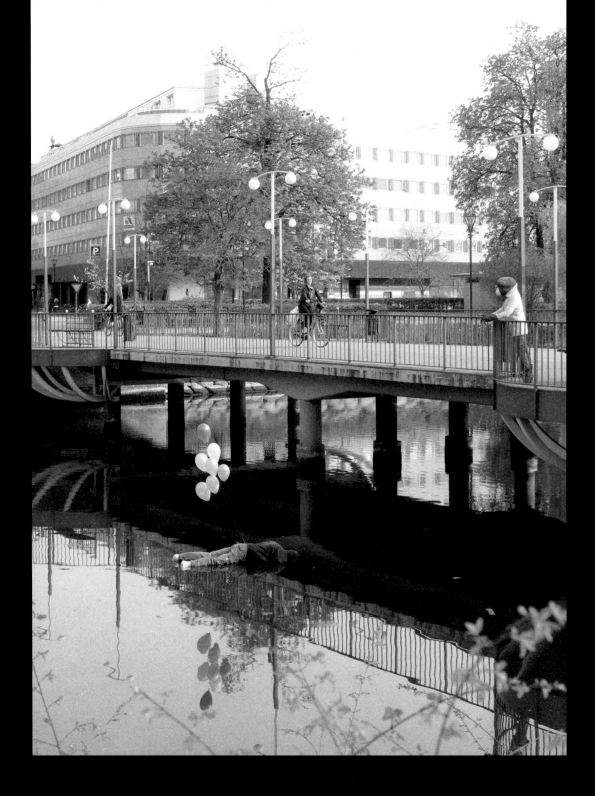

Floater

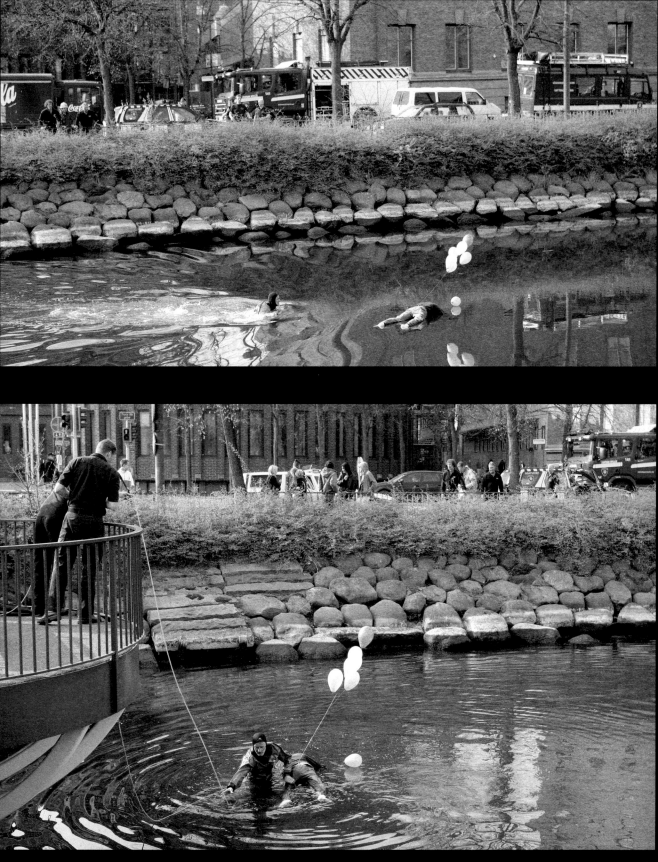

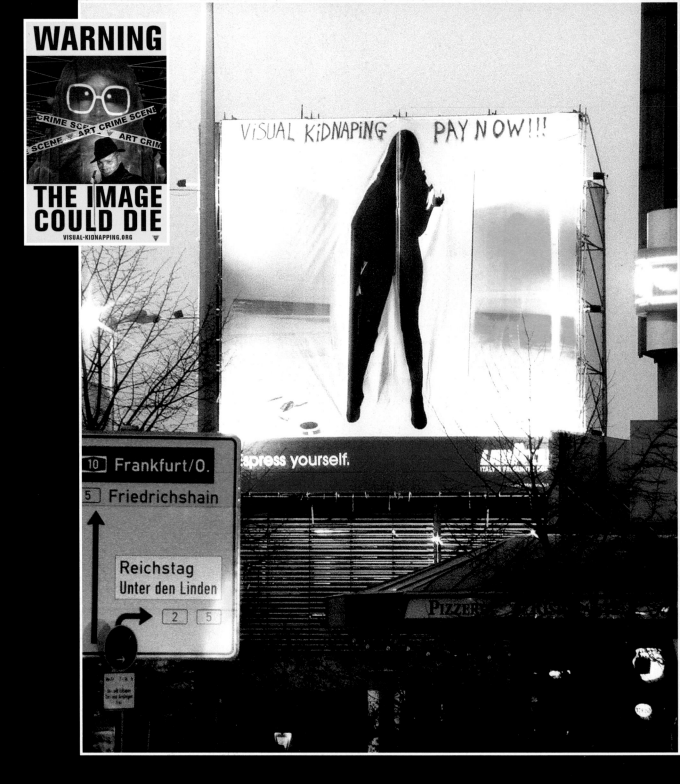

Visual Kidnapping – Berlin
Opposite: Visual Kidnapping – hostage apparition

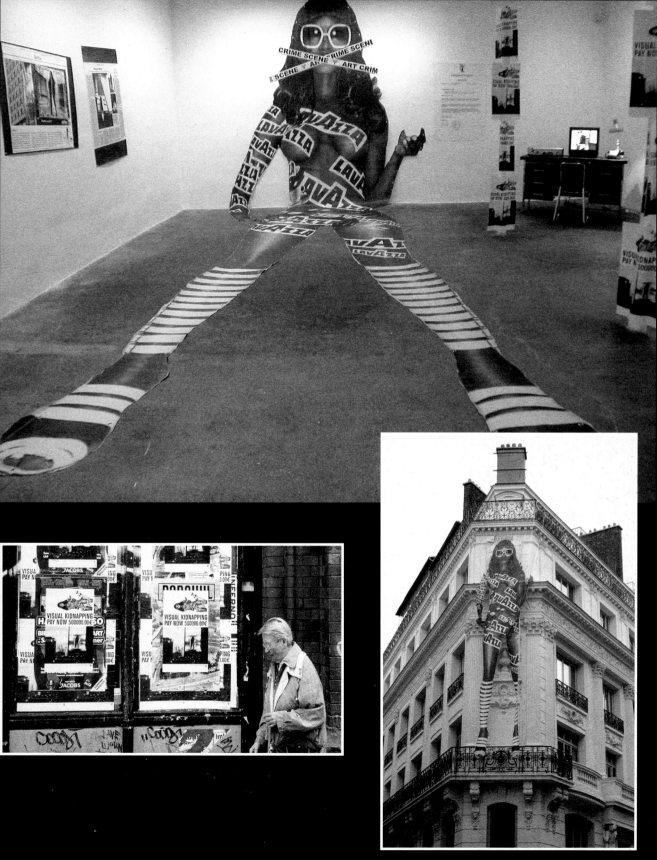

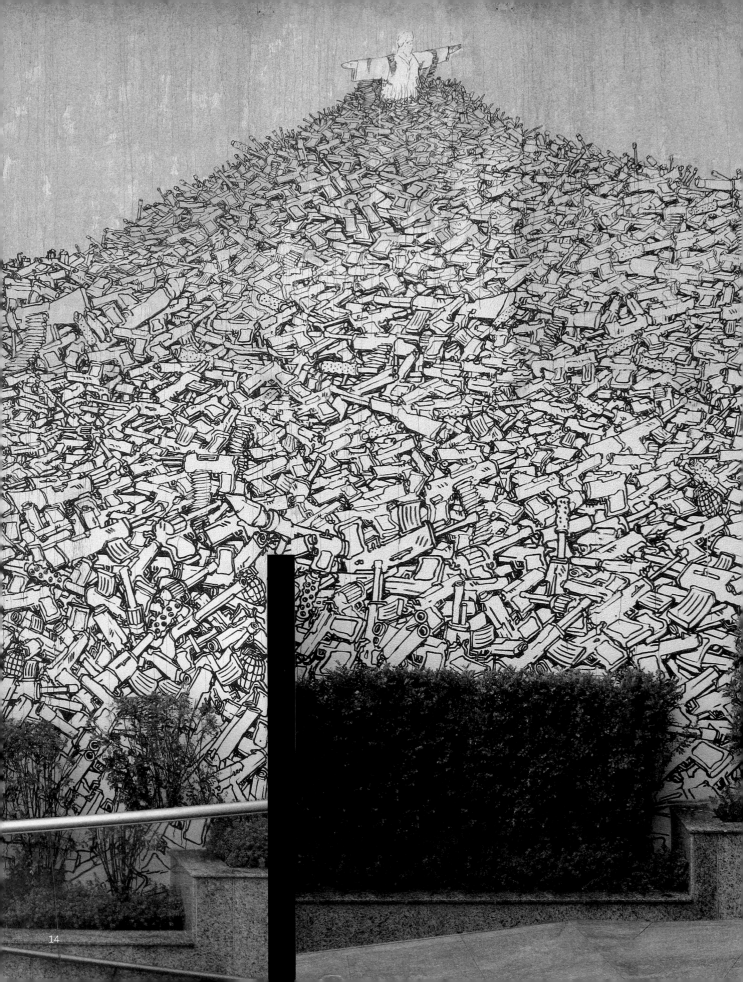

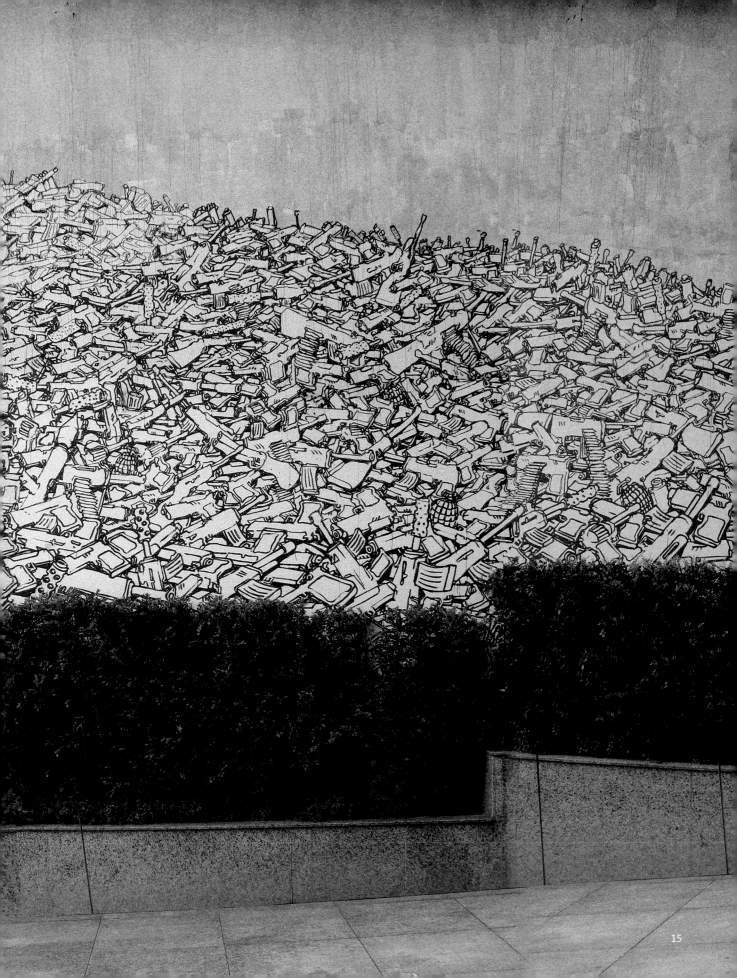

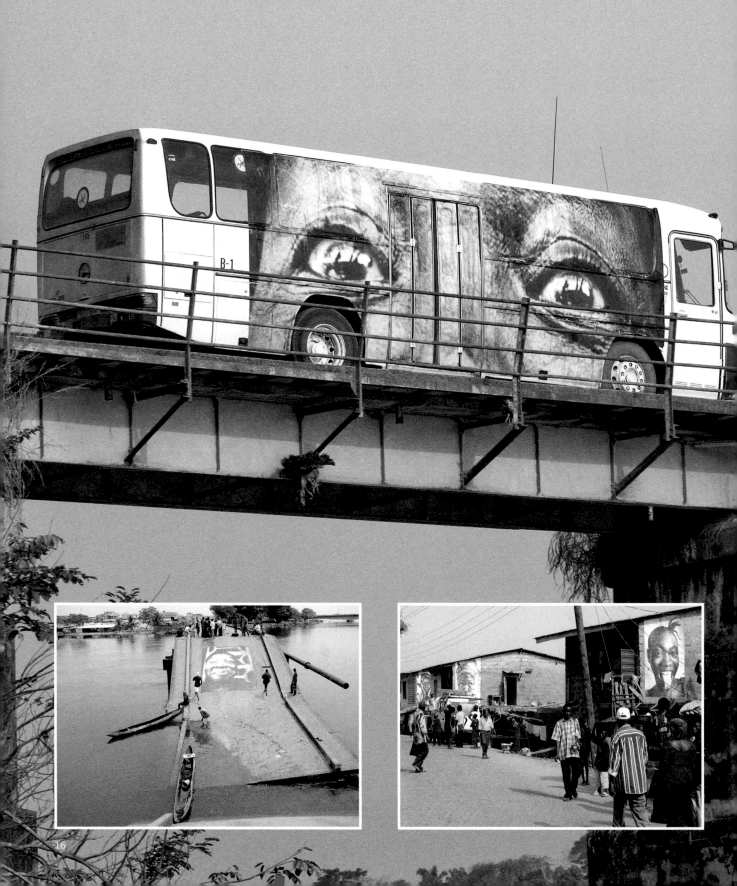

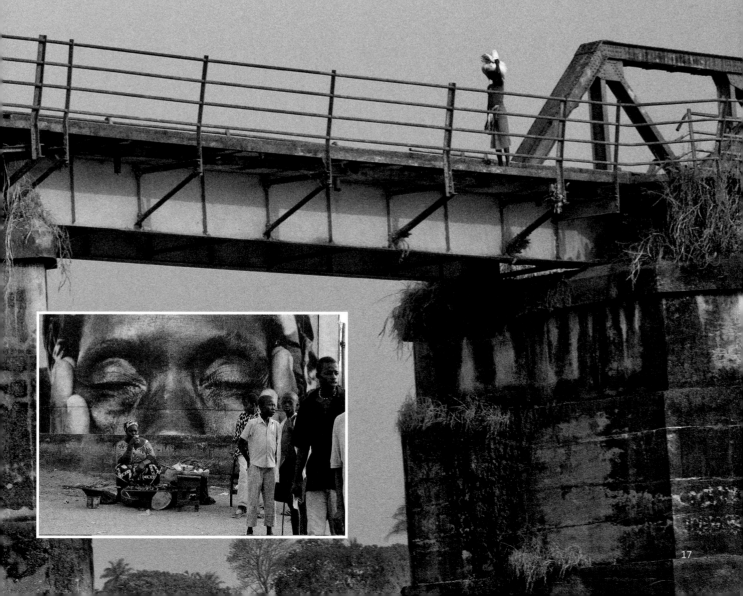

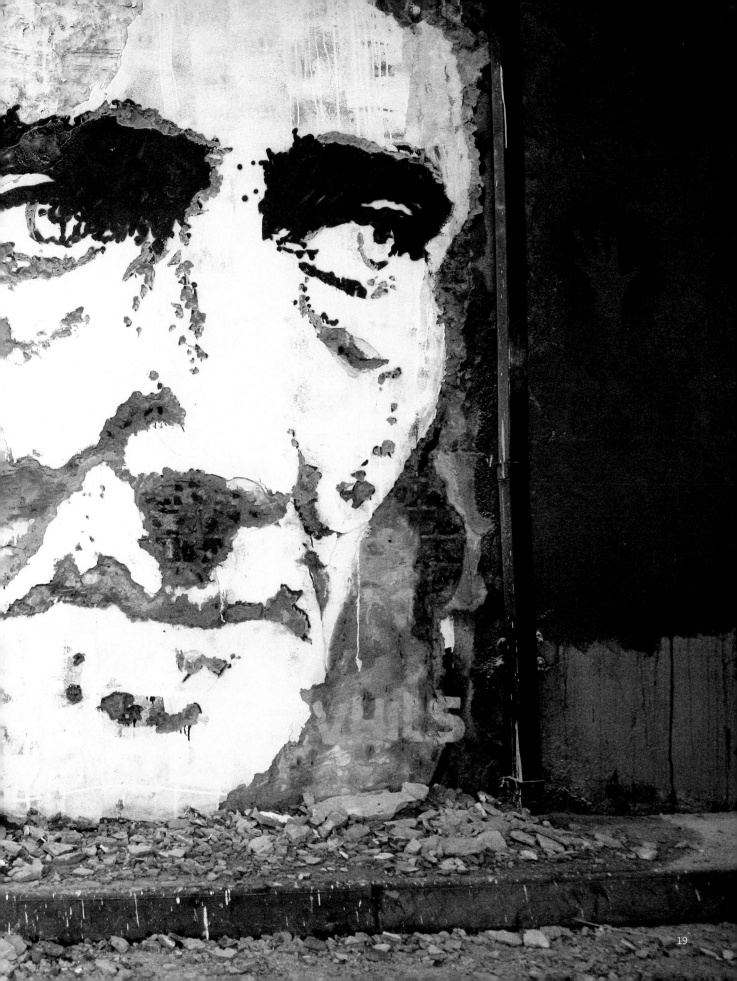

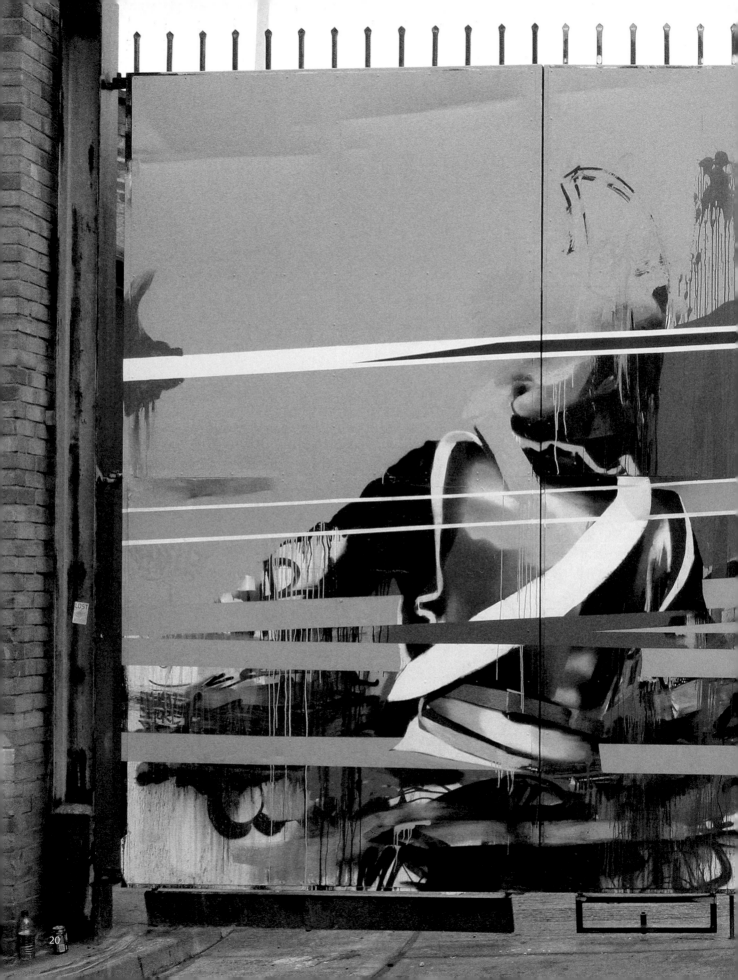

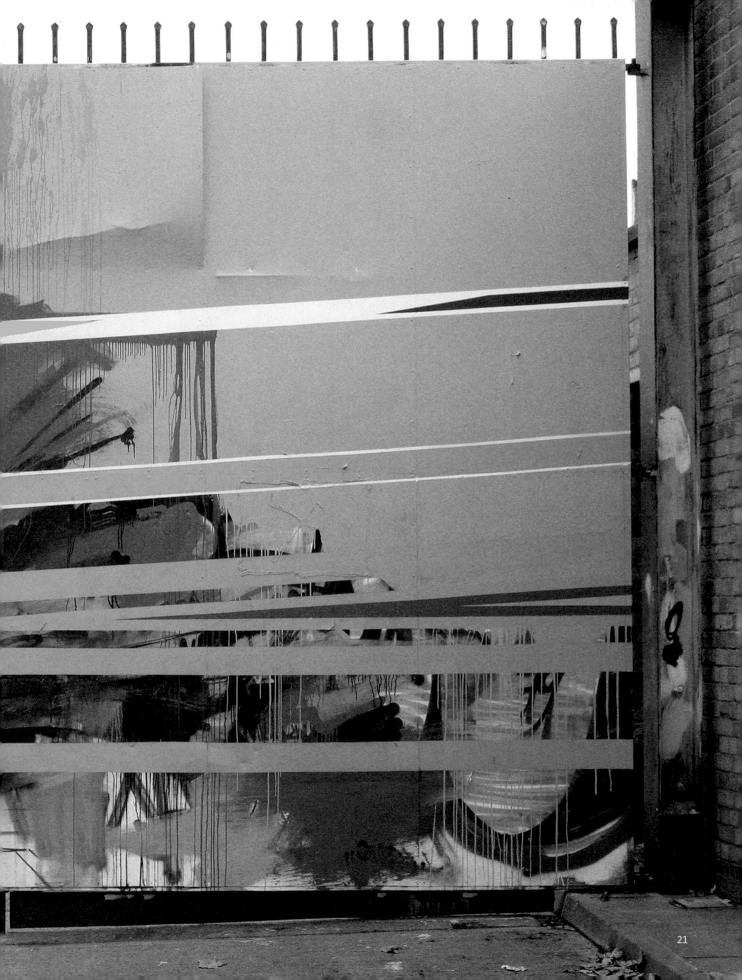

21

3D – Robert Del Naja

Robert Del Naja's painting and graphic design work have represented the music of his band Massive Attack for almost twenty years. Under his tag '3D' he was a central figure within the Bristolian graffiti movement of the 1980s that would eventually spawn several noted artists. Like his music 3D's art is both parts modern and grounded, challenging and seductive, industrial and ethnic. The conscious elements of the pieces are a reminder that Massive Attack were outspoken commentators on global issues long before say, Al Gore's populist documentaries gave this generation a right to question the establishment.

3D is working more seriously than ever before. His enormously well-received 2008 show War Paint, artwork inspired by the UNKLE album, *War Stories*, marked his coming-of-age as an artist in his own right.

Blu

The offensive element of street art can be under-rated; after all, who has not raised a chuckle at a well-placed and esoteric spurting phallus. Blu's work is a colourful collage of youthful self-expression, but it is obviously many stages removed from a crude penis. However, it pulls no punches.

To label Blu as simply offensive is small-minded of course; his outdoor pieces might echo slogans of hate or mobile numbers scrawled on public lavatory walls, but they are quiet rather than brutal, and observational as opposed to demanding. Like a child proudly presenting his mother with the results of his latest amateur wildlife dissection, Blu simply wants to know if we have ever thought about *this* before, and what we might have to add to his conclusions. When we turn away in disgust and chide him, he is mystified and disappointed.

Blu's work discusses what really lies behind our façades using a jab-cross-hook combination of brutal, eloquent and democratic metaphors. Cars are laid to rest with full honours; academics perform witty suicides utilizing the books that are tools of their trade; and his interpretations of the human internal workings echo perverse practicioners such as infamous fetish illustrator Dolcett. Adding another layer of complexity though, Blu's style is gentle and unassuming. Ultimately its humour and imagination are unparalleled. Whilst some notorious modern artists may seem inappropriate for display and enjoyment, Blu's horror remains somehow appealing. Indeed, he is one of three artists featured in this book who painted the exterior of London's Tate Modern gallery in May 2008.

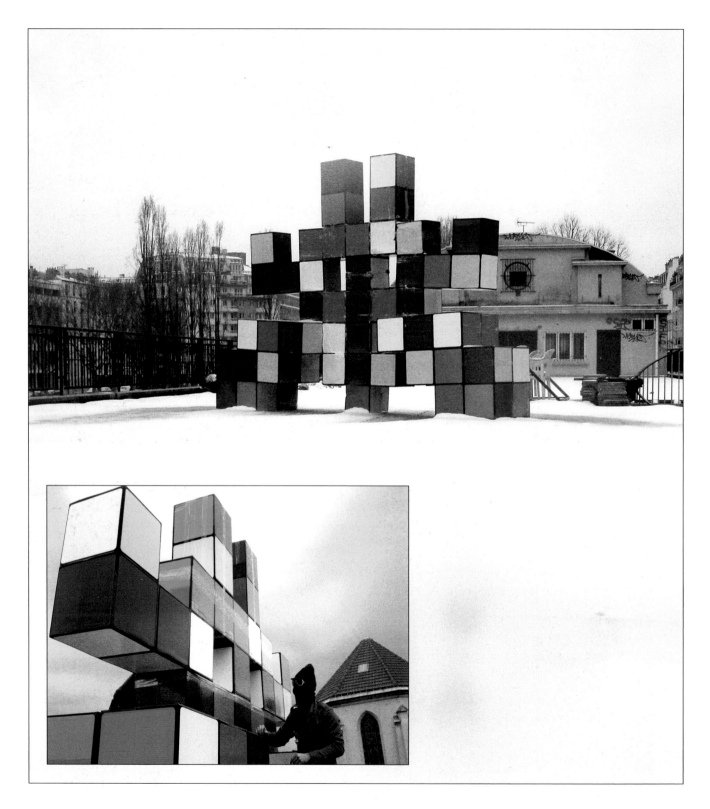

Above: Big Galaxian
Opposite: Varanasi and Kathmandu

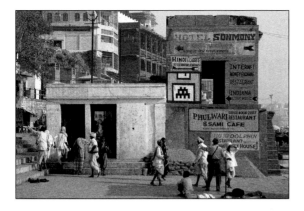

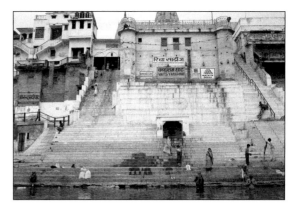

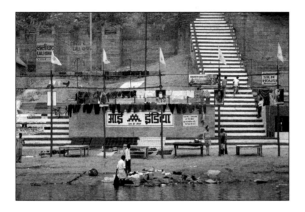

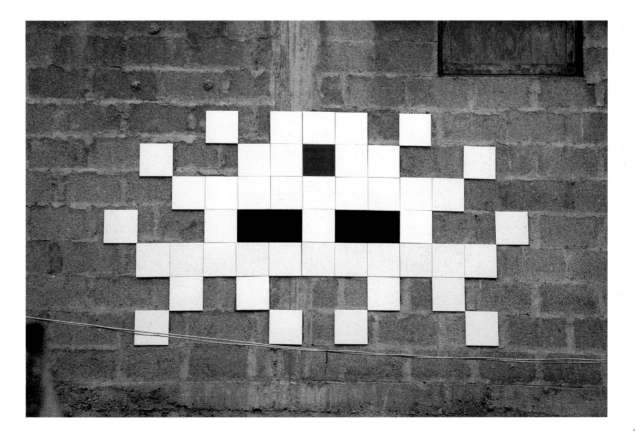

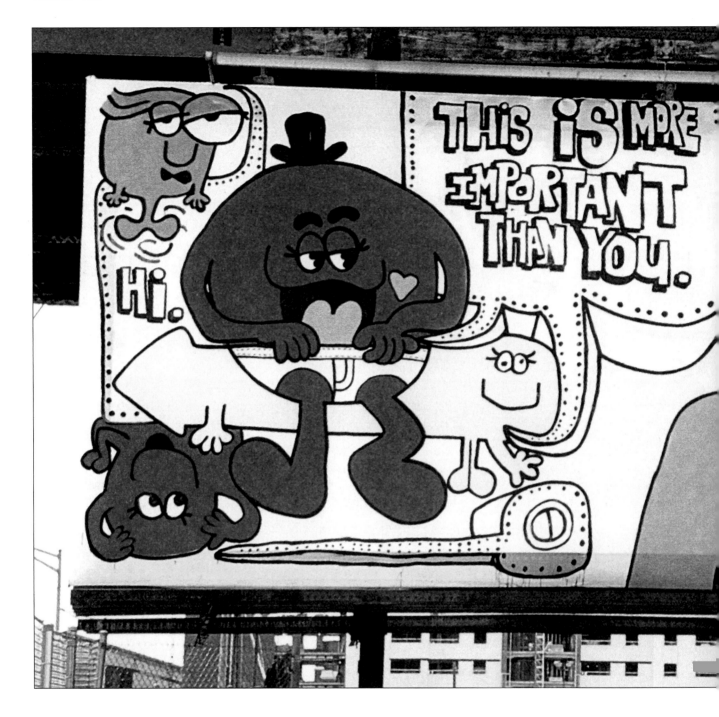

Bill board, Philadelphia: This is more important than you
Billboard, LA: Popsicle party

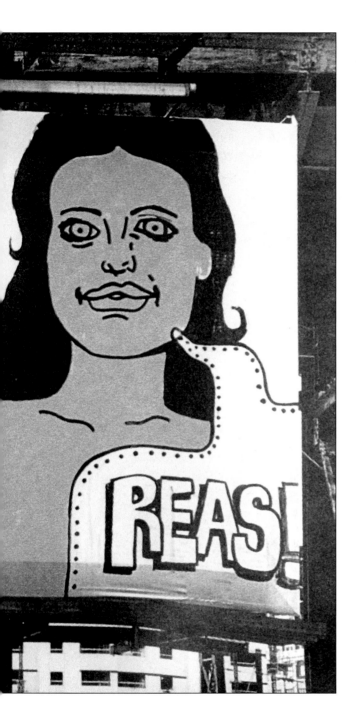

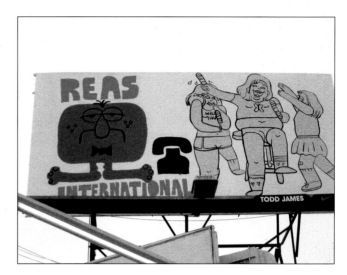

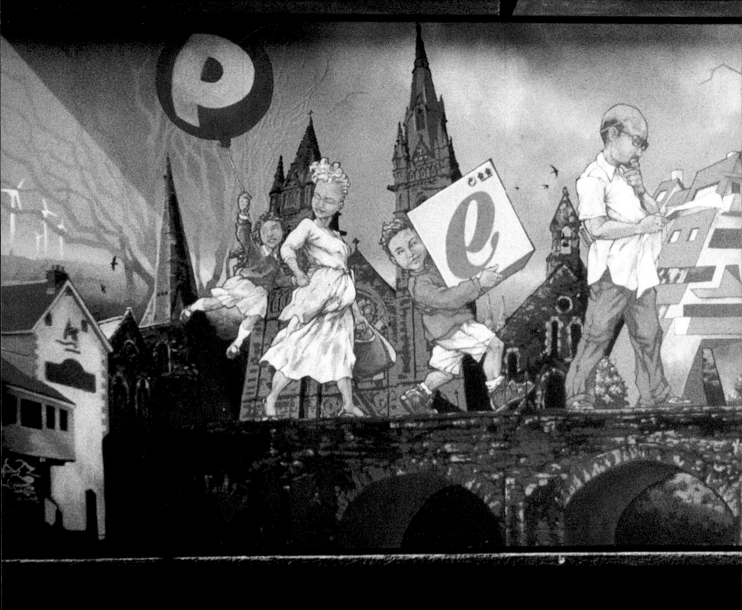

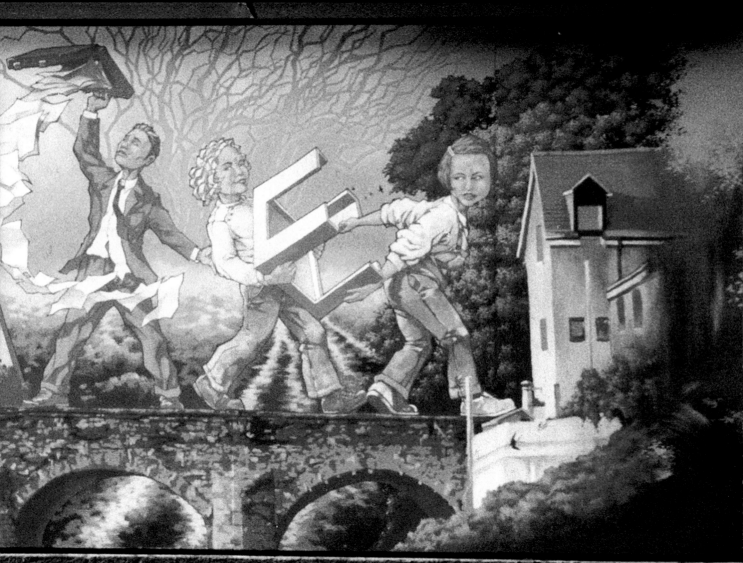

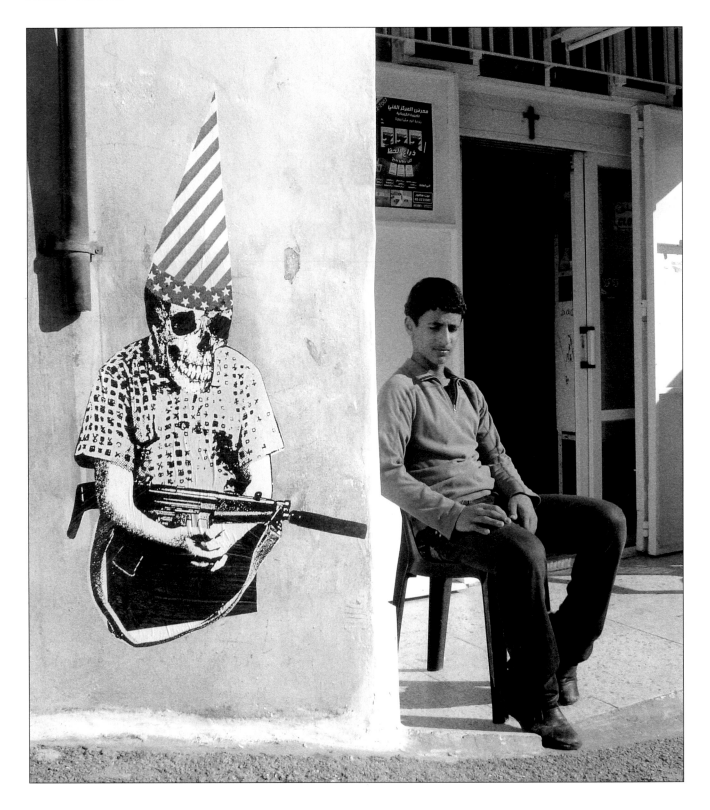

Palestine

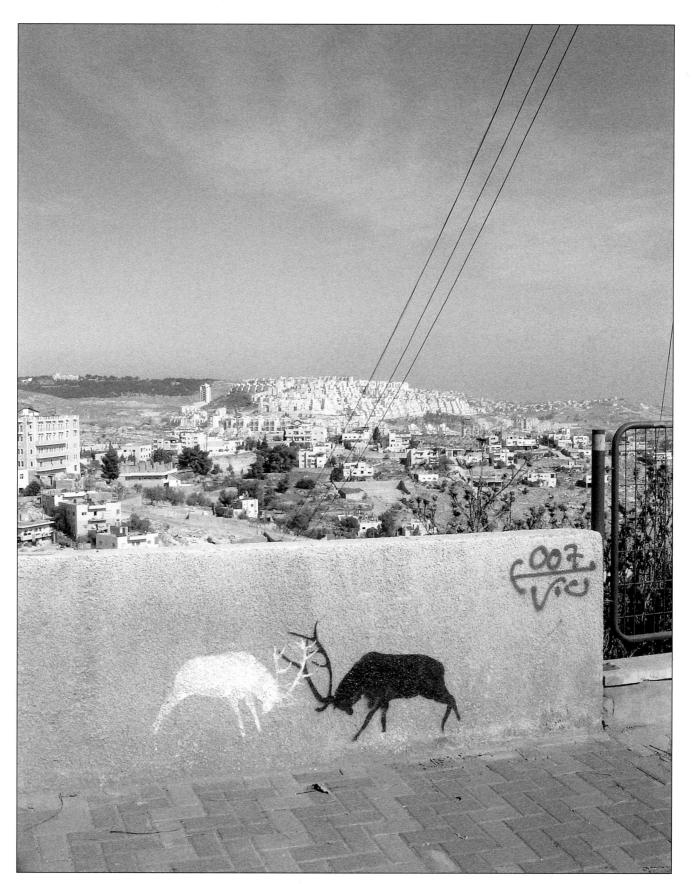

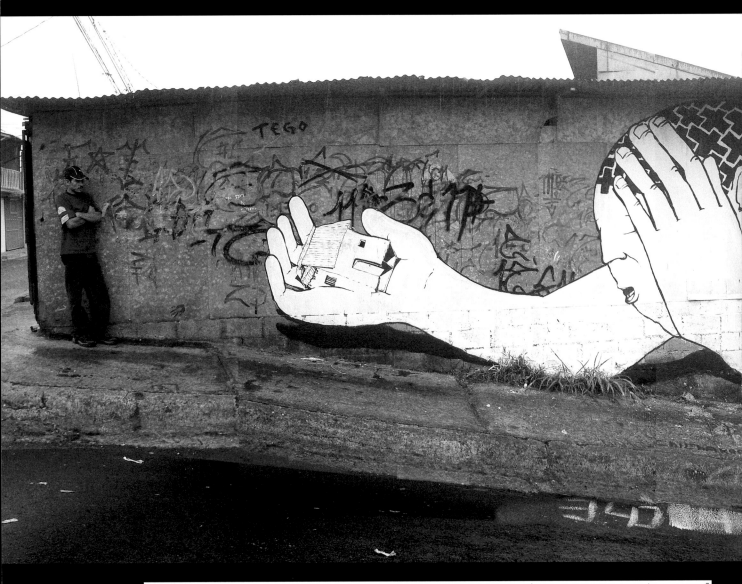

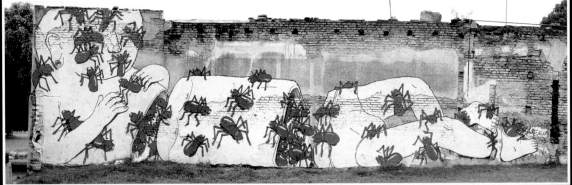

Costa Rica, Argentina

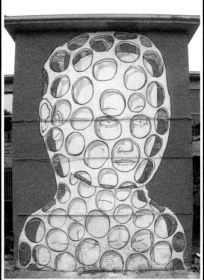

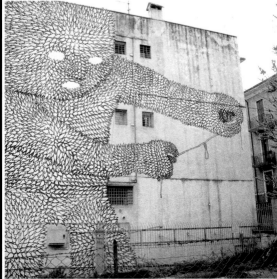

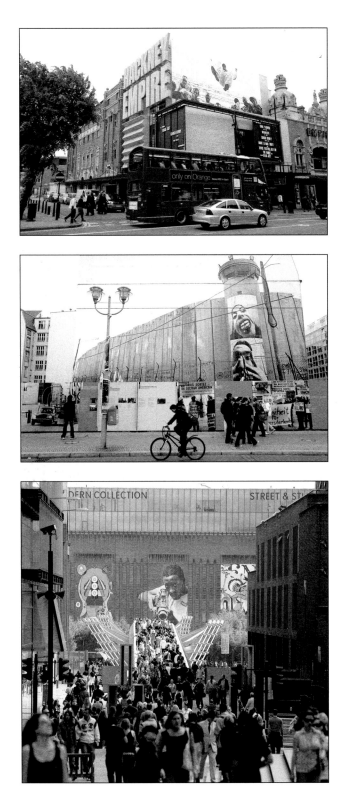

Above (from the top): London, Berlin, London
Right: London

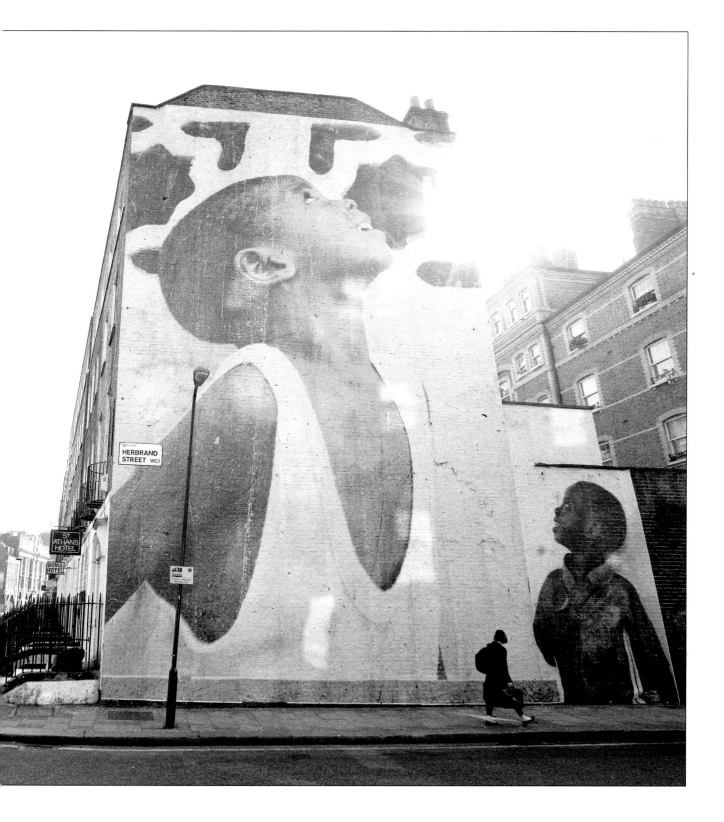

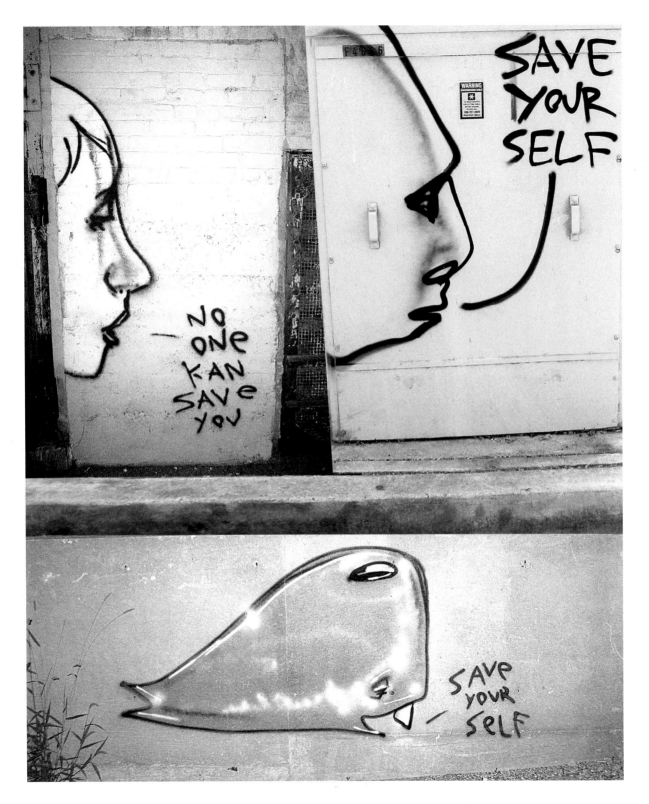

Above: Save Yourself
Opposite: Ride the Bus; AA

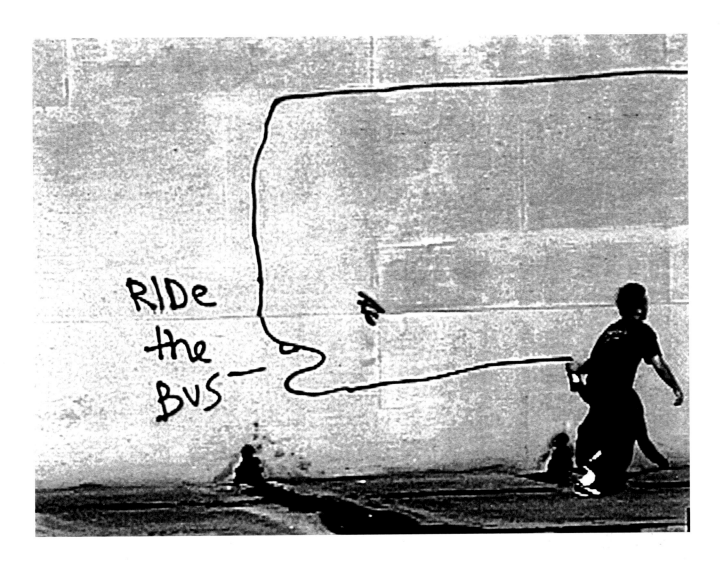

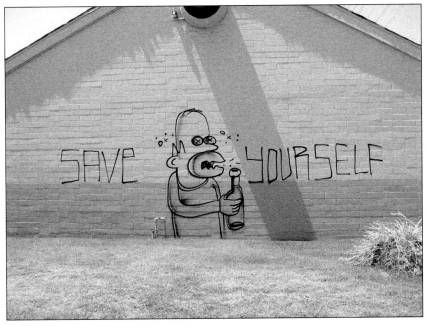

Kelsey Brookes

Kelsey is a former biochemist who attributes his raw style to an education system "that refuses to teach scientists to draw". He abandoned biochemistry because: "I thought I was going to be there for a few months to get myself some money. Three years later I was left wondering if I had become what I always despised – the funny guy at the water cooler... except not so funny. I was the confused not so funny guy at the water cooler."

Science's loss is art's gain and Kelsey's powerful canvases attracted due attention when he showed in London for the first time at Santa's Ghetto last year. The work's potency lies in its clash of ancient and ultra-modern references and the way these manage to drown out the sex and death (which also features heavily). Kelsey describes his art as "an unrefined and some would say unskilled mix of sex, comedy and animals which is derived from a true passion for all three, except not necessarily at the same time".

Kelsey's work is also embraced by the California surf scene that devours his free time.

David Choe

Choe sculpts and paints in oils, acrylics, crayon and mixed media. His credibility as an 'artist', albeit one inclined to utilise public spaces every so often, is hardly in doubt. Influences flow through comic book culture to gothic art, impressionism and the surreal. The content of Choe's work is equally complex and in contrast to the slick, succinct, populist messages of some of his contemporaries. The fictional military heroes of GI Joe wield boomboxes above Arabic slogans; hip young metropolitan ladies whisper their cruel conspiracies; seedy delights beckon from behind pretty vistas; grown men scream for ice cream; absurdist animals rope humans into their incomprehensible schemes. On the street, base titillating yet supposedly 'tasteful' advertising becomes doctored with intestines and tribal fetishes, echoing the sensual abyss of de Sade. The titles of his work include *I Fuck Nerds*. Equally, Choe's figurative and collage work displays sensitivity and intricacy rarely matched by Manhattan's girly fashion illustrator set. We should be grateful, not offended, by the insights into Choe's potent imagination and agenda; and the alluring, intricate slag smelted from its process of reconciliation.

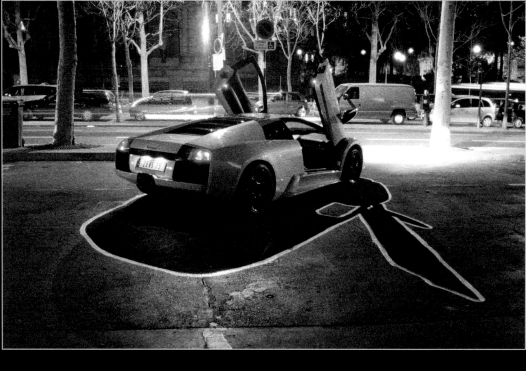

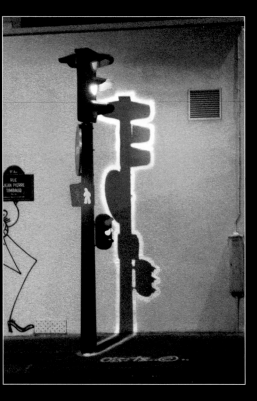

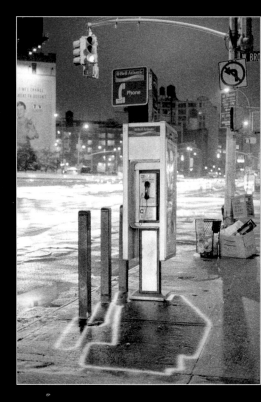

Electric Shadow – Paris and NYC

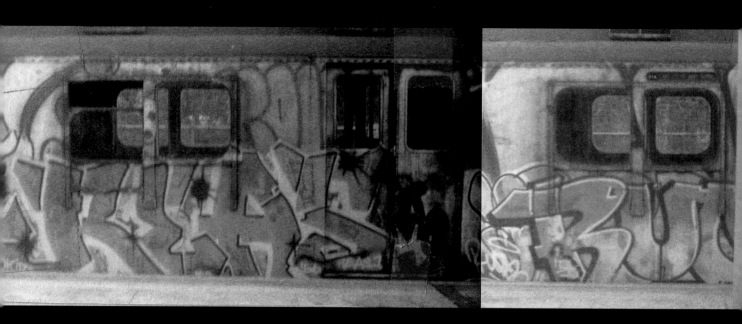

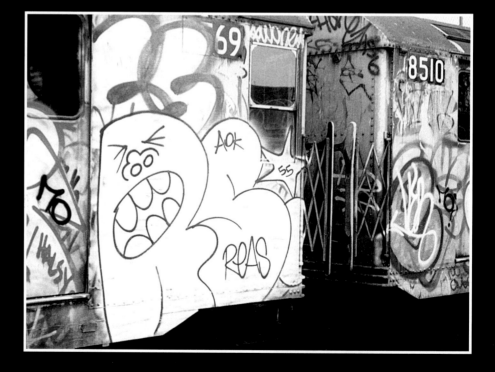

Above: RUone Ven; RS Throw Up
Opposite: Reas in Frying Pan

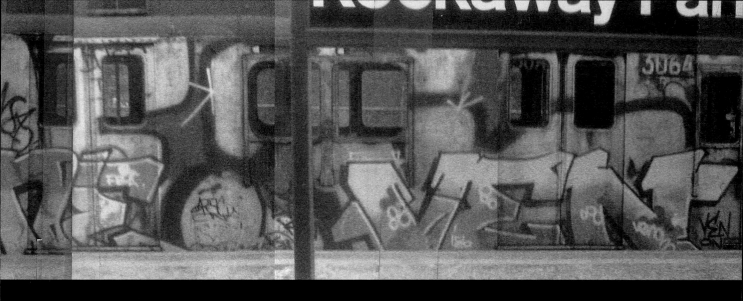
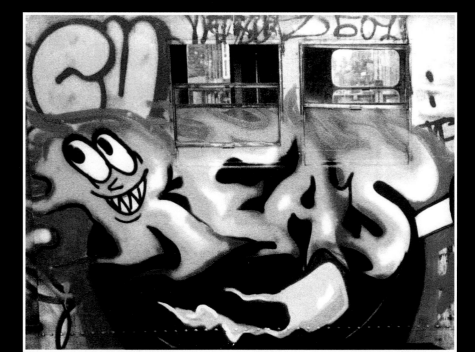

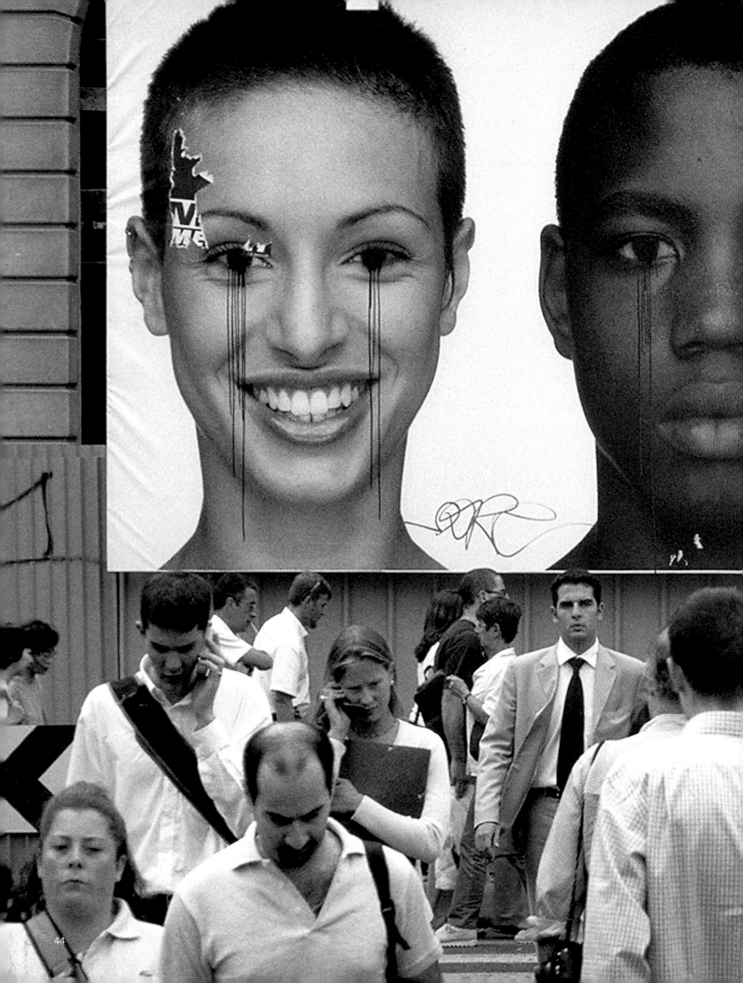

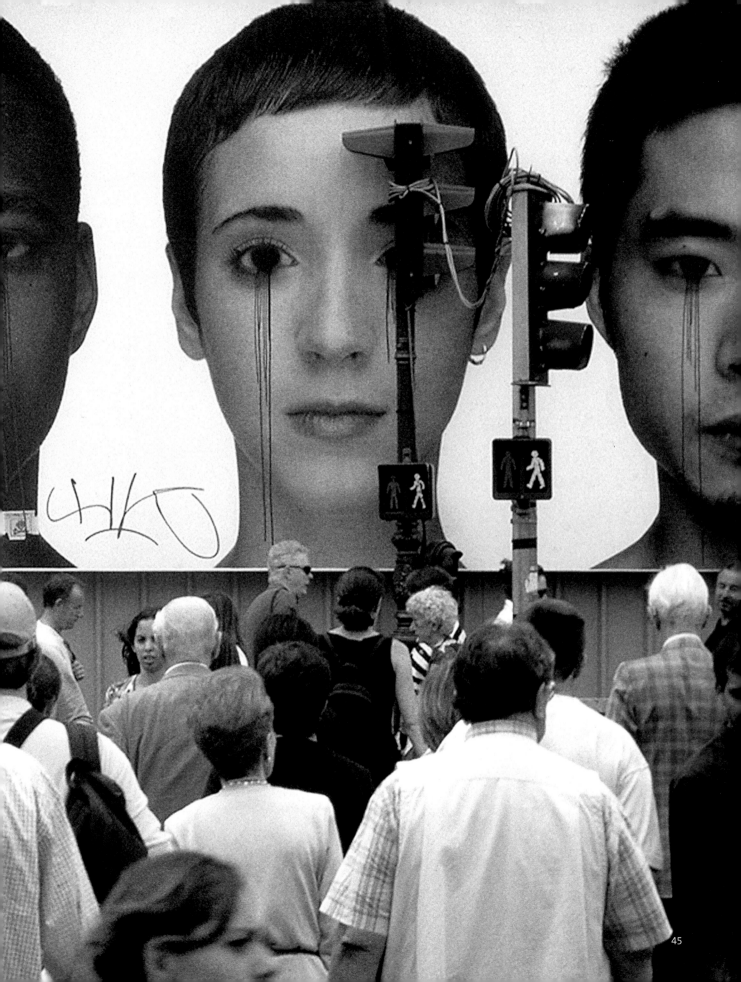

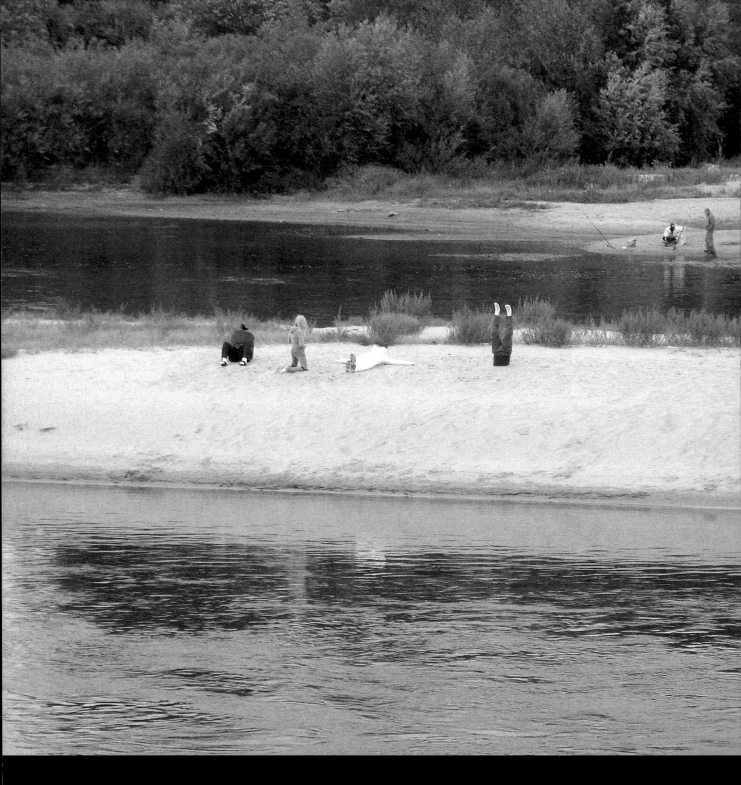

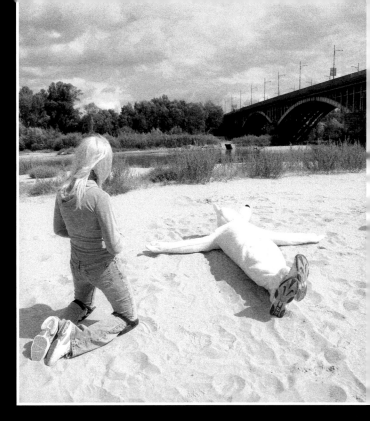
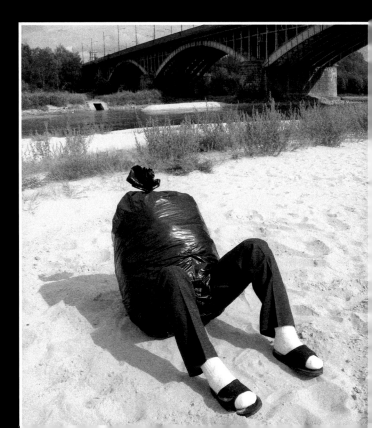

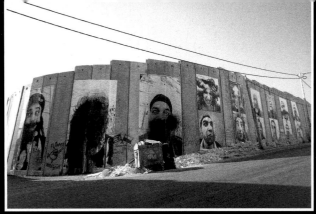
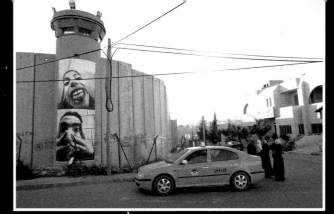
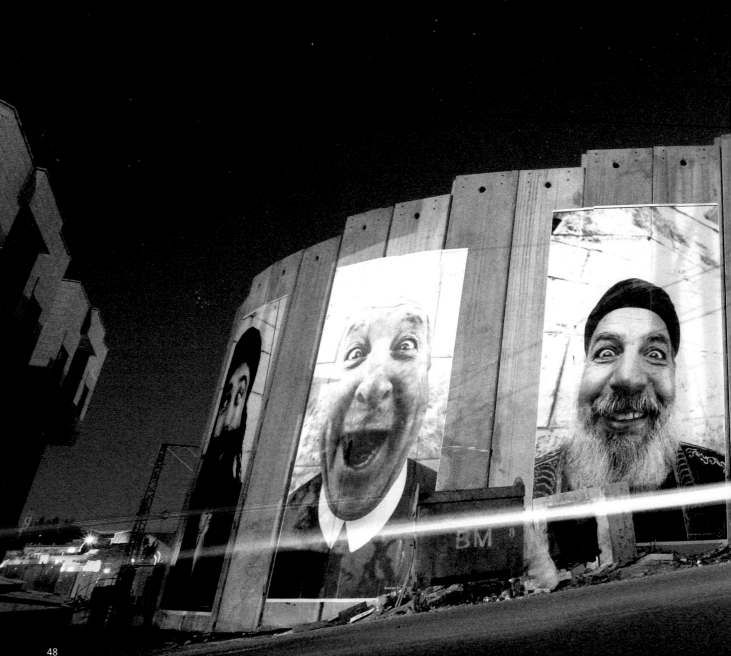

48

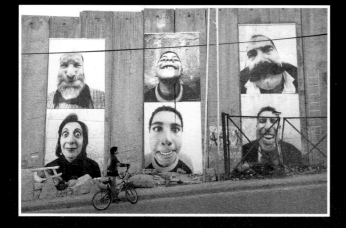
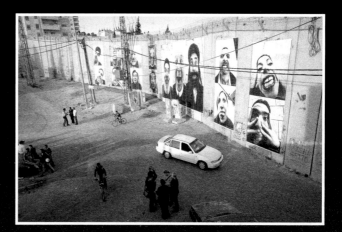
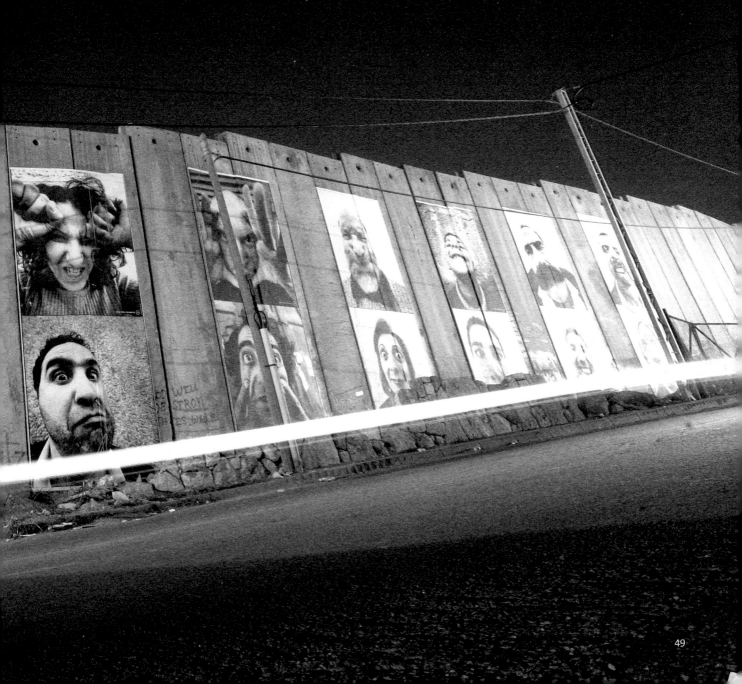

Miranda Donovan

Miranda Donovan's three-dimensional panels, some almost a metre and a half tall, are unique in the field of graffiti art.

"I work around the five centimetre depth of the panels too, blurring the boundaries between object, sculpture and painting," she explains further. The pieces are, as you can see, visually striking besides their three-dimensional, free-standing, physical presence. Miranda's work combines one of art's most traditional and supposedly soothing formats – the landscape – with rudimentary but vivid forms of graffiti; her own tag, 'Tear', appears regularly. However, the work is far less cosy than it may seem, posing inquisitive and quietly confrontational questions about this generation's relationships with our upbringings, idealism, and civil responsibility. What makes an idyll and what contributes towards a dystopia? Whilst Donovan's consideration of middle class values is clear – "I'm presently making copies of Dutch 17th century landscape painters, which for me evoke a lost world of innocence," she says – the artist also puts the definitions of 'social conscience' and 'beauty' up to debate. One is reminded of infamous Soho-ite, commentator and drunk Jeffrey Bernard who allegedly claimed that despite feasting his eyes upon the architectural wonders of the ancient world, he had "never seen anything quite so beautiful as the rotting fruits and vegetables of Berwick Street market".

Stanley Donwood

Once described as "the Terry Gilliam of Radiohead", which he hated, Stanley Donwood countered by saying "a soundbite is a statement designed to preclude intelligent thought". The powerful visual identity he's created for the band is considered so in tune with Thom Yorke's music that the debate still rages as to whether he and Yorke are one and the same, despite the pair accepting their 2001 Grammy Award for best packaging (a limited edition of *Amnesiac*) together.

Mischievous and macabre in a very British manner, Stanley's art veers from propagandist graphics to introspective illustrations, but a consistent strength is its combination of deep personal and political emotions with modesty and humour; weighty subjects examined not entirely seriously but certainly respectfully. This is England, certainly, but it's the homeland of dogging, curfews, botched amateur occultism and free-growing amanita muscaria. The new Jerusalem isn't coming, and it's no-one's fault but our own.

Notoriously reclusive, Stanley himself doesn't pander to the disingenuous trend for grandeur, and like many intelligent creatives operating in such a conceited sphere, cannot resist underselling himself (one of his several books – a pulp thriller, *Catacombs of Terror* – he describes as "written in a month for a bet").

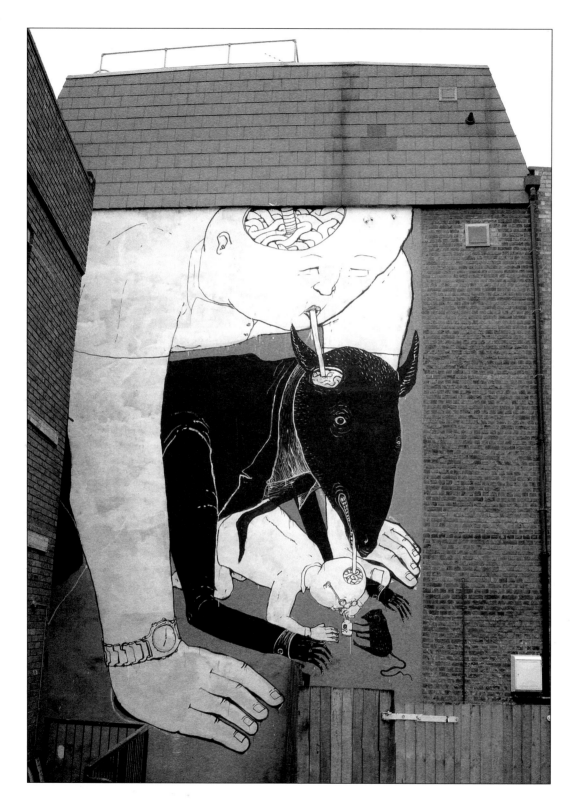

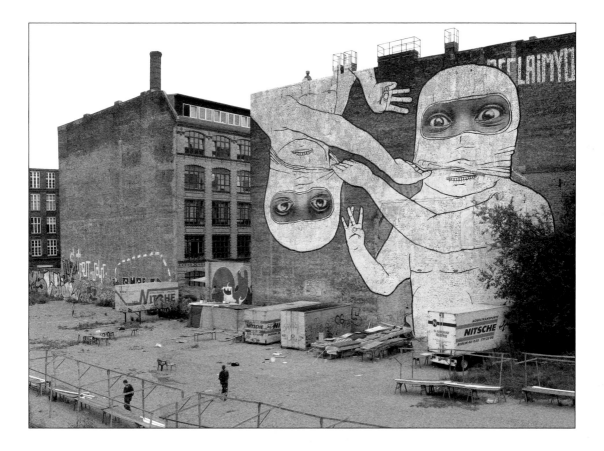

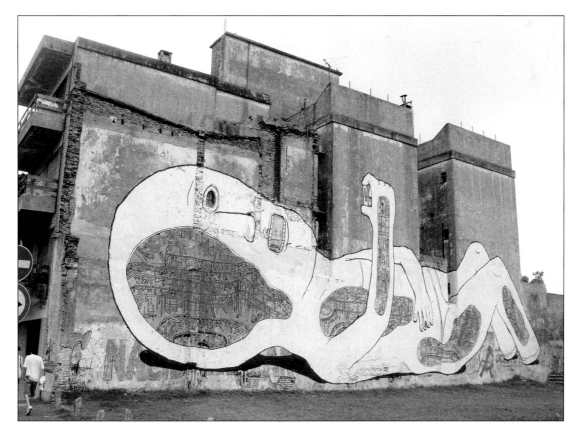

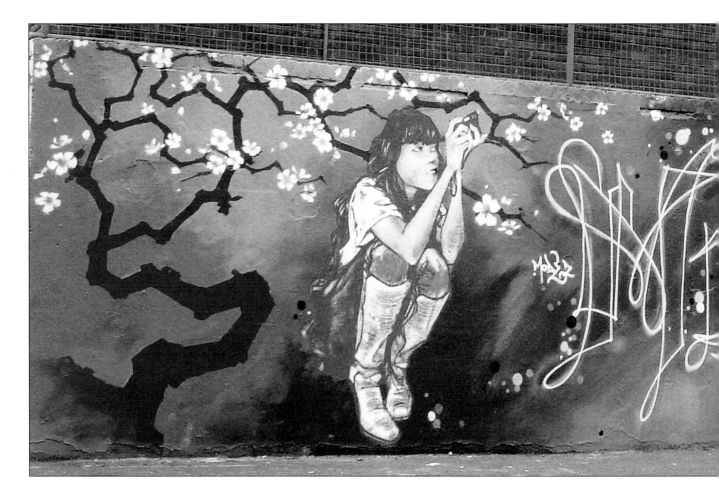

Above: Blossom *(Mode & Elk)*
Opposite, from left: Aeroglyphics, Perth; Paris

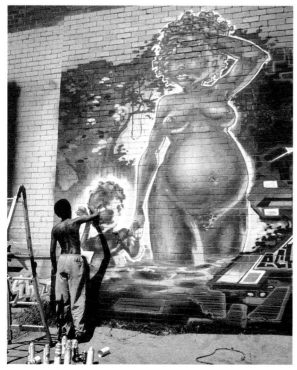

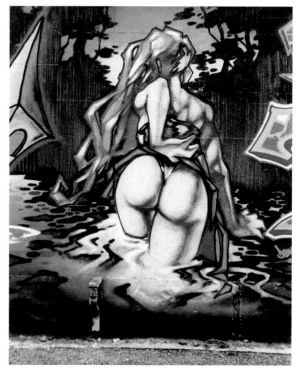

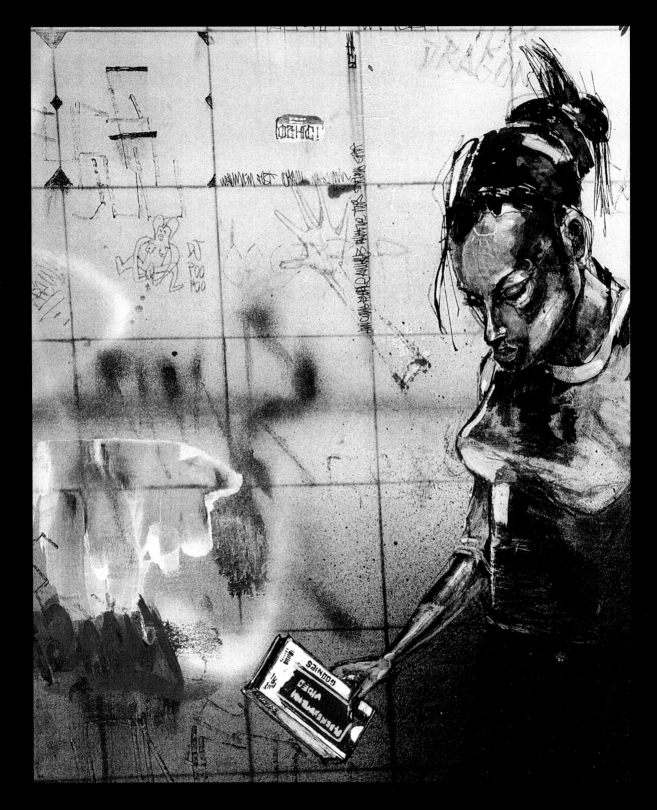

Above: Goonies
Opposite: Heidi Fliess mural

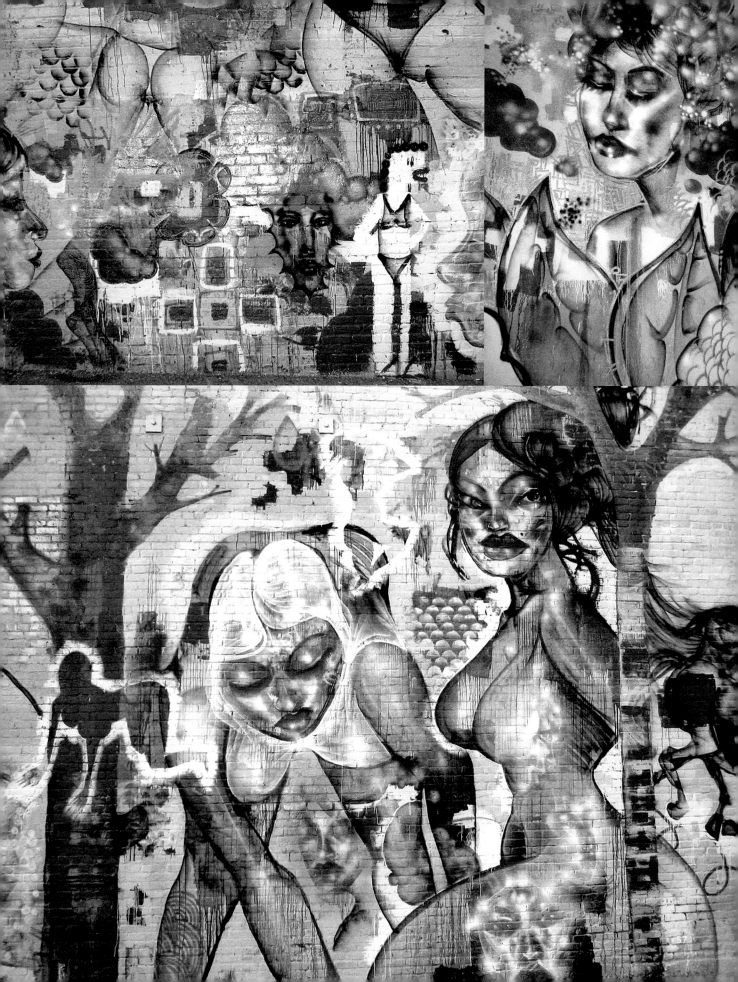

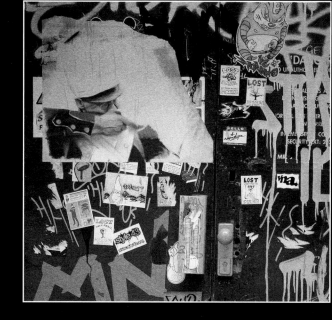

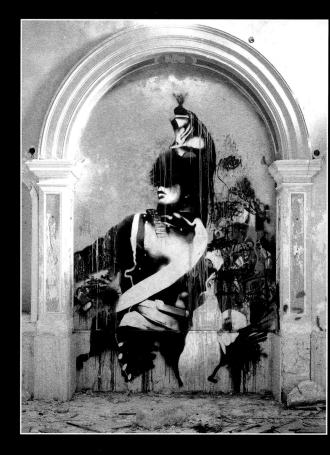

Left: Dinnertime Bandit, London
Above top: Napoleonic Charcoal 1, London
Above: Grottaglie Monastery

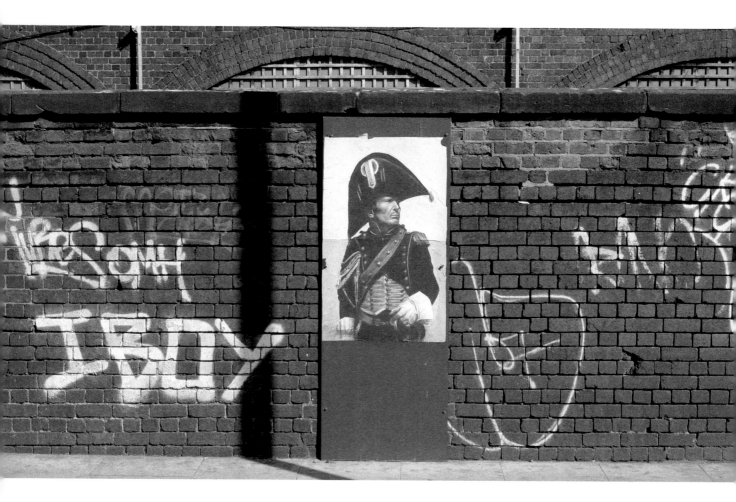

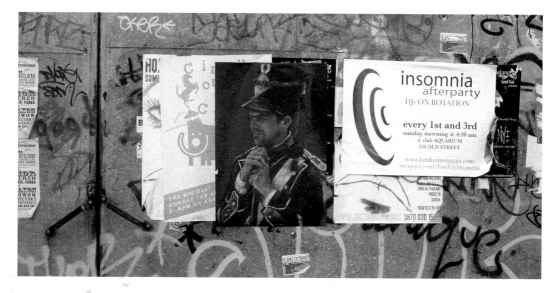

Above top: Napoleonic Charcoal 3, London
Above: Napoleonic Charcoal 2, London
Opposite top: The Carnival Goes On (Wall), London
Opposite: The Carnival Goes On (Charcoal), London

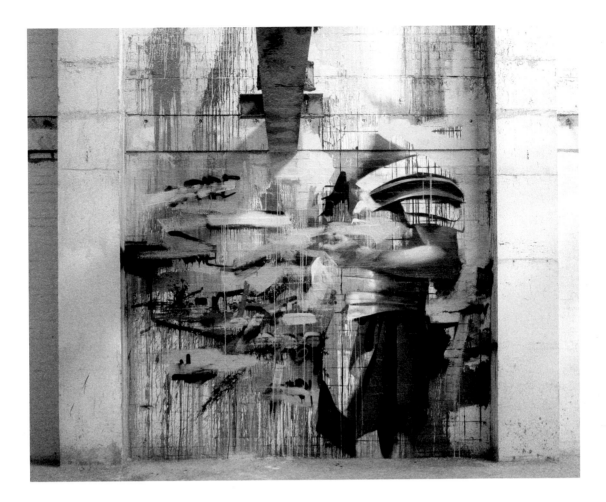

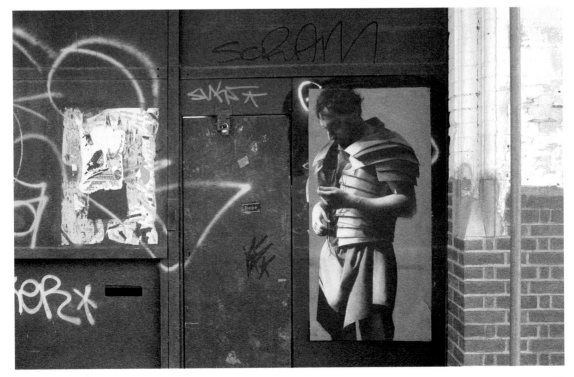

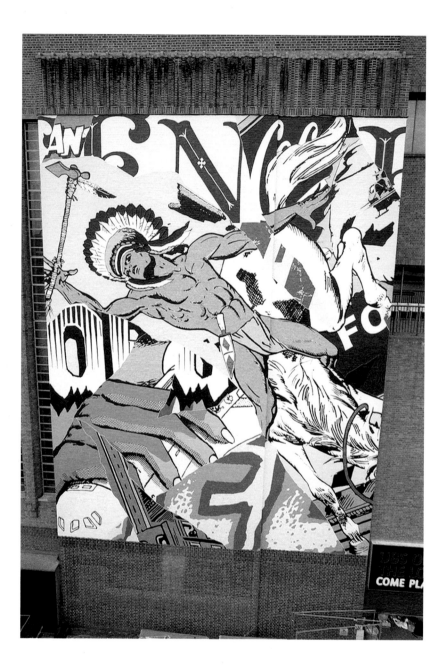

Above: Tate Wall
Opposite: N 8th St & Wythe Ave, Brooklyn, NY 11211

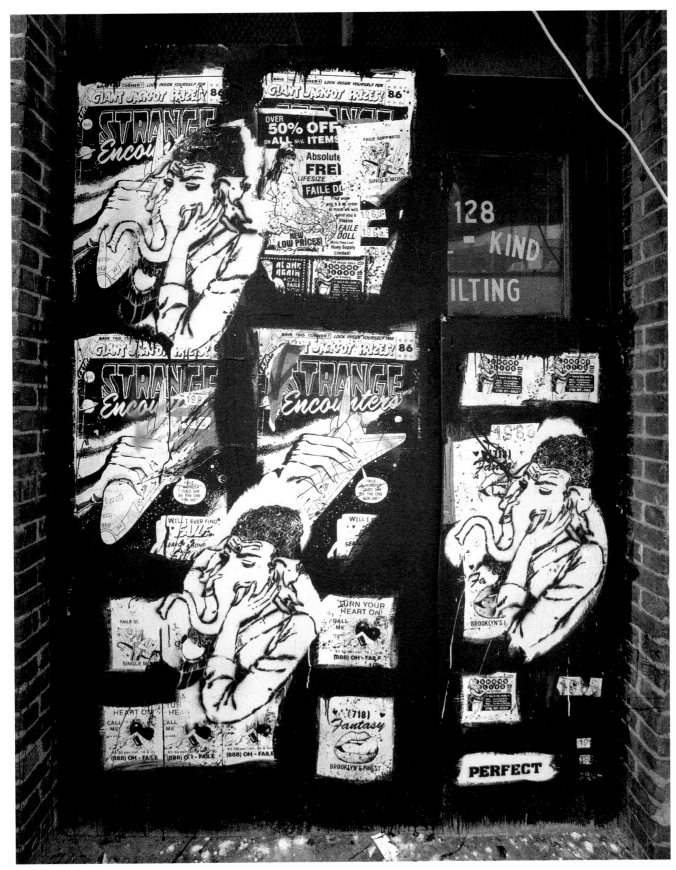

Faile

The Faile collective are one of the most popular and recognizable international producers of street-displayed artwork. Their allure has prompted an invitation to paint the exterior of London's Tate Modern gallery in May 2008. In 2007 their shows in London and New York sold out instantly, and inspired memorable, and widely-reported, scenes amongst would-be buyers that were considerably uglier than Faile's seductive and eye-catching art.

Eliminating the problem of painting on walls whilst keeping one eye out for the authorities by simply slapping the finished art up as a flyposter, Faile's tremedously appealing work graces brick surfaces across the world. Lacking in aggression, perhaps, but certainly not passion, the pieces here testify that the real power of Americana is that it can always be appropriated and enjoyed on one's own terms.

Faile have produced four books featuring art and writing, the most recent of which, *Lavender*, was released in 2005.

They are the nice guys of the graffiti world, and like all nice guys they will win in the end.

Ian Francis

Ian Francis originates from the West Country of England. His hyper-intelligent, multi-layered, work is intricate in form and content. It's effortlessly uncomfortable whilst at the same time dramatically appealing; seemingly parochial yet peppered with pan-national references. Figures in intimate situations are illuminated by far-reaching backdrops. Mainstream motifs play out complex, open-ended scenes made with the ultra-modern methods of graphic art pioneers such as Bill Sienkiewicz and Dave McKean.

Francis himself says his work is "about pornography and news reports from warzones rather than sex and death", echoing the atomized and hedonistic nature of modern everyday life. He has repeated that his work is "about celebrity", but equally it concerns a lack of it. However, for all this the human spirit cannot be dulled and remains a force; hope, pleasure, laughter and love are more than possible without fame.

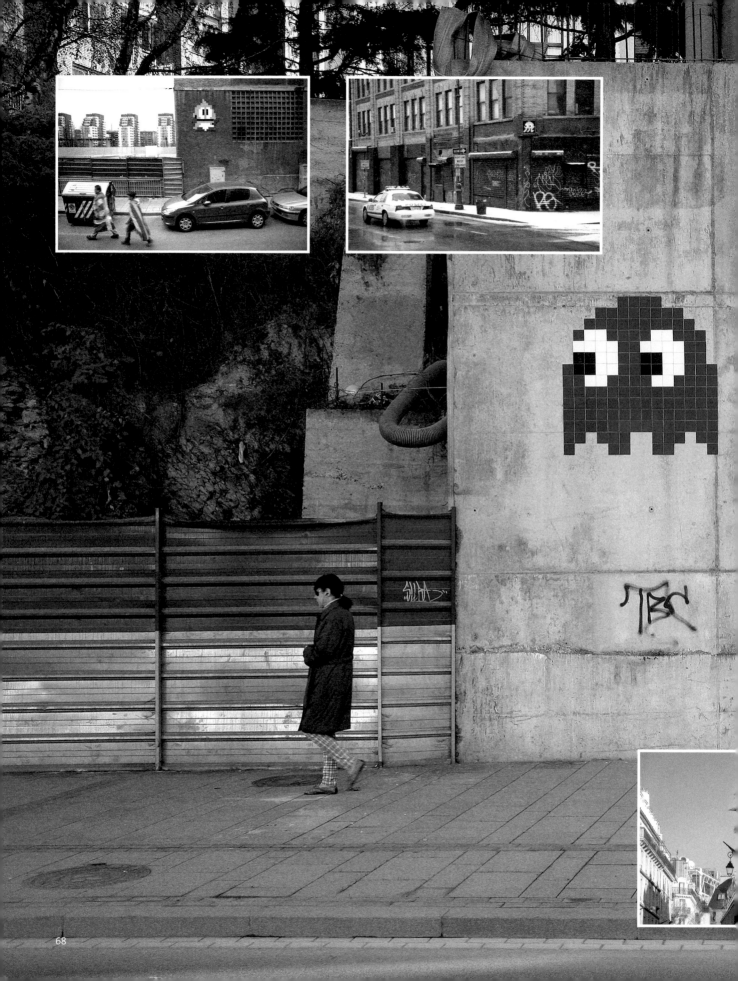

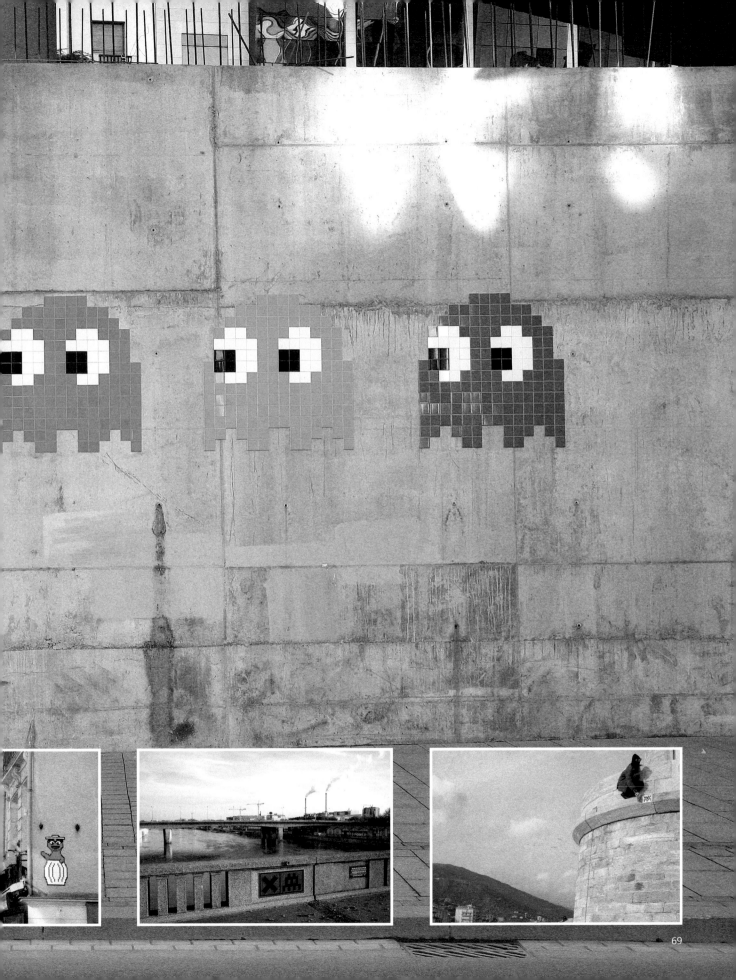

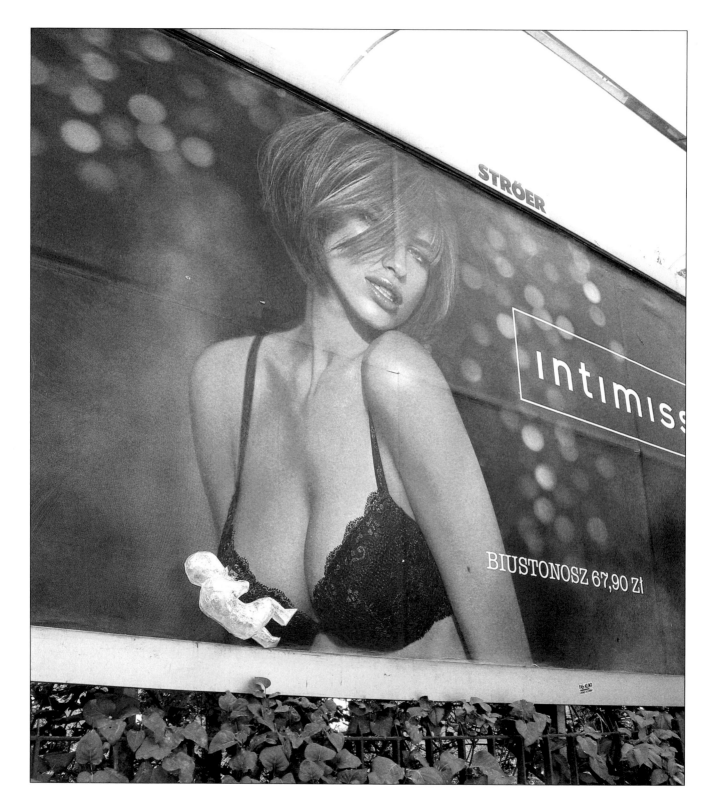

Above: Girl
Opposite: Warsaw

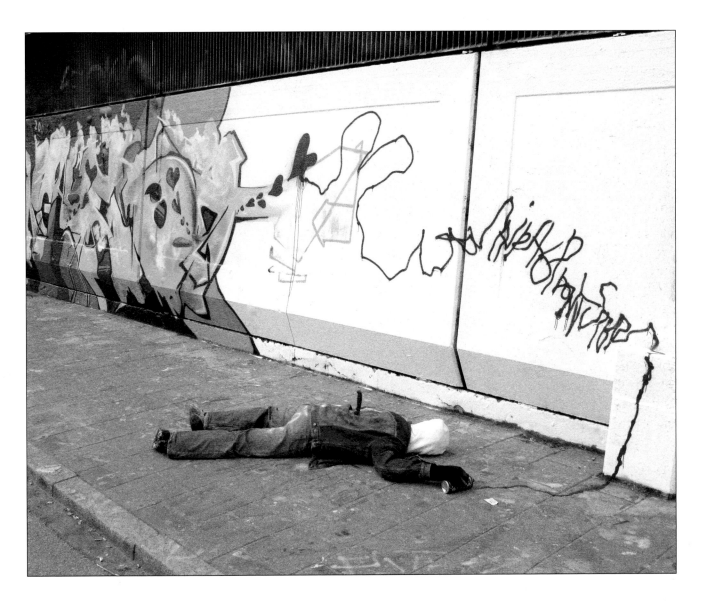

In

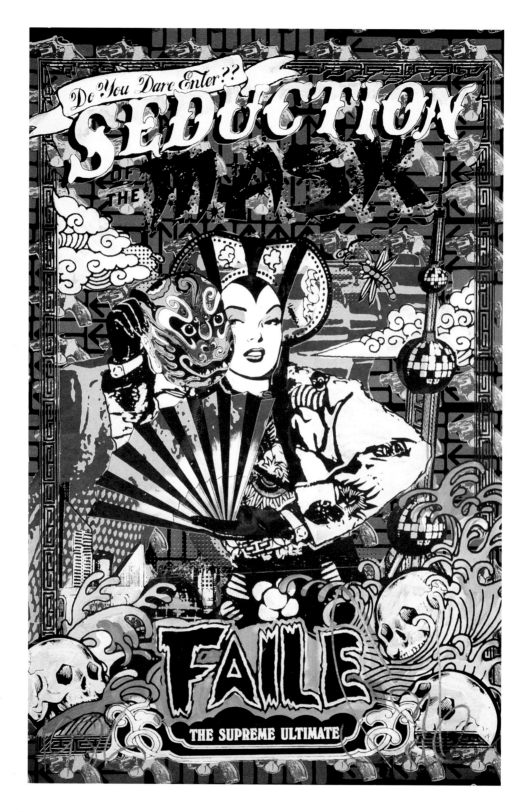

Above: Seduction of the Mask Archive
Opposite: Perils Torn

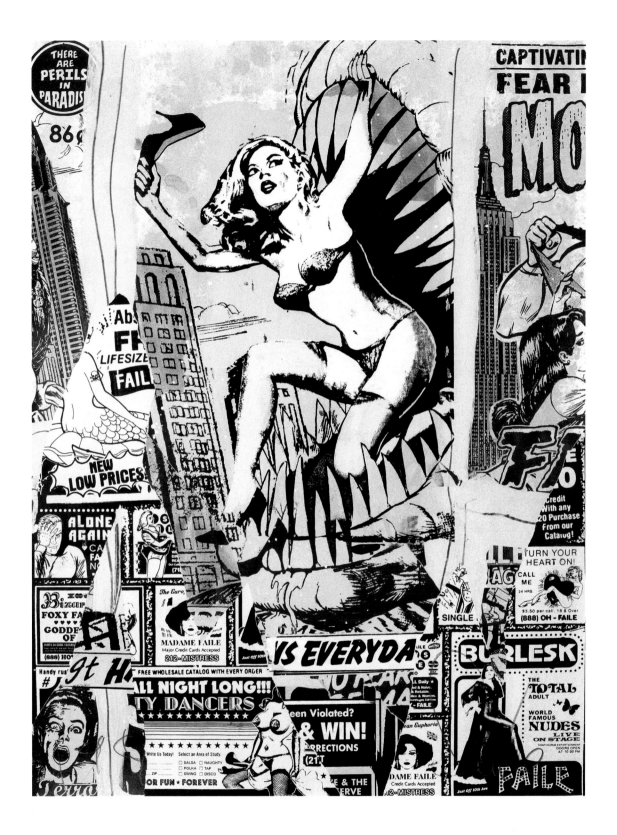

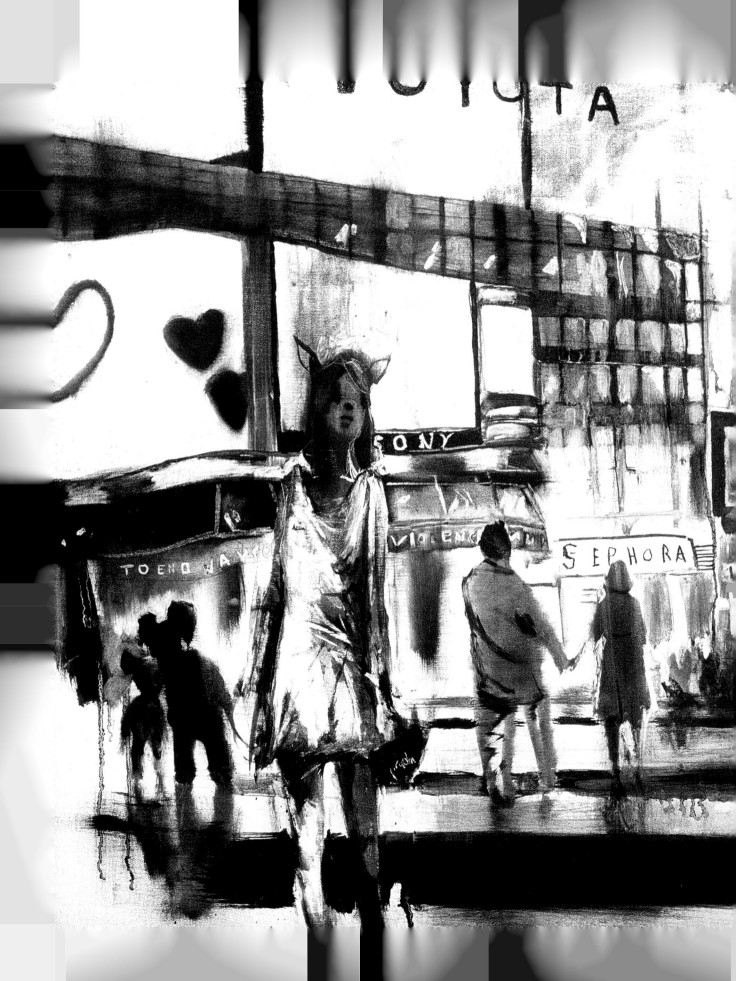

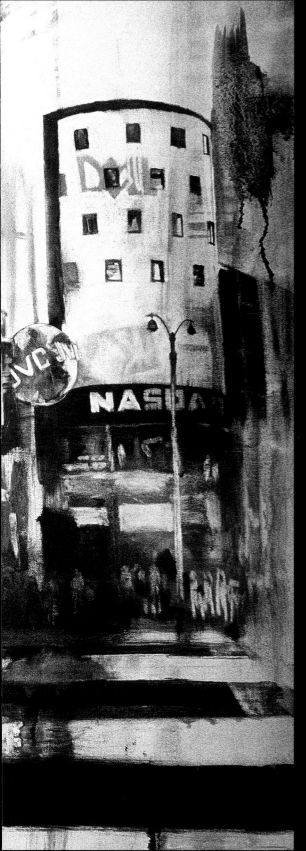

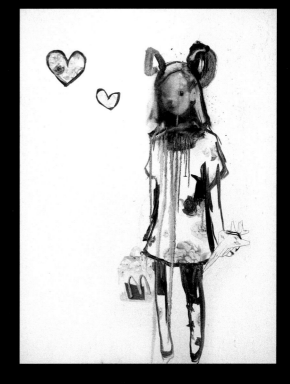

Left: Girl in Times Square
Above: Happy Spaz

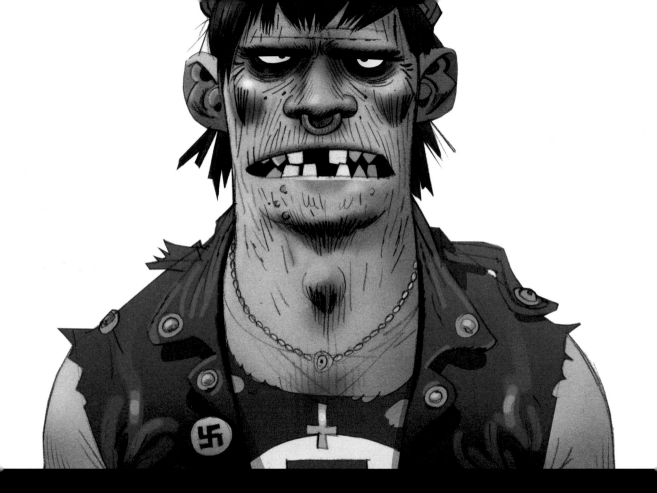

Above: Thick

Opposite: Troops go in *(originally commissioned for Amnesty International, Secret Policeman's Ball 2006 invite - www.amnesty.org)*

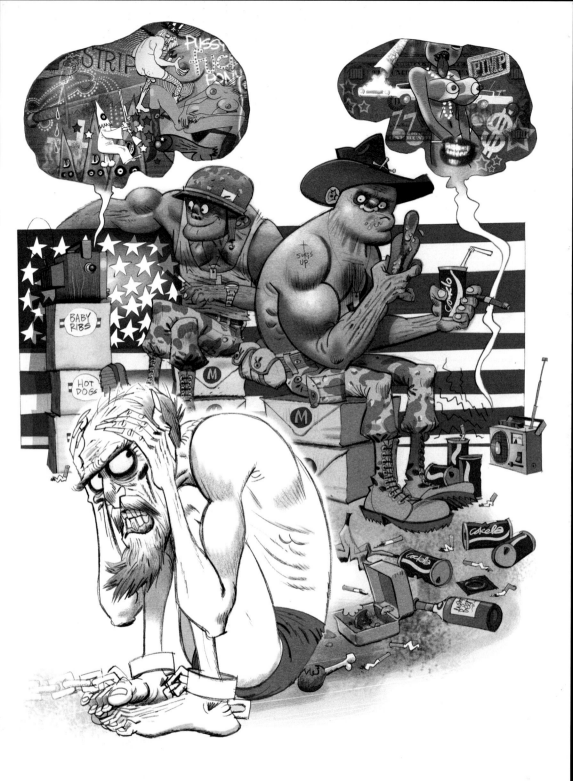

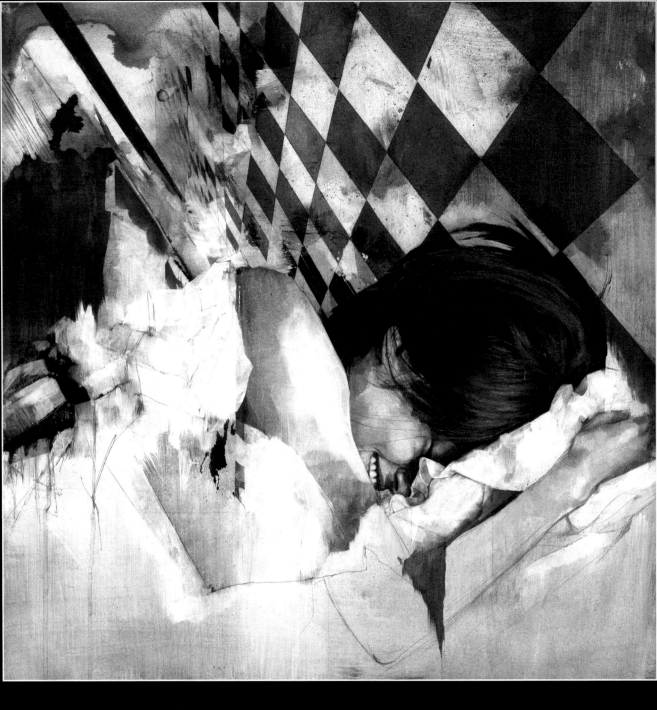

Above: Aya Ueto Takes a Holiday From all Her Troubles
Opposite: A Cheerleader Decides to Shoot Her Friend (This Scene is Real);
All the World's a Stage – Sometimes With Scenery

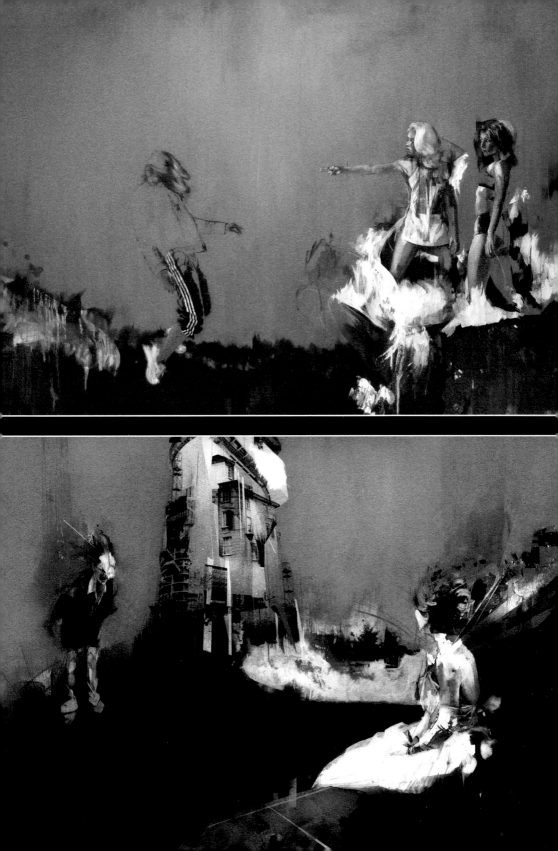

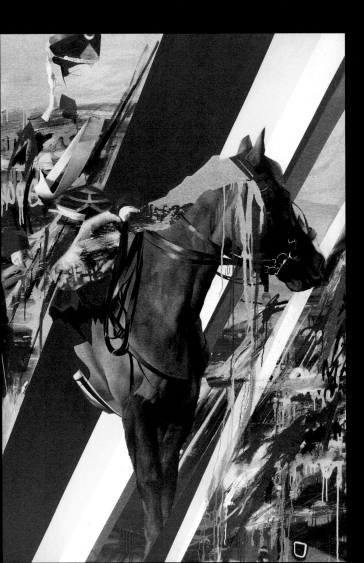

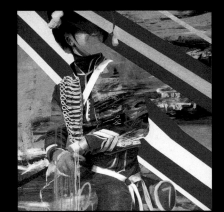

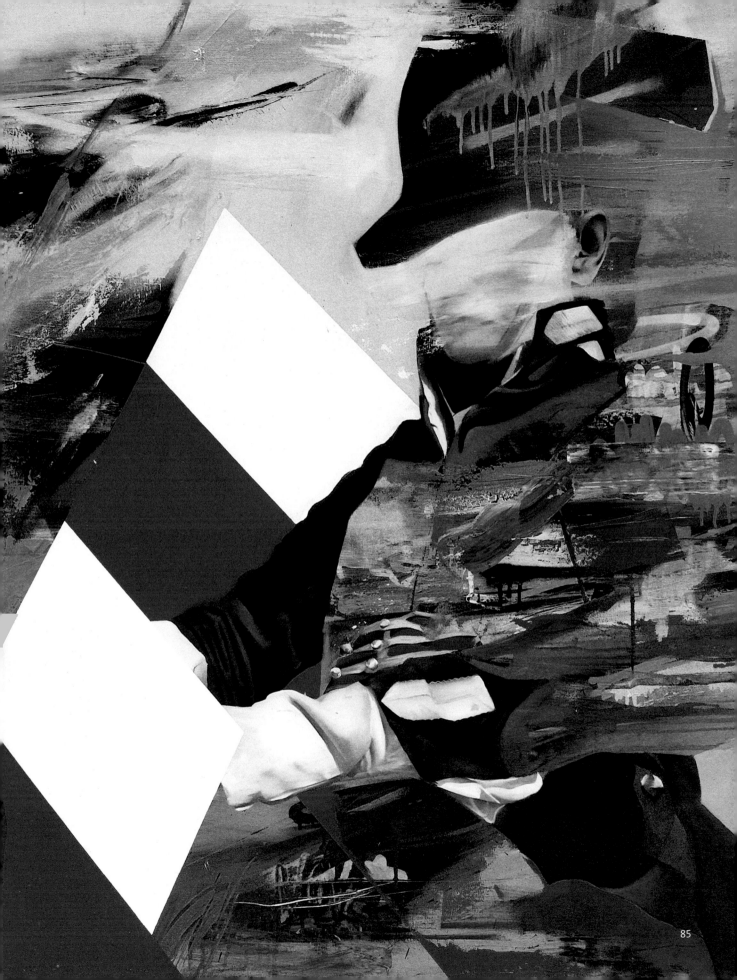

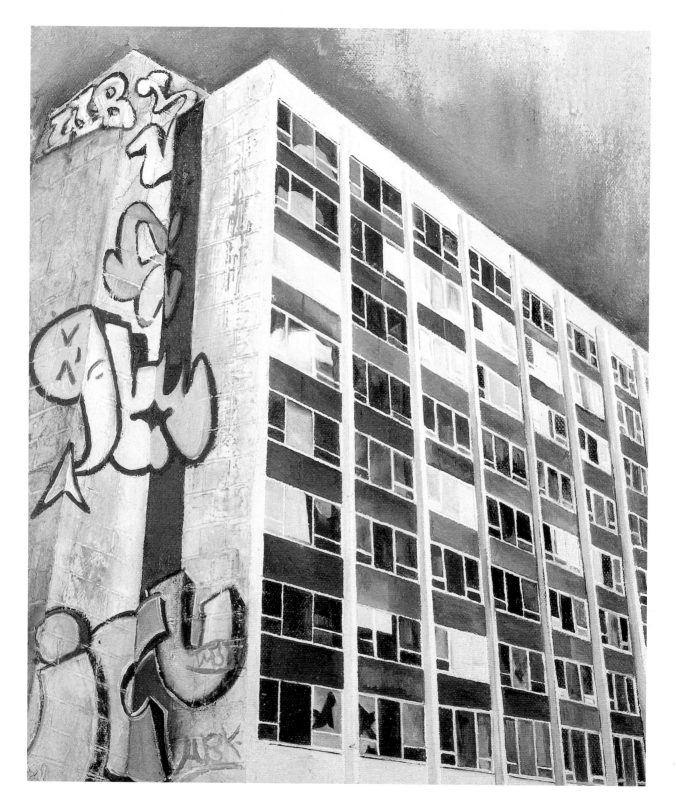

Above: German Graff
Opposite: Shit Hole

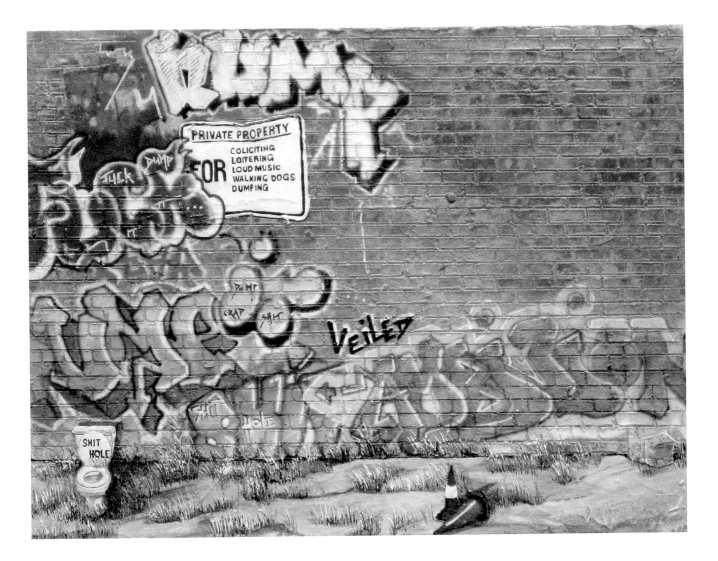

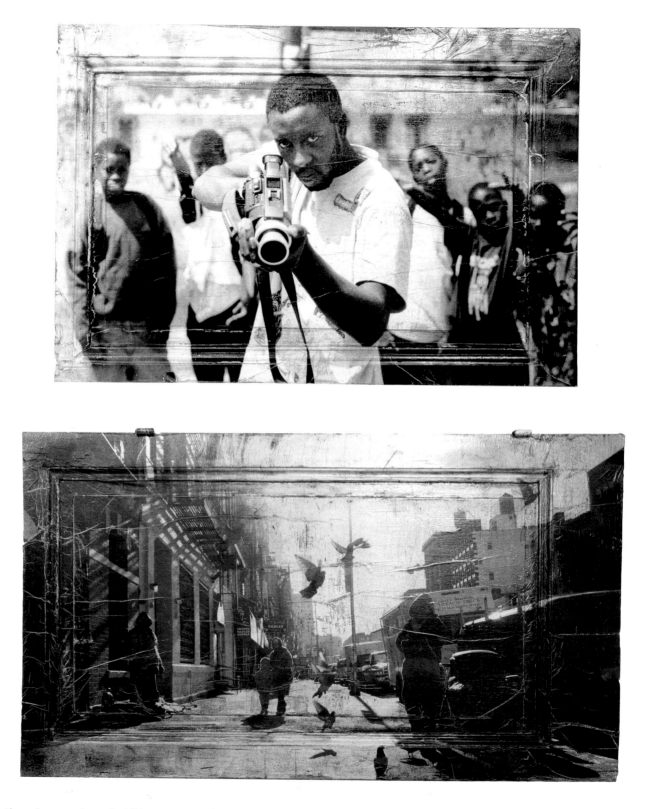

Above: Braquage; Lower East Side
Opposite: Rome

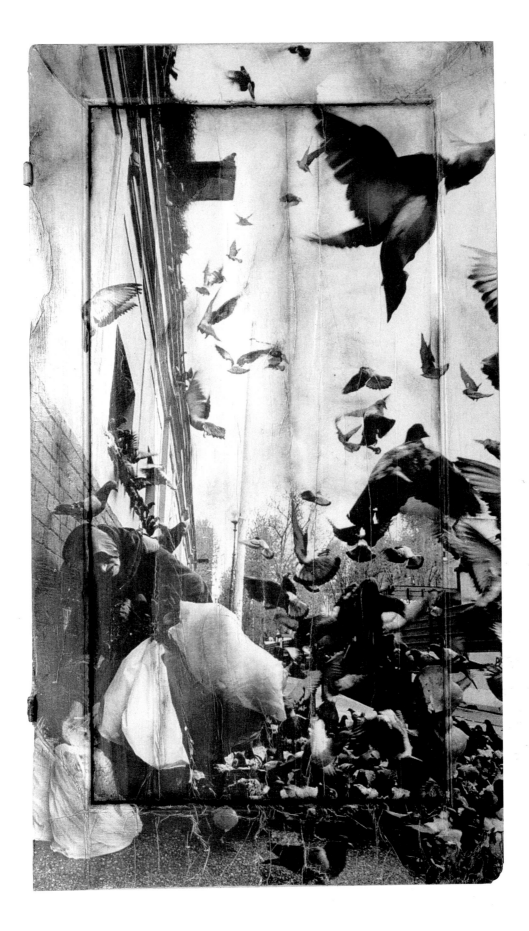

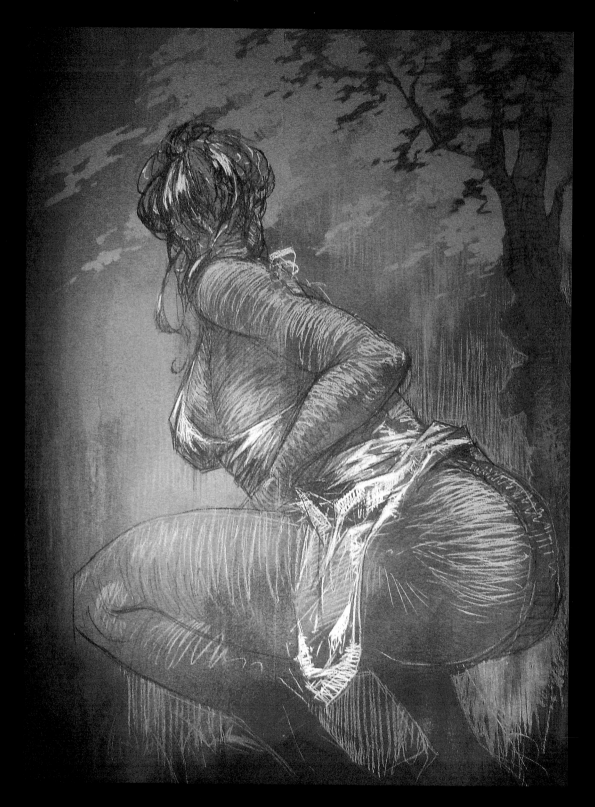

Above: Lazarides Office toilet wall
Opposite: Mozayeni

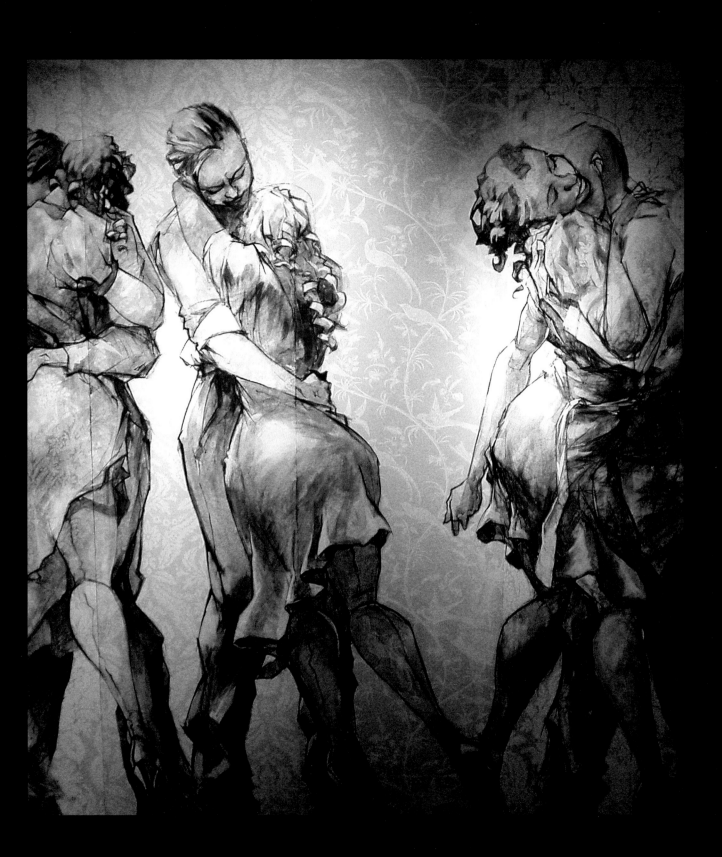

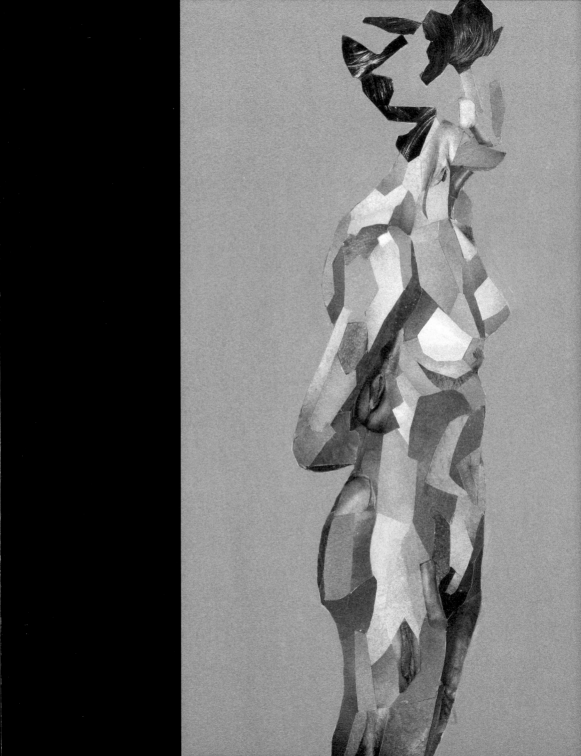

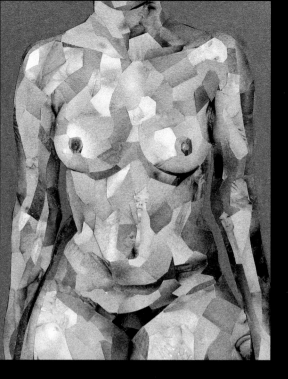

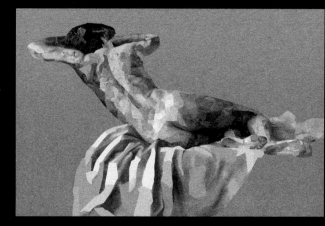

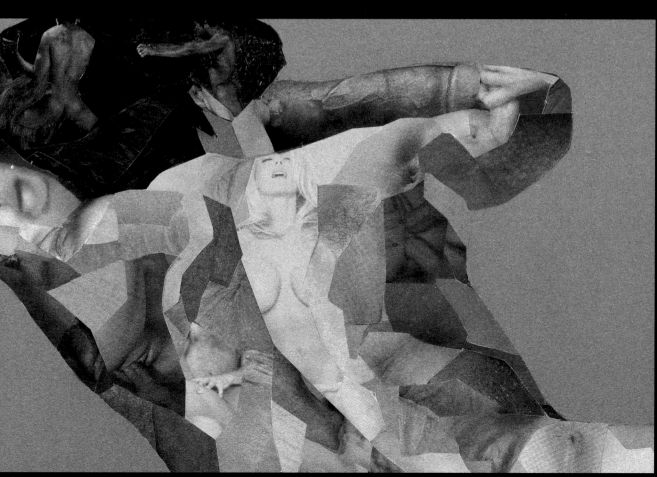

Conor Harrington

Conor's from Cork in Ireland. His work is an incredibly successful collusion between 'fine' art and 'street' techniques.

According to Conor himself, central to his oil canvases is "the male figure, referring to the masculinity of urban culture". The men in Conor's paintings allude to the not necessarily heroic, but stoic and pensive male of the modernist painters; however the pieces are plastered with post-modern graffito flourishes in a pertinent clash of styles; "I'm interested in the dynamics between opposing elements," says the artist. Whilst both the male figures and abstract elements of the work are unarguably contemporary, the emotions they transmit are timeless, if currently under-rated – dignity, courage and a quiet sense of duty to oneself and those around us. At a time when men are accused of being somehow redundant within society, Conor's work is an intelligent and modest reminder of their positive emotional contribution. It also shows that graffiti doesn't have to shock – or equally be soppy – to have substance.

Jamie Hewlett

Jamie Hewlett was born in 1968, the Year of the Monkey. Creator of comic book military chick Tank Girl and co-creator of Gorillaz, Hewlett has forged a distinctive visual style and a unique place in British pop culture. He is influenced and inspired by Chuck Jones, Ronald Searle, Stanley Kubrick, Hunter S. Thompson and zombie films.

In the late 1990's Hewlett met Damon Albarn and the Gorillaz concept was born; the band's self-titled debut was released in 2001. The release of Gorillaz' second album *Demon Days* (2005) cemented the band's reputation for musical and visual innovation. Their ever more inventive videos and sublime live shows, designed and directed by Hewlett, garnered critical acclaim and commercial success around the world. In 2006, Hewlett won the Design Museum's Designer of the Year Award for his work with Gorillaz.

In 2007 the opera *Monkey: Journey to the West* premiered at Manchester International Festival. Designed by Hewlett, the production has since played in Paris, Charleston and London. It follows the Chinese story-come-legend originally written in the 16th century. The album *Journey to the West*, based on the opera was released in August 2008.

Further projects have included: *Phoo Action*, a live action TV series based on Hewlett's comic strip *Get the Freebies*, and titles for the BBC's coverage of the 2008 Olympic Games in Beijing, a campaign produced by Hewlett and Albarn.

Hewlett works from his design and animation company, Zombie Flesh Eaters.

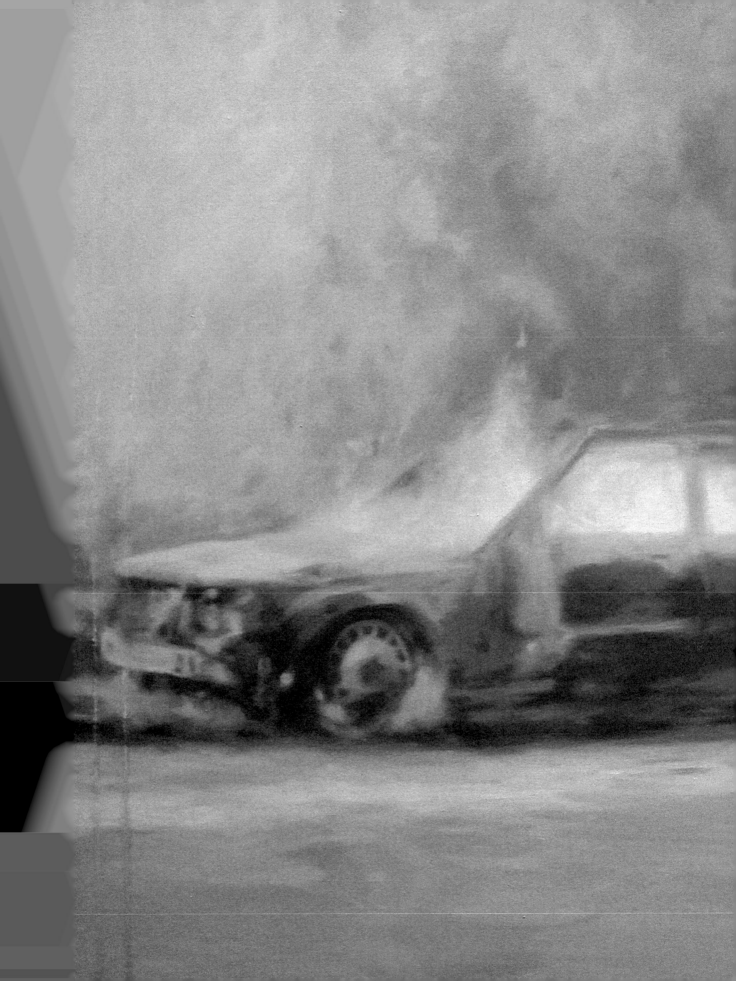

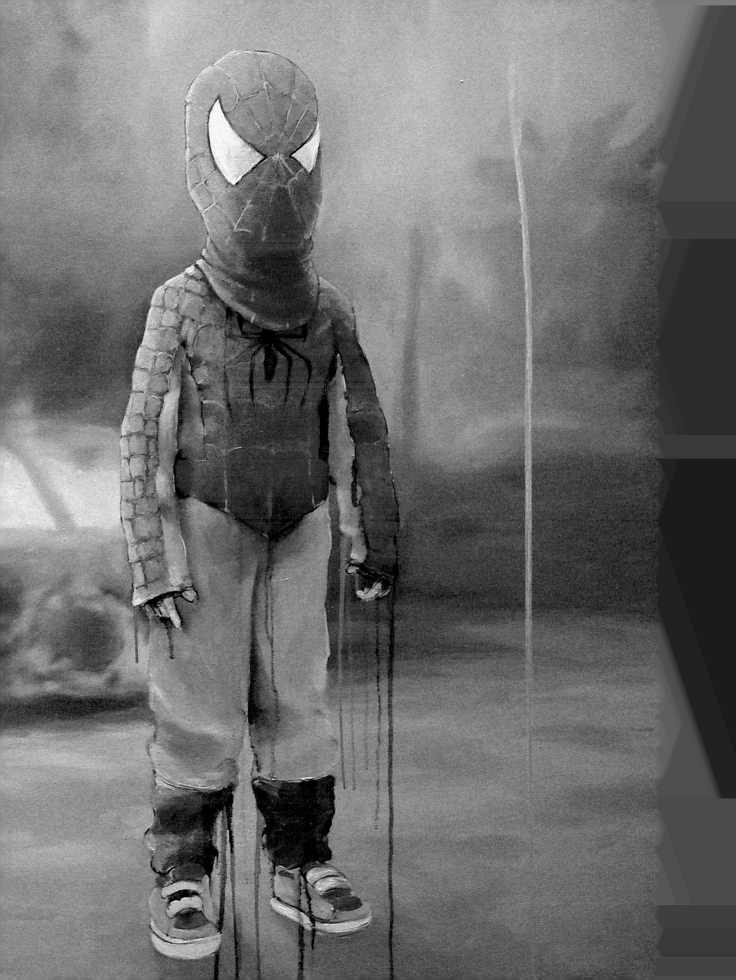

Above: Red Sketchbook 20
Opposite top: Red Sketchbook 22
Opposite: Red Sketchbook 16

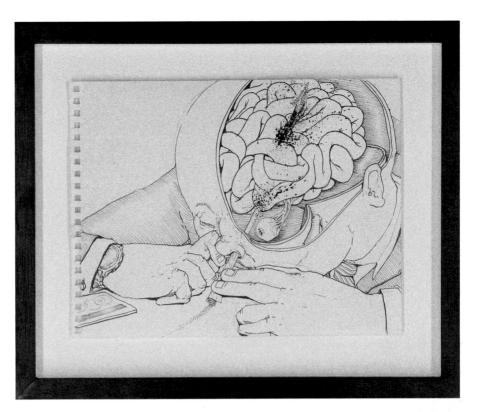

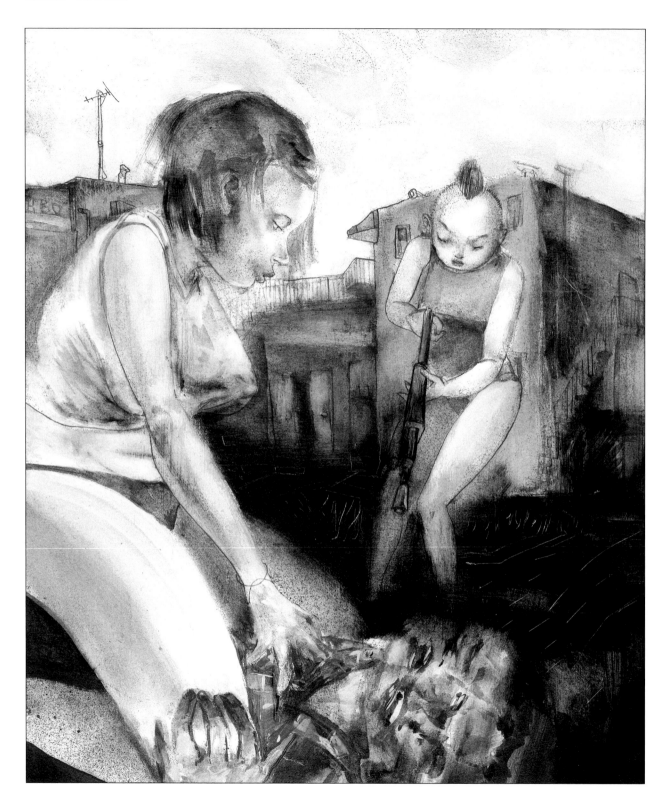

Above: Hold Him Still I Can't Get a Shot
Opposite top: City Girl
Opposite: Falling for Grace

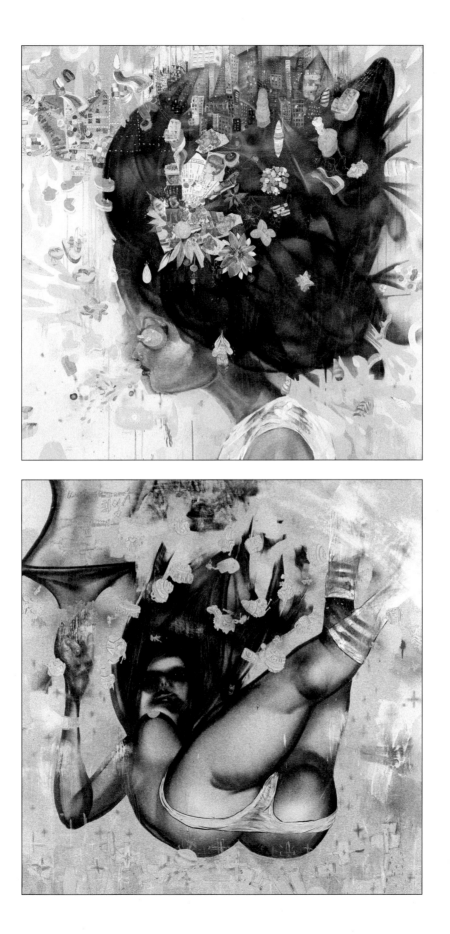

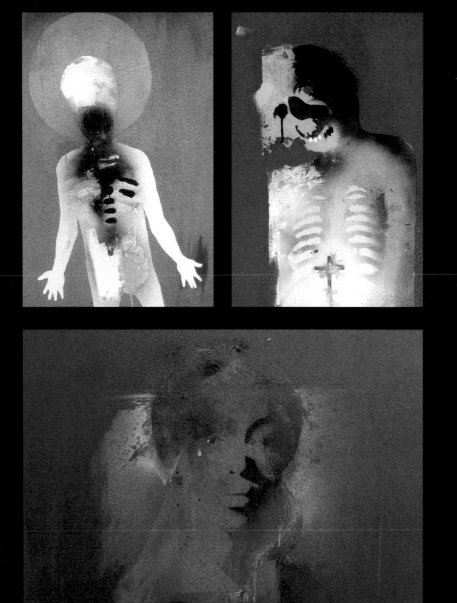

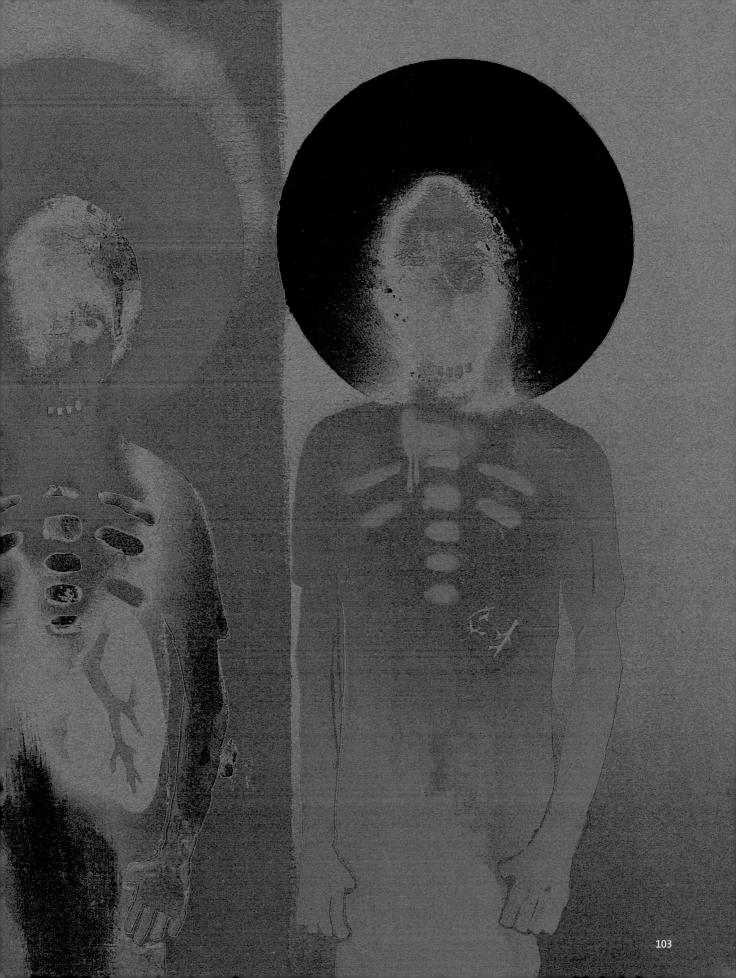

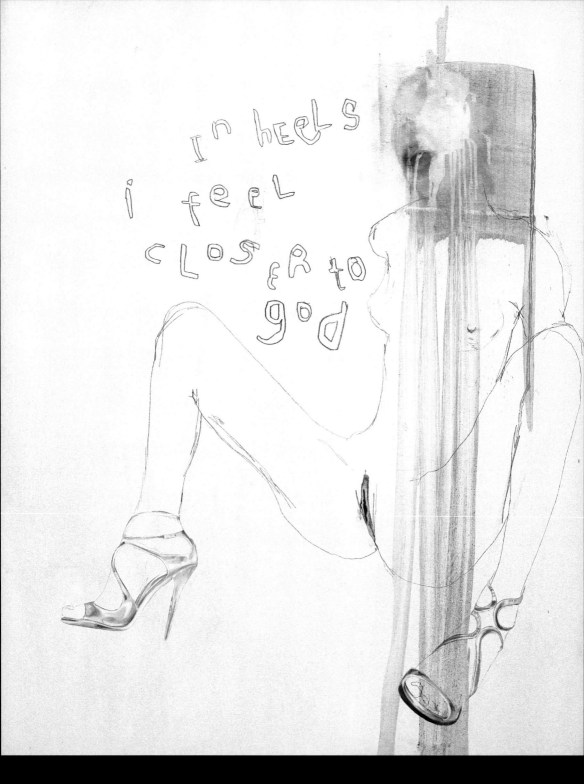

In heels i feel closer to god

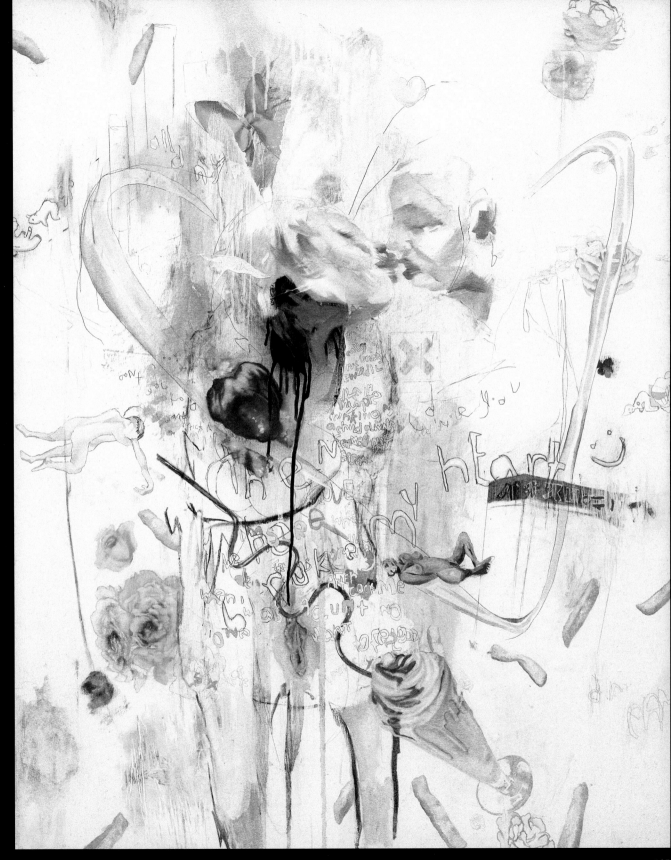

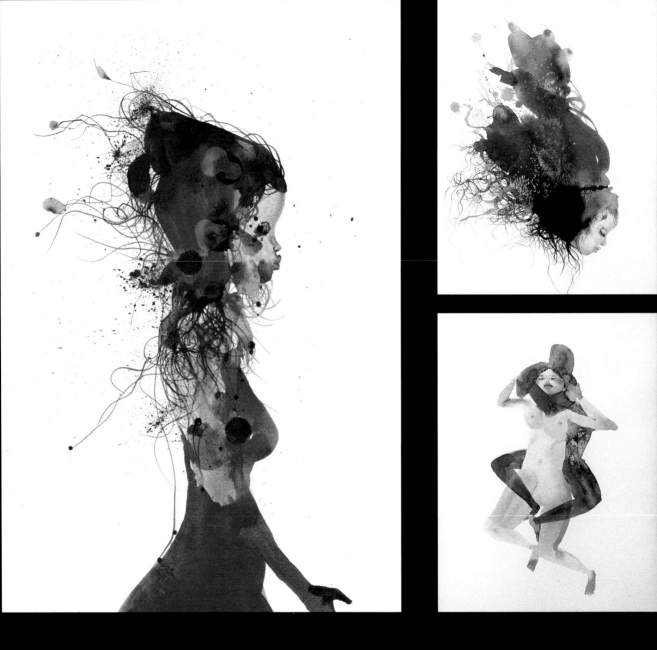

Above (clockwise from left): Blood Painting; Hunger Strike; Grappling Death
Opposite: Lust

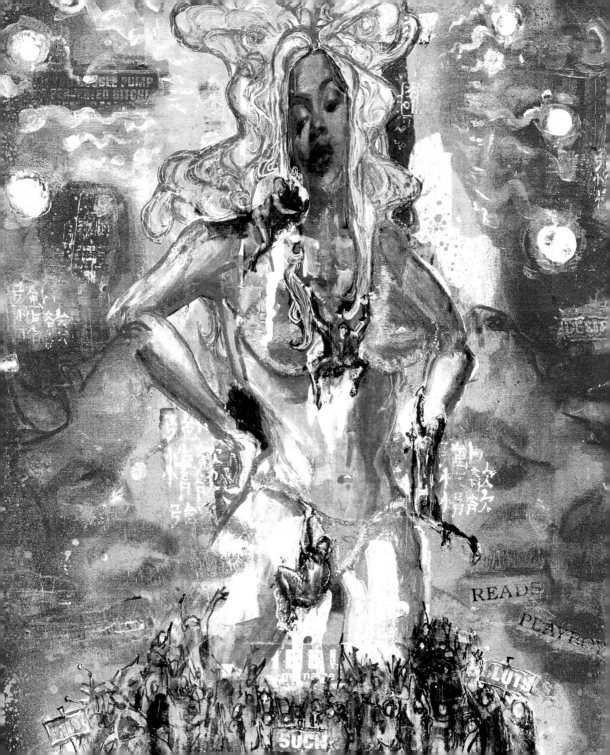

Paul Insect

Paul Insect's refined interpretation of visceral subject matter has thrust him towards fame in the past year, with a noted collector absorbing his entire 'Bullion' exhibition. Equally, Paul's work has evolved considerably. Victorian graphics have been replaced by Dada-ist collages fusing adolescence, aggression, and rough-around-more-than-just-the-edges pornography. These motifs are tempered by a joyous use of colour and an ambitious style. Equally, the images are provoking and provocative: dripping as much with sensitivity and gravitas as they are with sex and death. Moreover, they are a window onto the mind of the frustrated modern male: boiling over with unkempt aggression and sexuality, but yearning somehow for a higher moral purpose than the gradual accumulation of acceptance. Clowns crack and go on the rampage; kids in cowboy outfits contemplate the worth of their peers; and babies are contented to consider the consequences of the quantum age.

Invader

This artist is responsible for perhaps the most recognizable street art stunt of the last decade. In a planet-wide war of attrition, the pixilated expansionist aliens from Toshiro Nishikado's infamous 1978 arcade game Space Invaders stalked the Earth once more, appearing everywhere from on the 'Hollywood' letters to Jacques Chirac's lapel. Despite a counter-attack in Los Angeles, where a local 'vigilante' group fought back against the Invaders, defiling any they saw, eighty-five percent of the original put-ups remain.

Gallic in origin, Invader's work is distinctly *Rive Gauche* in its whimsicality, offering the viewer not only some tasteful Parisian-style vandalism but the opportunity to theorise wildy about what its purpose may be. Is it easier to see the modern world through the values of a simpler and more idealistic age? Are the pieces an aggressive attempt to conquer the artist's alienation from his surroundings? This is the sort of stuff you find yourself thinking when confronted by French graffiti.

Invader's new gallery pieces are made up from hundreds of original Rubik's cubes (we're not telling you where they're from, but we have loads out the back). Ranging from interpretations of iconic images (the Mona Lisa, Alex from *A Clockwork Orange*) to the abstract (representations of fragmented and de-fragmented hard drives), the Rubik's pieces are as instantly recognizable as Invader's, and on their way to becoming just as internationally recognized. No little square stickers were peeled off and moved around in the making of these artworks.

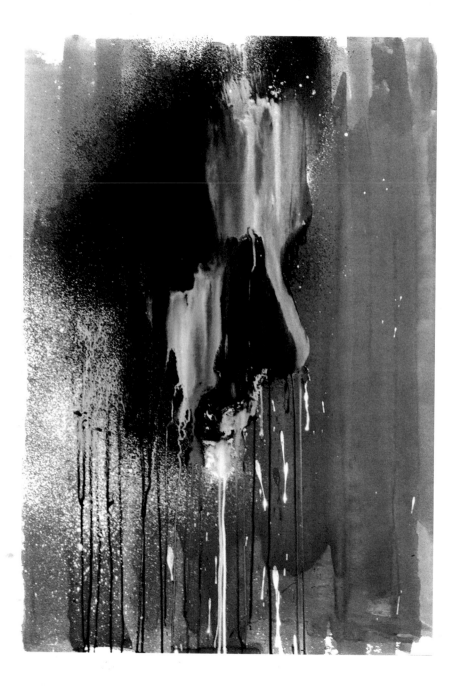

Unknown Faces Edition

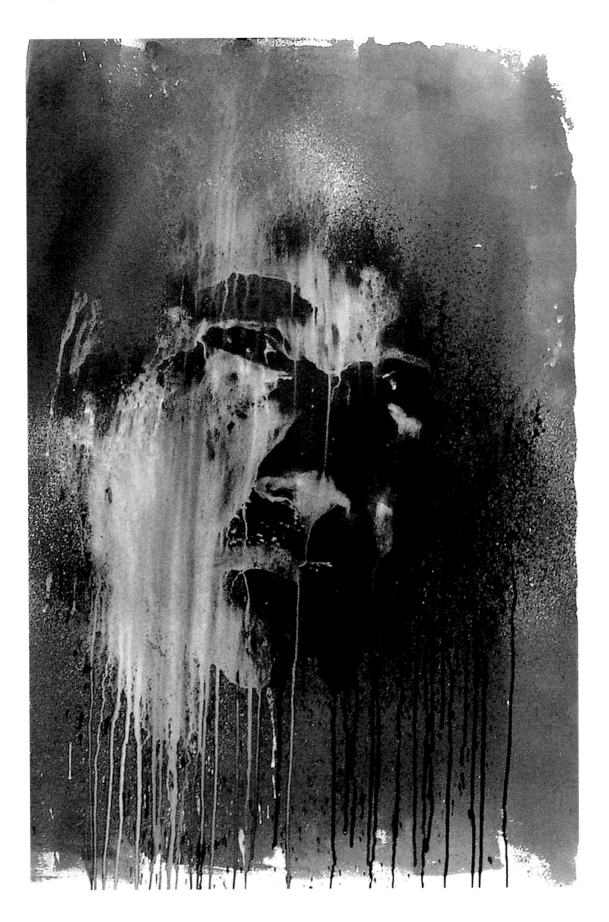

FOR A BETTER VIEW

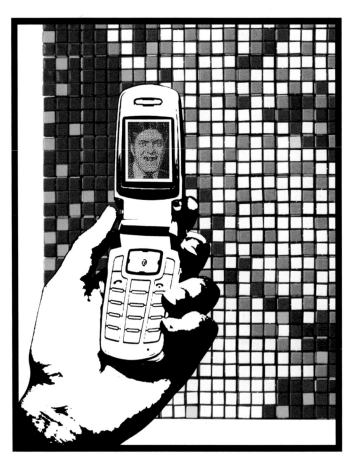

DIGITAL CAMERAS OR CELL PHONES RECOMMENDED

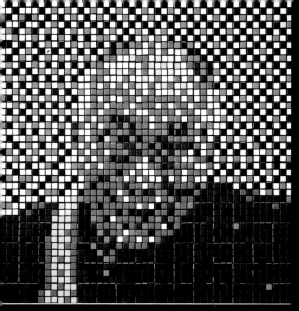
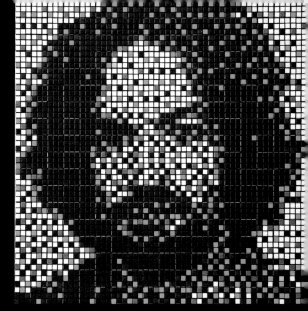

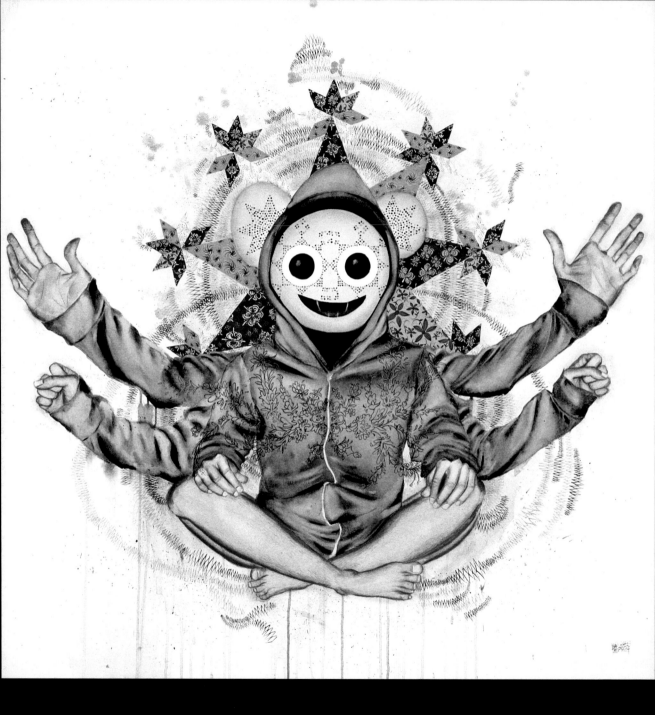

Above: The Humorist
Opposite: The Humorist's Wife

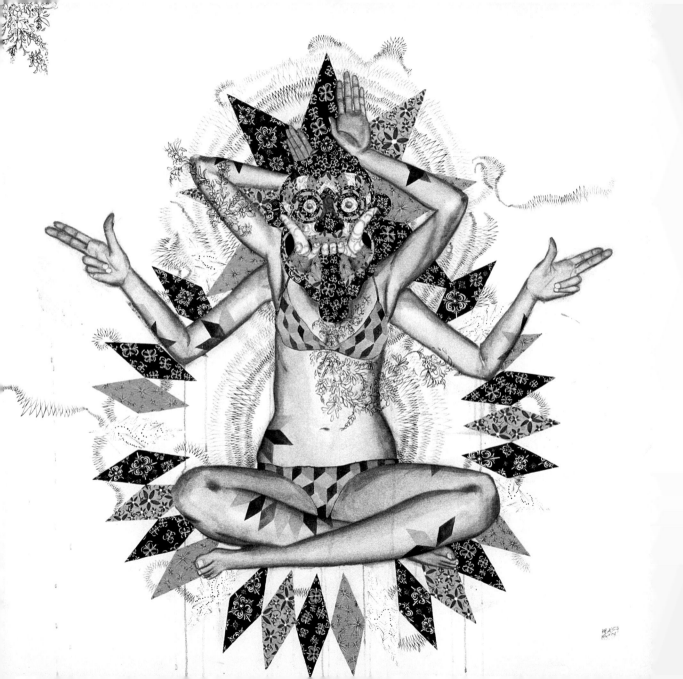

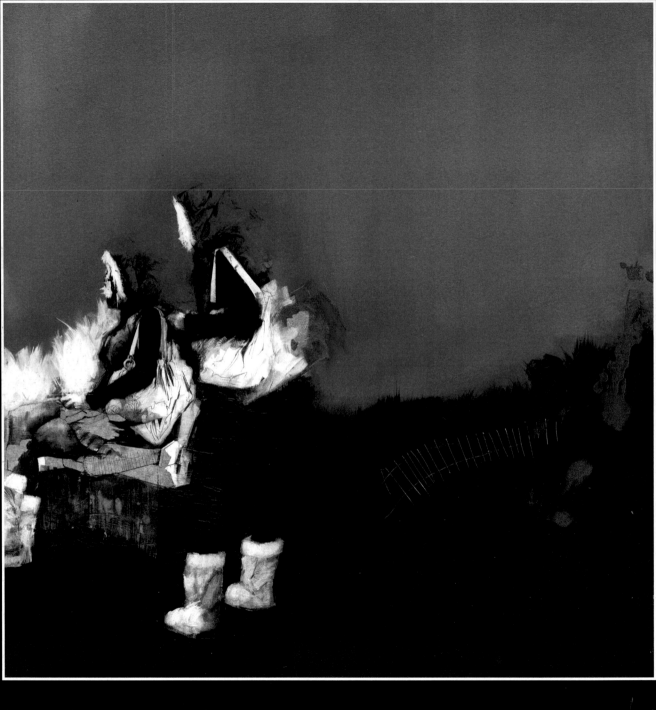

Above: A Girl Catches a Train Twice in London (II)
Opposite (main): Two People Discover a Palace Near Harajuku Station

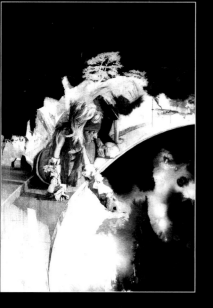

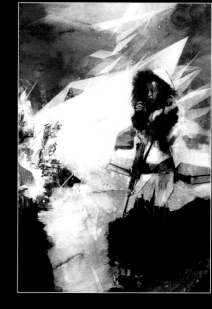

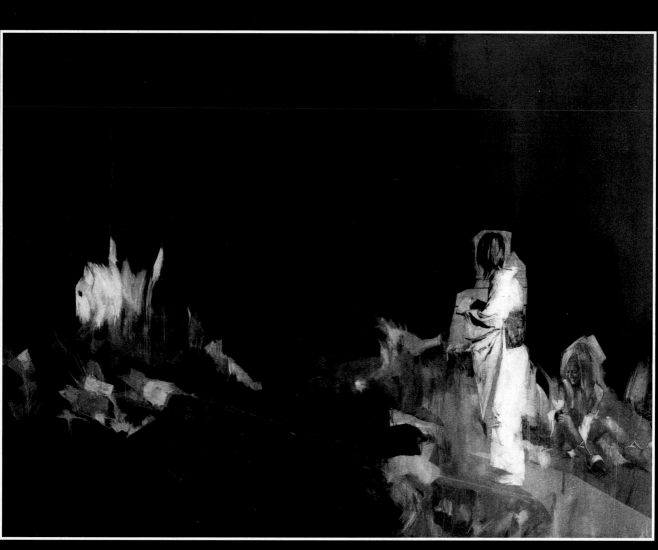

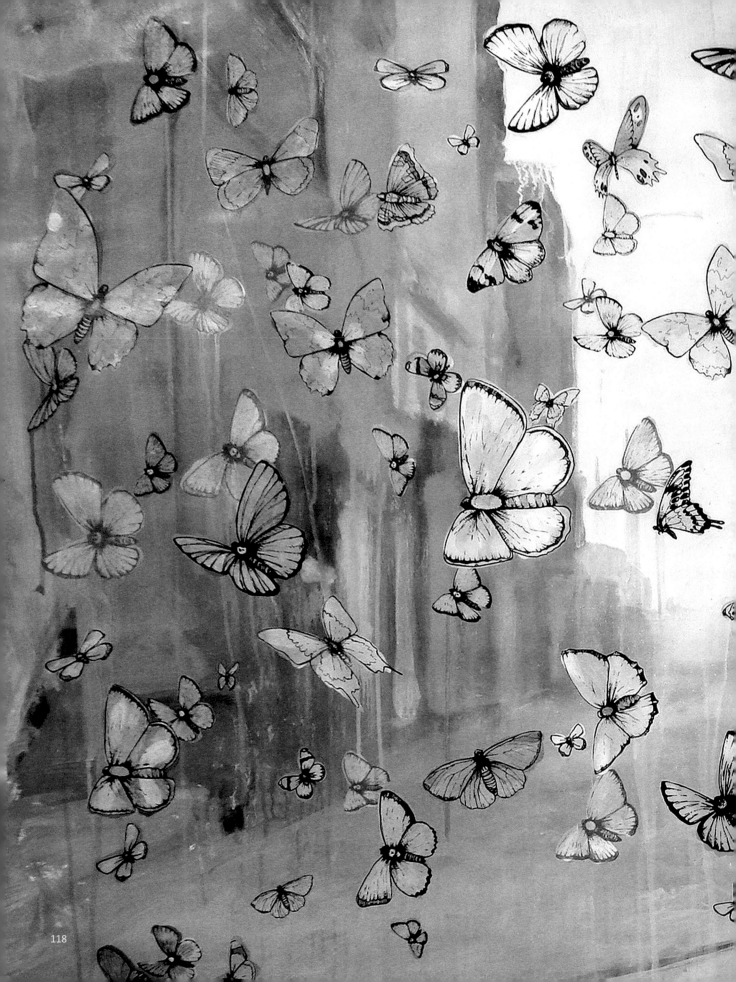

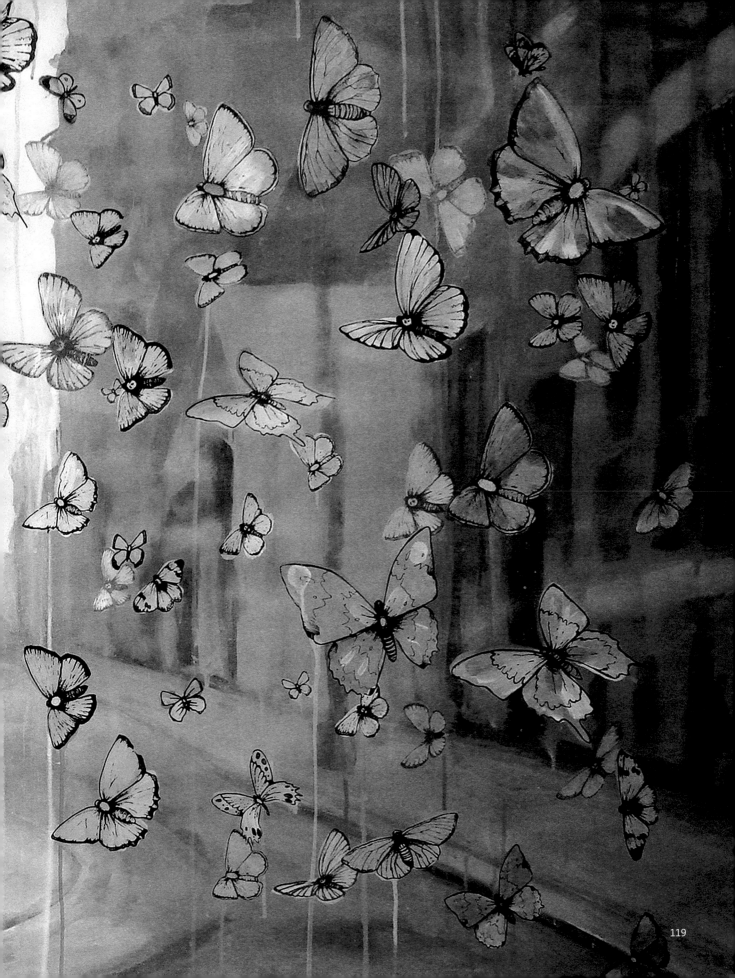

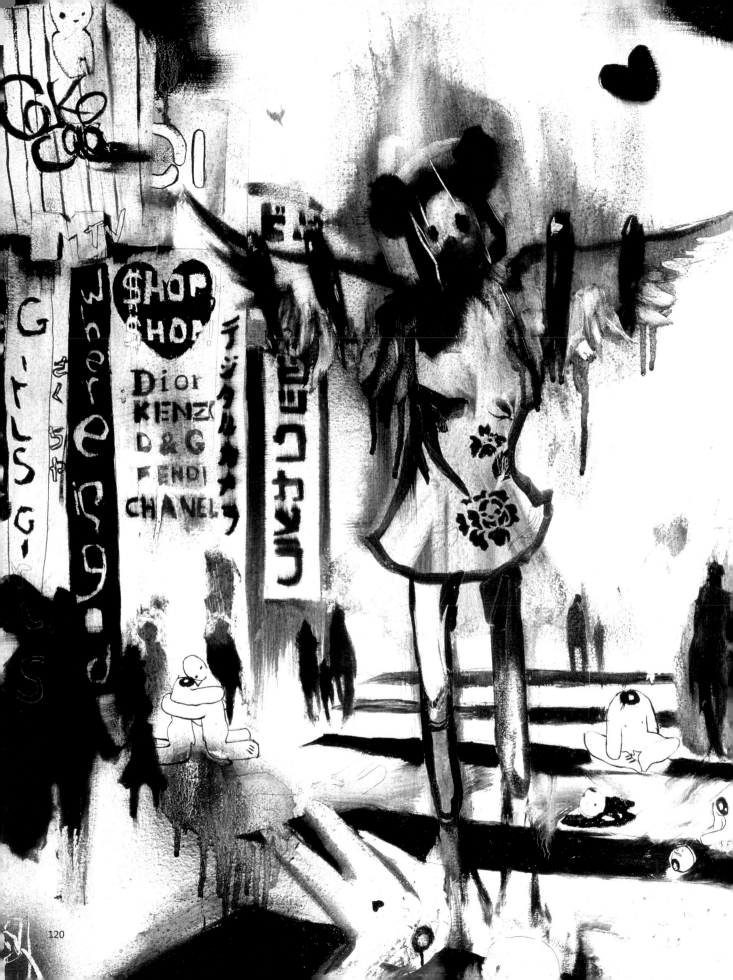

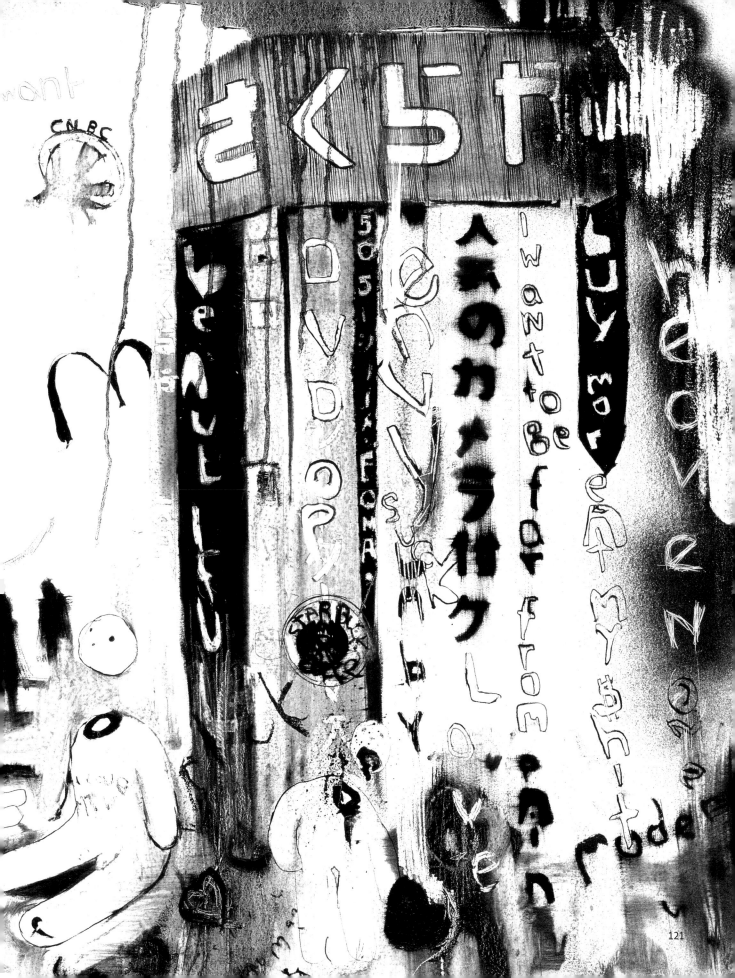

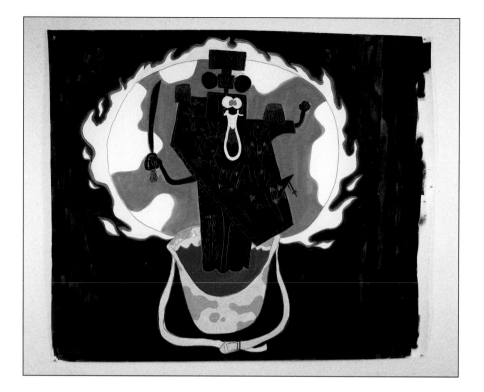

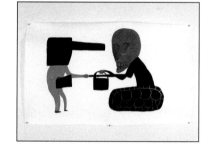

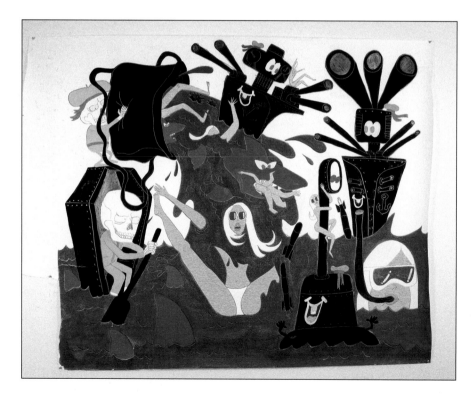

Above (clockwise from top left): Carrier in Helmet; Blood Coffin; New Deal; Blood Sea
Opposite: War Party 2007 – Trouble

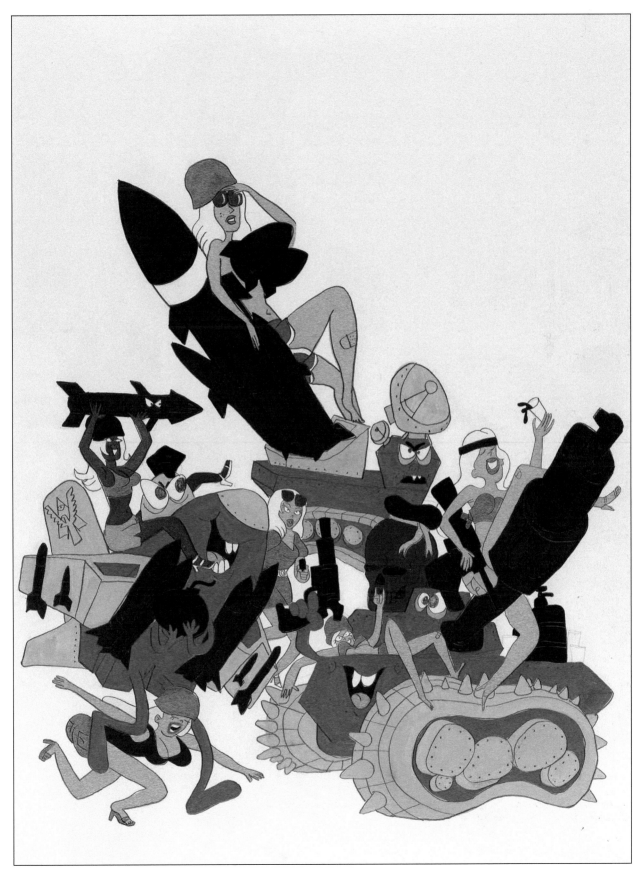

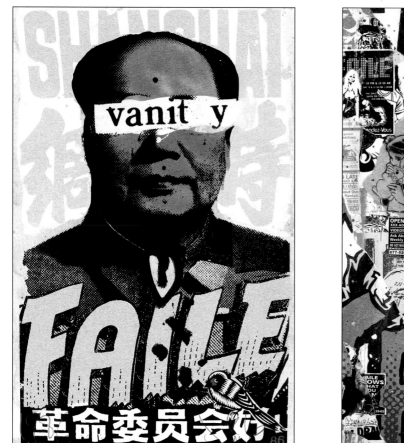

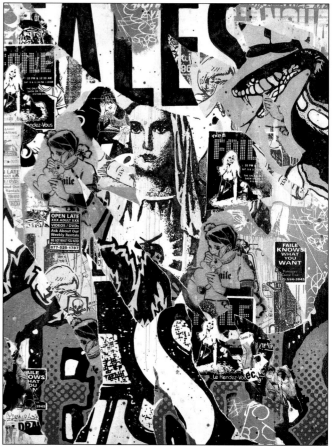

Above: Terrible Day; He Said It Was Love; Shanghai Vanity in Pink; Faile Mary Remix
Opposite: Mermaid in the Stars; Yellow Pages Ganesha; Naughty Bunny Boy; Baghdad Rampage

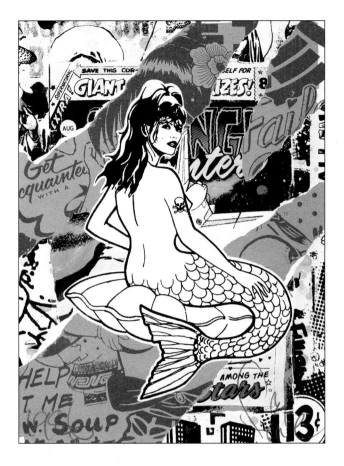

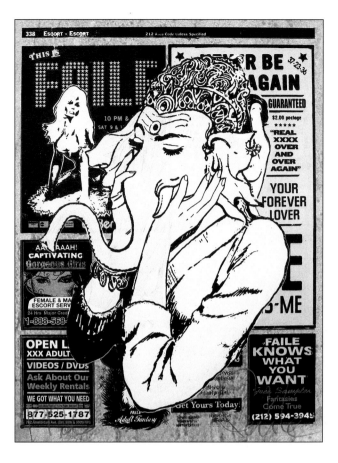

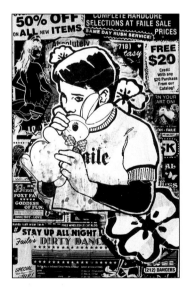

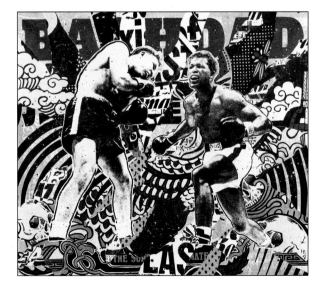

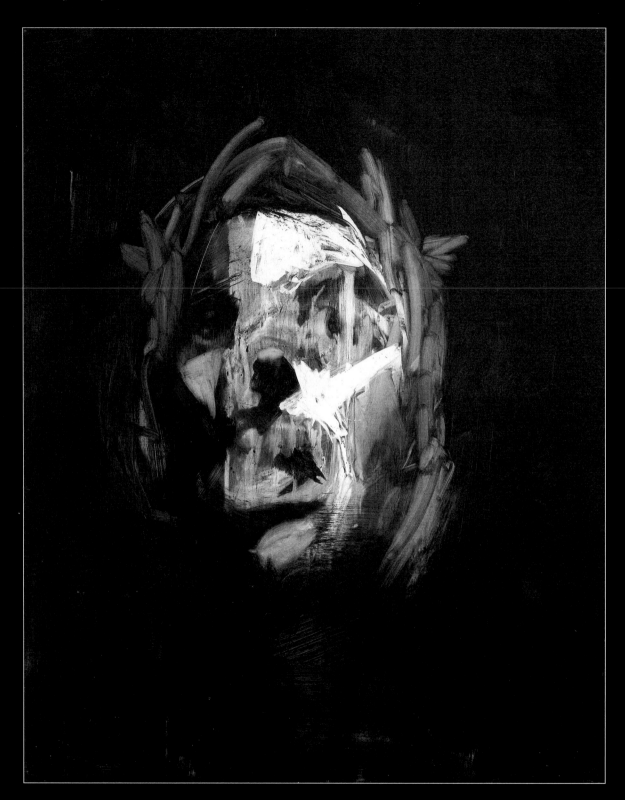

Above: Portrait in Black
Opposite (clockwise from top right): Fuck Face; Dreamer; Face

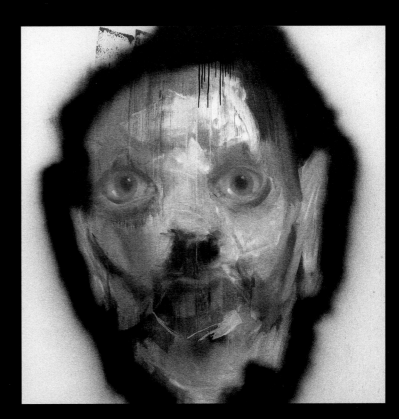

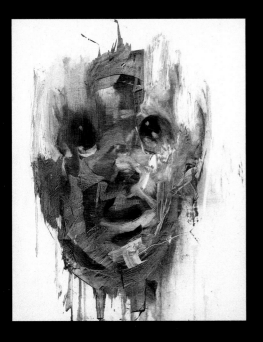

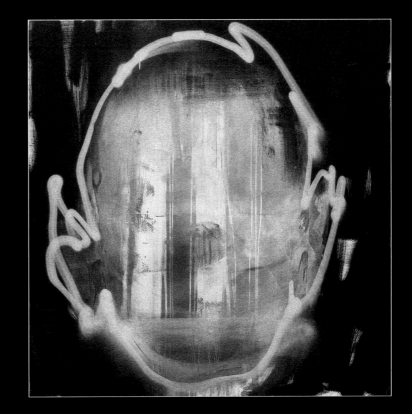

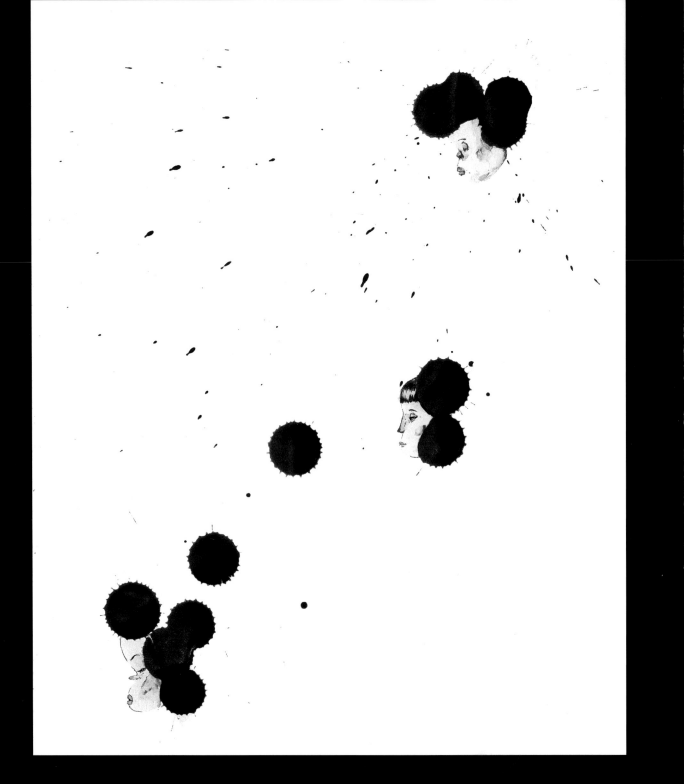

Above: Blood Drops
Opposite: Blood Drops 2

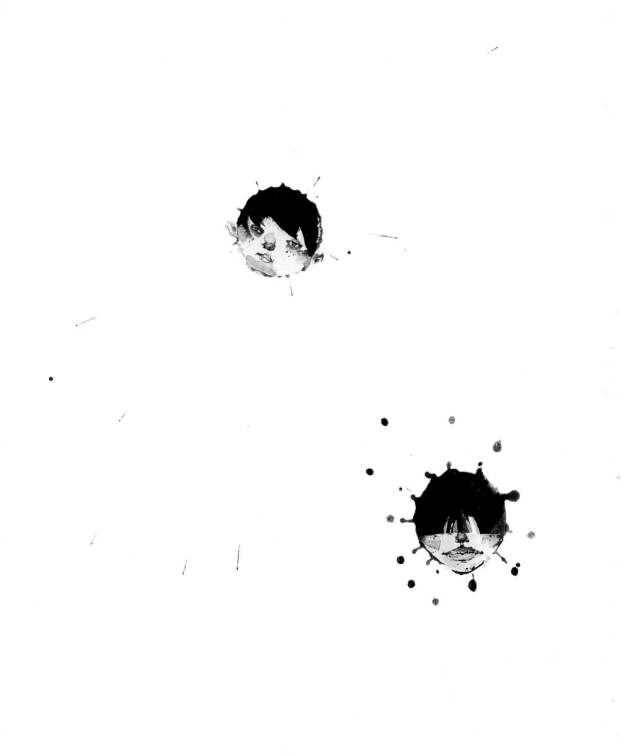

JR

From France, JR's work is as good as unique. His regular modus operandi is to bill-post giant, unexpected, monochrome photographs in positions of high visibility – including rooftops, church windows and along the sides of buses. The work has graced the covers of *Liberation* and the *Financial Times*. Its goal is clear; to assist viewers in recovering their humanity.

JR has undertaken three major projects using this format. *Portrait d'une Generation* featured shots of the young natives from the much-maligned Paris *banlieus* (suburbs). However, in contrast to the public image of young immigrants – snarling, alienated and primed for social disorder – the subjects were pictured pulling funny faces through a fish-eye lens, inevitably lending an approachable, comic aspect. The giant posters went up in the grand central districts of Paris where the *banlieus* residents are considered thoroughly unwelcome (on a previous fact-finding trip to Paris, Laz Inc director Steve Lazarides was forbidden entry to bars along the Champs Elysees due to his mildly Cypriot appearance).

This theme has been extended to two further executions. Face 2 Face, dubbed 'the largest illegal photo exhibition in the world', appropriated the border wall running the length of the disputed areas between Israel and Palestine. Vast photographs of Jews and Palestinians of all denominations, including those with orthodox leanings, grinning goonishly into camera, ran side-by-side along a considerable length of the wall. JR's latest project, Women Are Heroes, has been even more well-received than those which preceded it. It saw him relocate to the strife-ridden African countries of Sierra Leone and Liberia. In contrast to the usual images of grief and despair, local women were pictured appearing happy and playful. JR is currently putting in motion a new 'exhibition' in India.

Todd James – Reas

Todd 'REAS' James is one of graffiti art's venerable statesmen. He was part of the seminal Street Market exhibition by Deitch Projects gallery New York that travelled to the Venice Biennale. He has overseen various hit satirical animations including Rap Toons and the high-profile, Jack Kirby-influenced, Minoriteam which included, amongst others, an afro-haired planet-eating supervillain named Balactus. His latest TV venture is the Henson-esque puppet show Crank Yankers.

REAS' work effortlessly surfs the everyday and the offensive, and not always together. Personal and socio-political sacred cows are usually the target: *Alive with Pleasure*, for example, features two chubby hipsters merrily smoking away. But REAS' portraits of city lifestyles, their hypocrisy and hubris, are not without their charm, as can be seen from the likes of *Yoga and Yoghurt*.

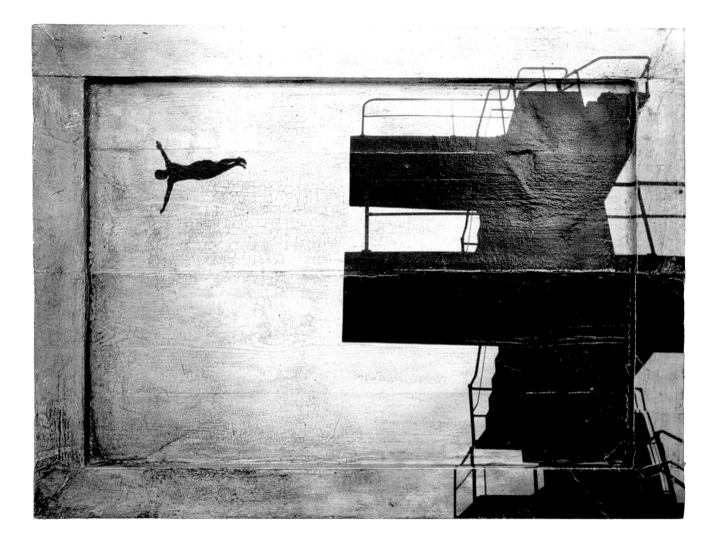

Above: Wild Jump
Opposite: Pigeon

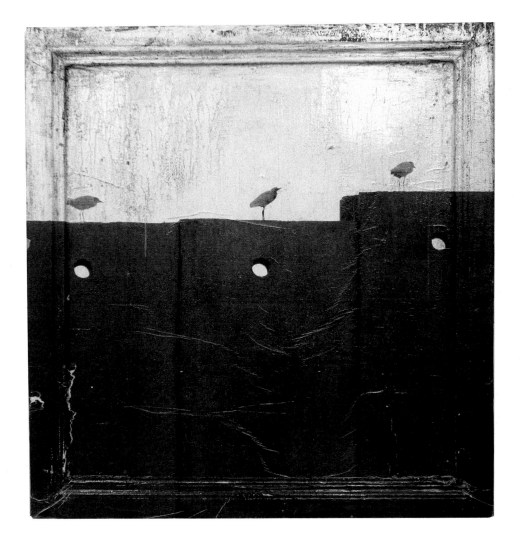

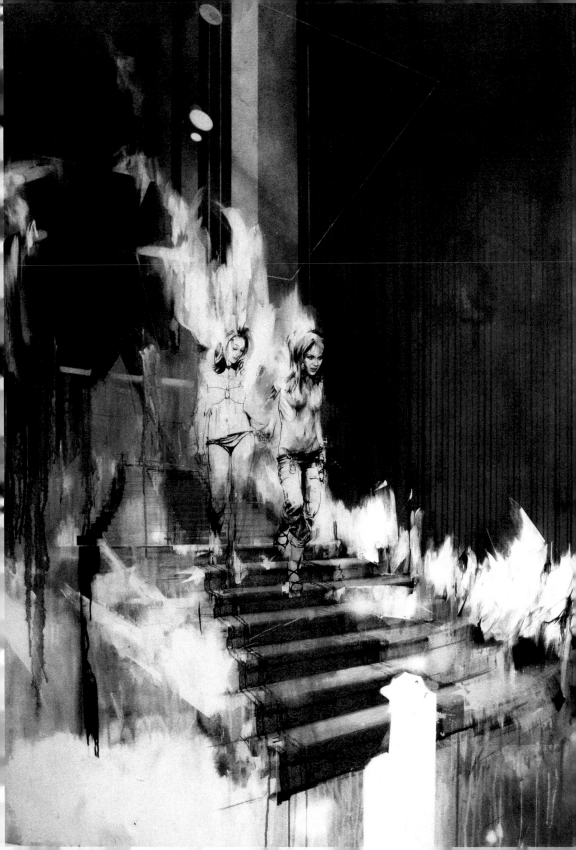

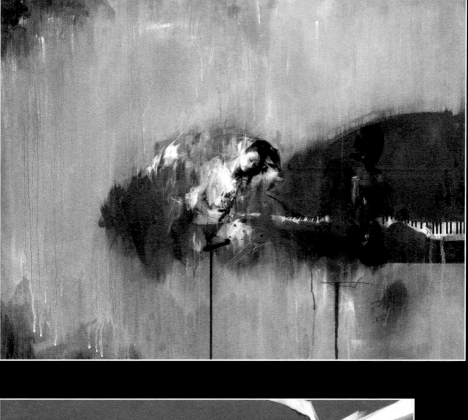

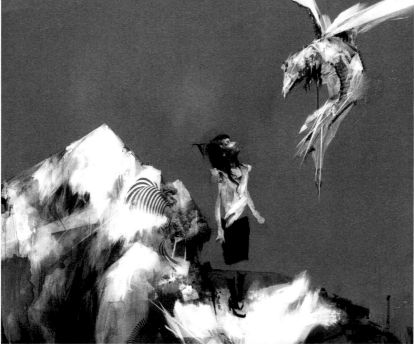

Above: A Dark Haired Girl Tries to Seduce a Piano Player; in the End, Maria Ozawa is Rescued by Some Kind of Dragon From Another World (a.k.a. Out of This World)
Left: Two People Arrive in the Lobby with Perfect Hair and Makeup

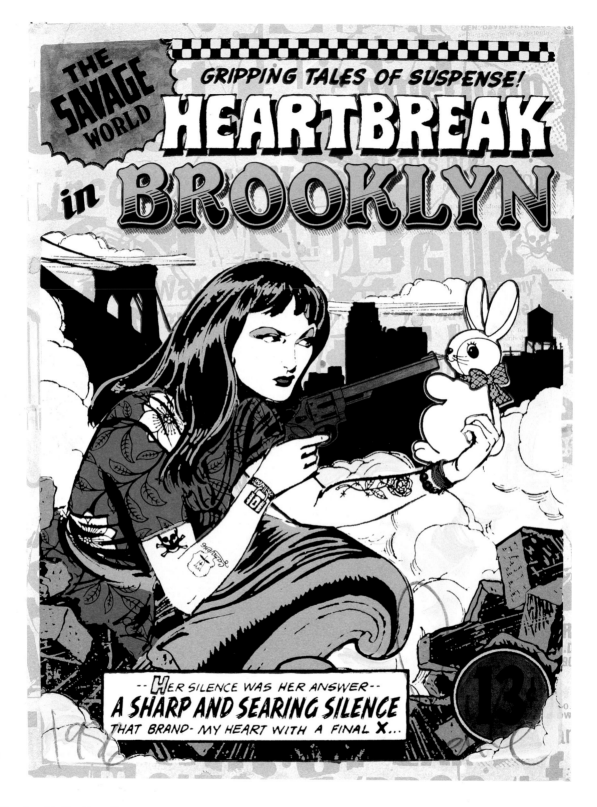

Above: Heartbreak in Brooklyn – Blue
Opposite: Master of Love and Fate

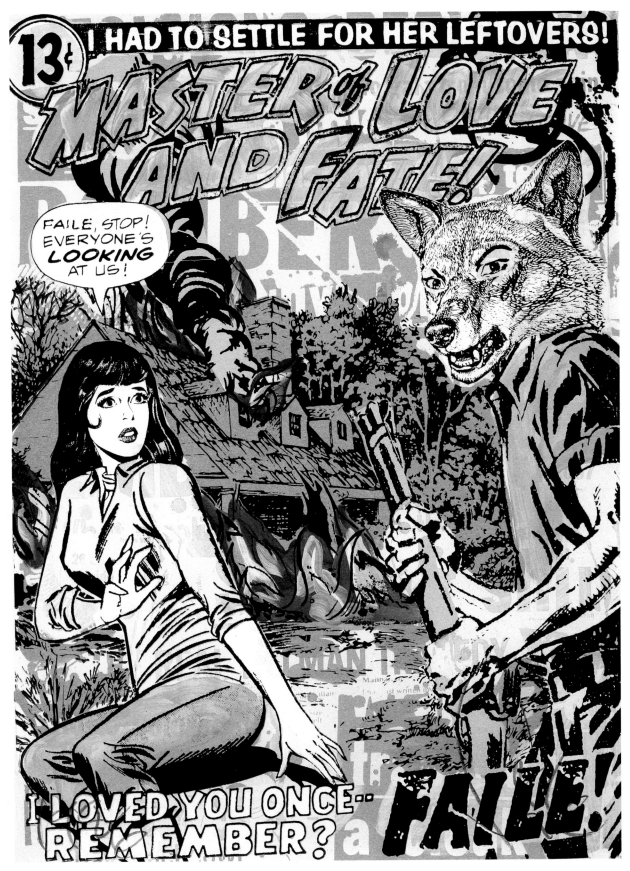

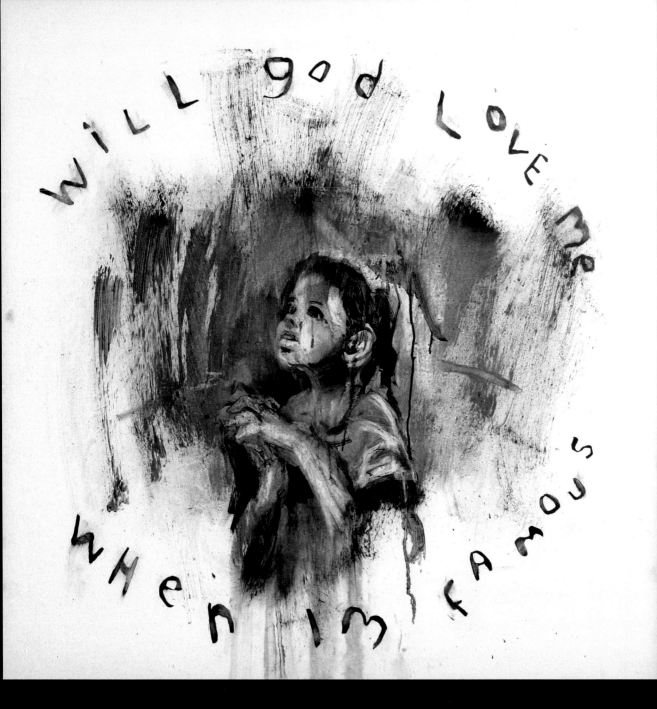

Above: Hope in Hollywood
Opposite: Bethlehem

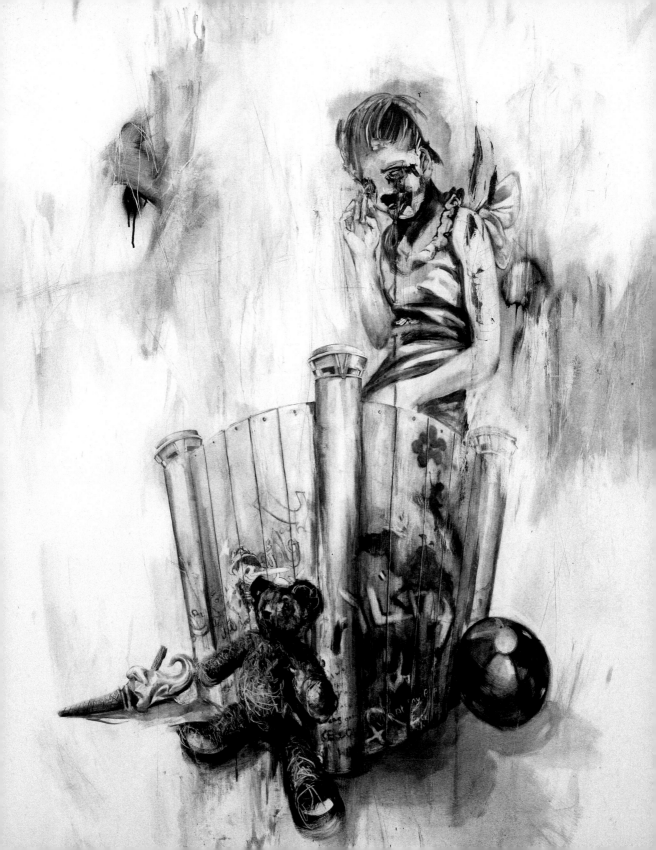

Pepper Nose

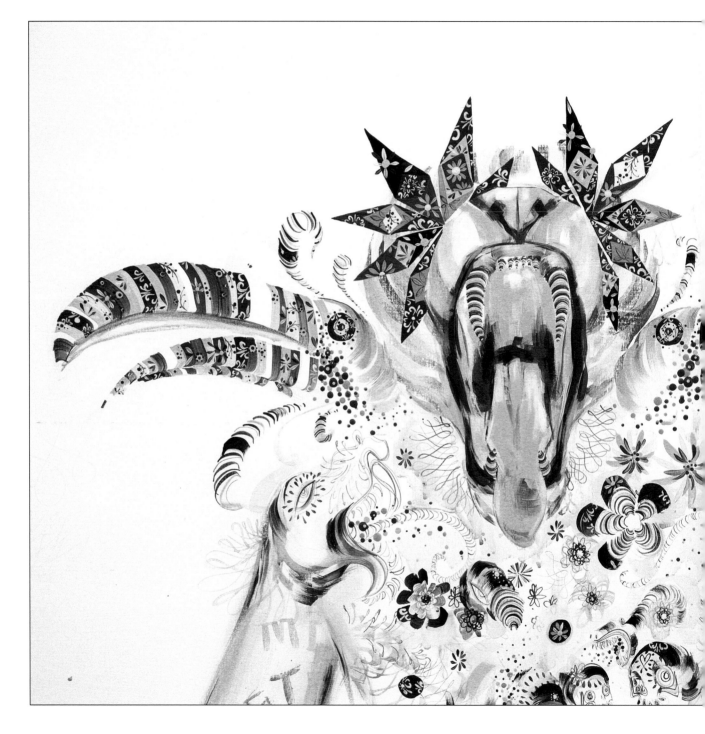

Monster Morals

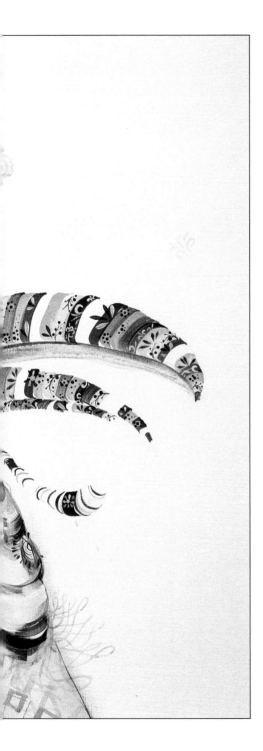

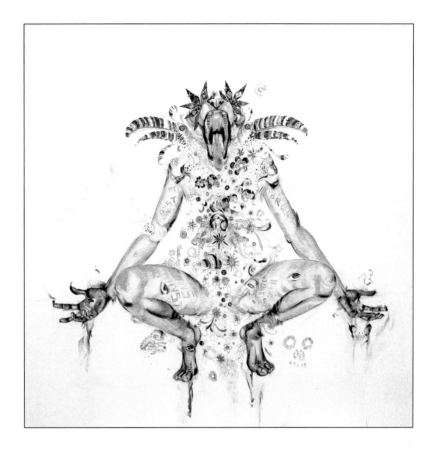

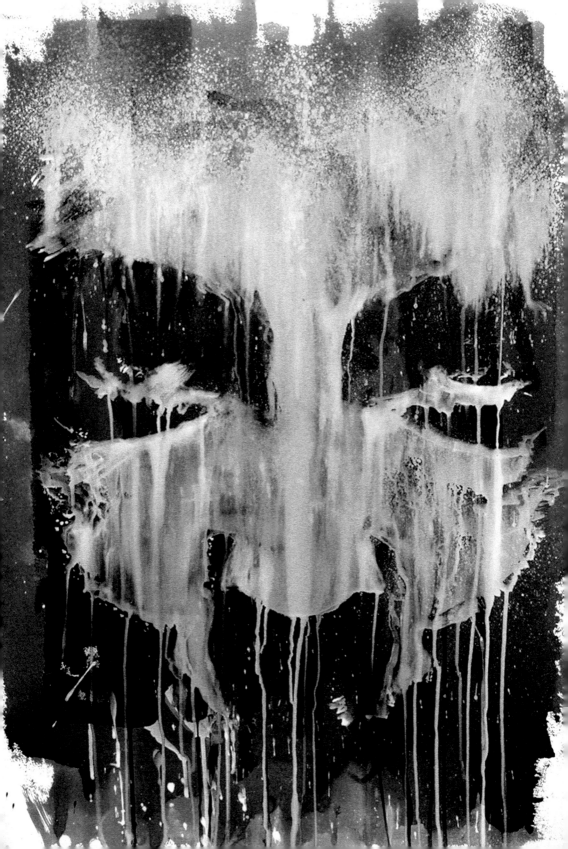

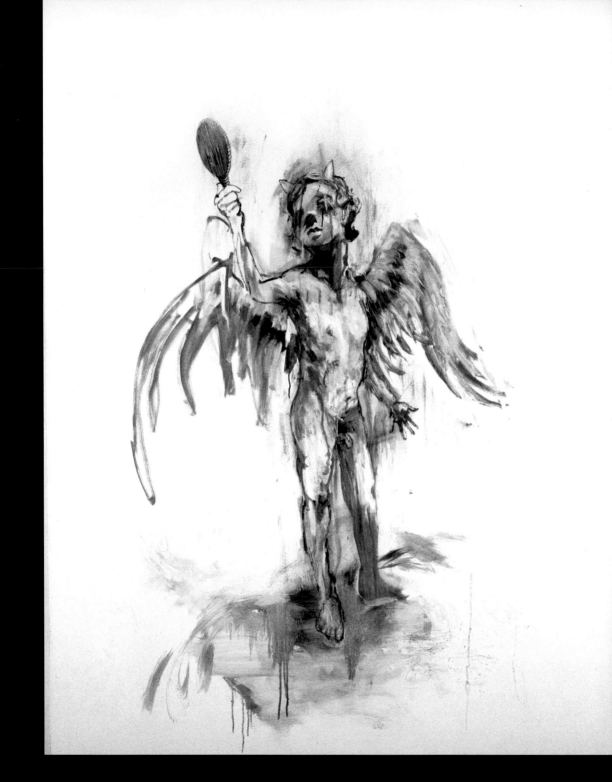

Above: God I Want to be Bad
Opposite: The Devil

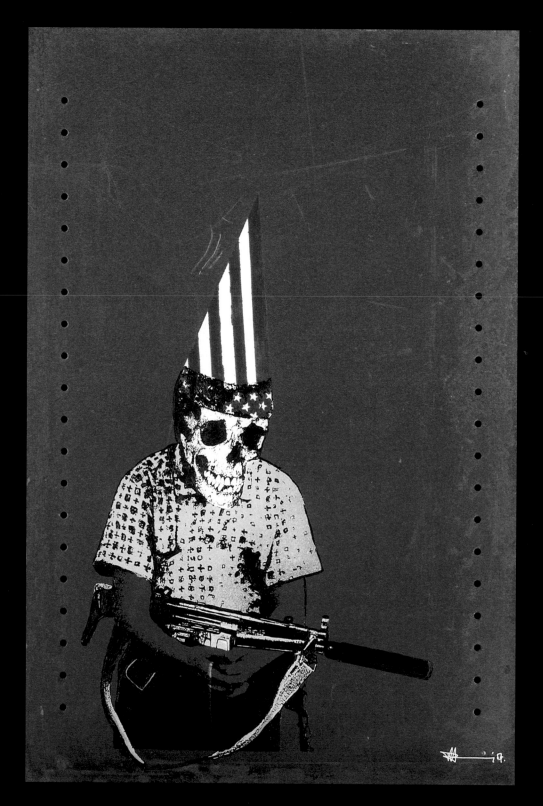

Above: Dunce Boy
Opposite: Unicorn; Dreaming

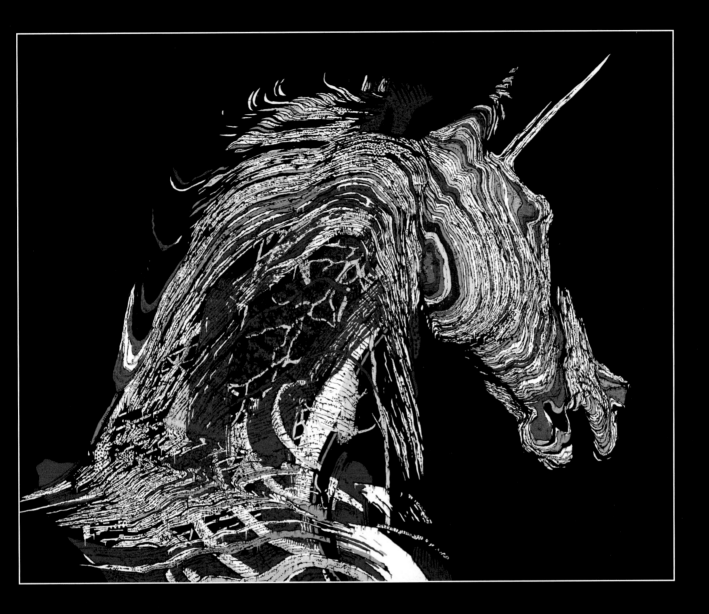

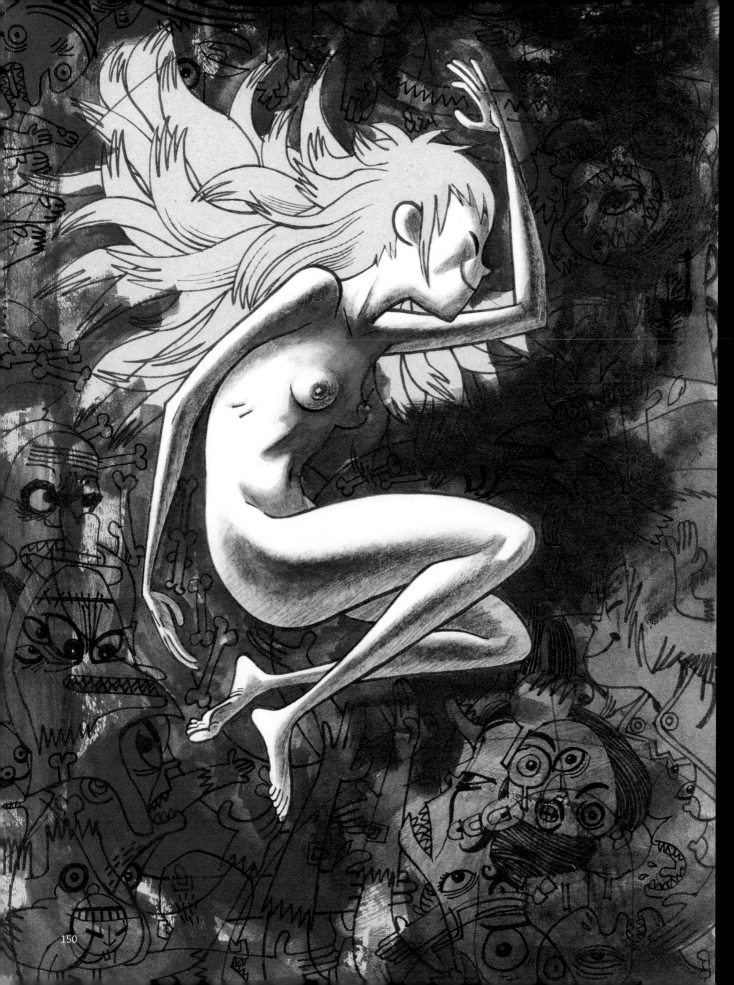

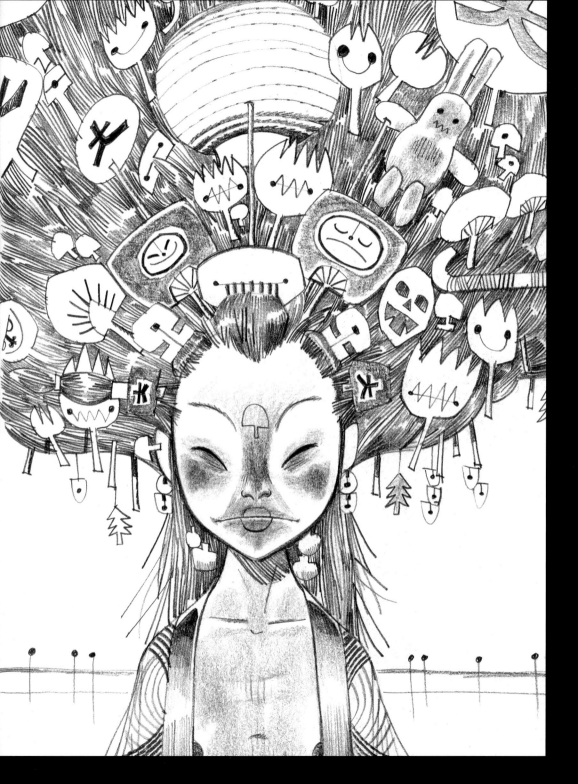

Above: Fan Girl
Opposite: Naked Laaaady

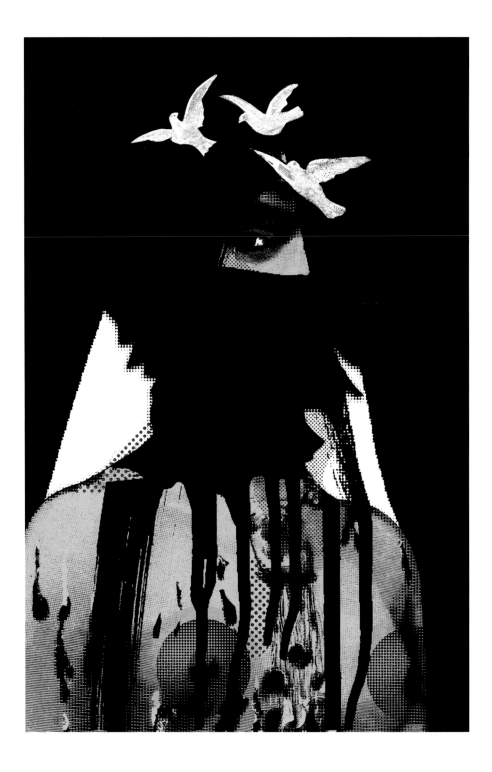

Above: Blue Bride
Opposite: Liberty

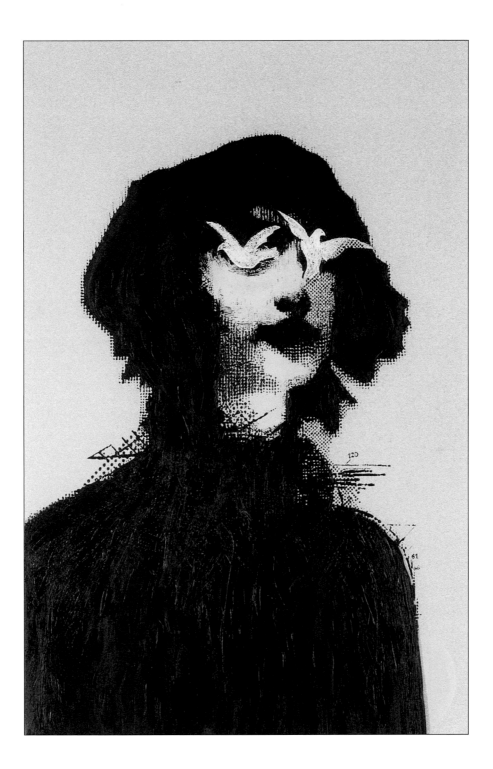

Mark Jenkins

Mark Jenkins' sculptures may look cute, but they have issues. At first witty and appealing, they prompt uncomfortable questions we'd simply rather not deal with. How can we be compassionate yet so ruthlessly concerned with our own urges? Are vagrants horrible, funny or sad? What on Earth shall we do with all our bullshit?

For instance, Mark once made a lot of 'Scotch Tape Babies' by wrapping girls' dolls in Sellotape. Leaving them dotted in the streets of Washington, the accompanying cards read "...if by passing one you feel strange sensations in your nipples or fingertips adopt the infant, breast feed, and give it plenty of TLC. It will gradually mature into a full-sized tape man or woman to co-habitate with you and eventually take you to the glazed paradise – or maybe oust you from your own home".

Also darkly comedic are Jenkins' "dummies" (his phrase) of tramps' body parts in violent and impossible situations. All the pieces pounce with the benefit of surprise. "There's so much rubbish on the streets already that the pieces I put up are camouflaged and ambiguous," says the artist, "the dummies too; the homeless have become such a part of our environment that we're desensitized to their presence." He uses his own hand-me-downs to clothe the dummies, and calls their placement "an out of body experience".

Mark's most notorious piece is a decapitated Christ upon the cross at Golgotha but they all creep us out. Can't help loving them, though.

Lucy McLauchlan

In an era when visual images are styled to perfection using technology, Lucy McLauchlan crafts using permanent materials like Indian ink and marker pen. "If I make a mistake I can't remove it; often though, the accidental details become my favourite," she says of this ambitious, but inevitably rewarding, process.

Lucy combines art deco, psychedelic and childlike motifs to make pieces that are delicate and tender yet compelling and provocative. With Rain People, a hanging structure made from multiple painted wooden elements, she recently branched into sculpture, effortlessly occupying the topical territory between installation and interior design.

Somewhat surprisingly Lucy hails from Birmingham – a city whose vibrant counter-culture is usually more associated with Heavy Metal music's less sensitive blend of fantasy and incitement. She has exhibited all over the world, from London's Victoria and Albert Museum to the Eclectic Gallery in London and Tokyo.

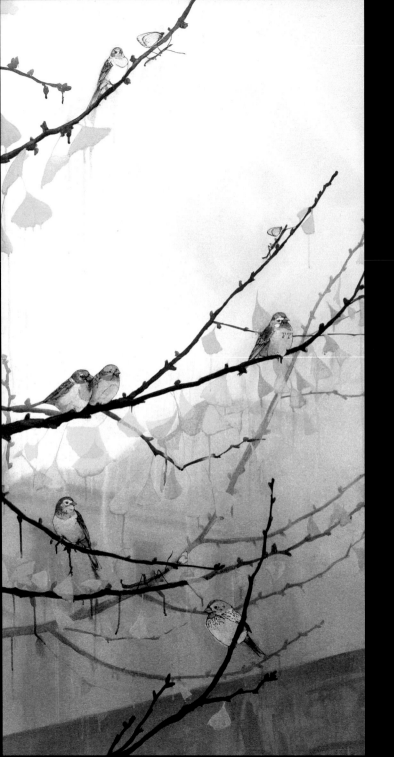

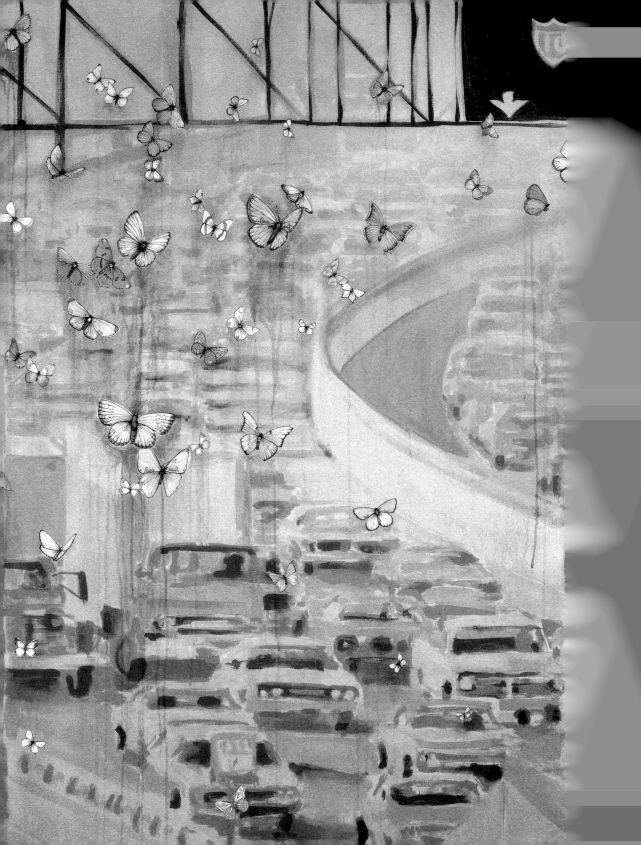

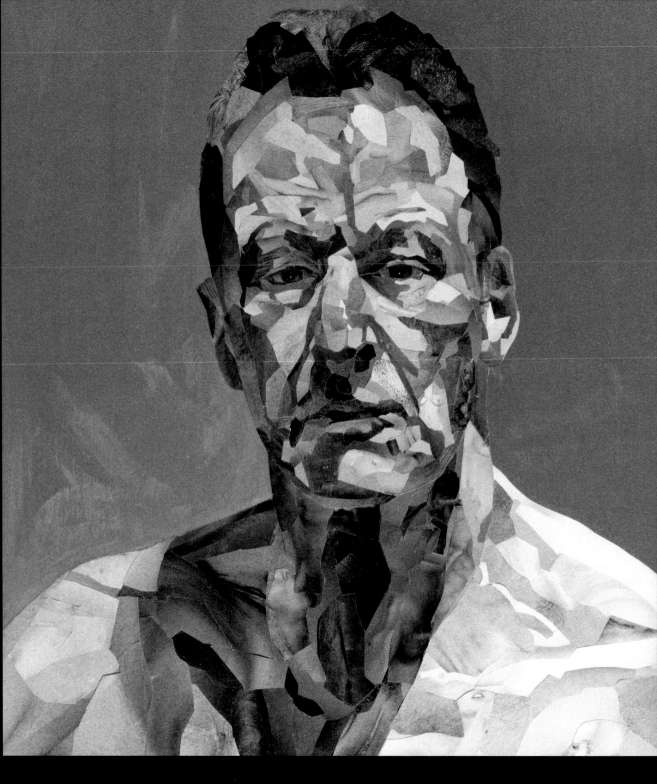

Above: Homage to Freud
Opposite: Andromeda

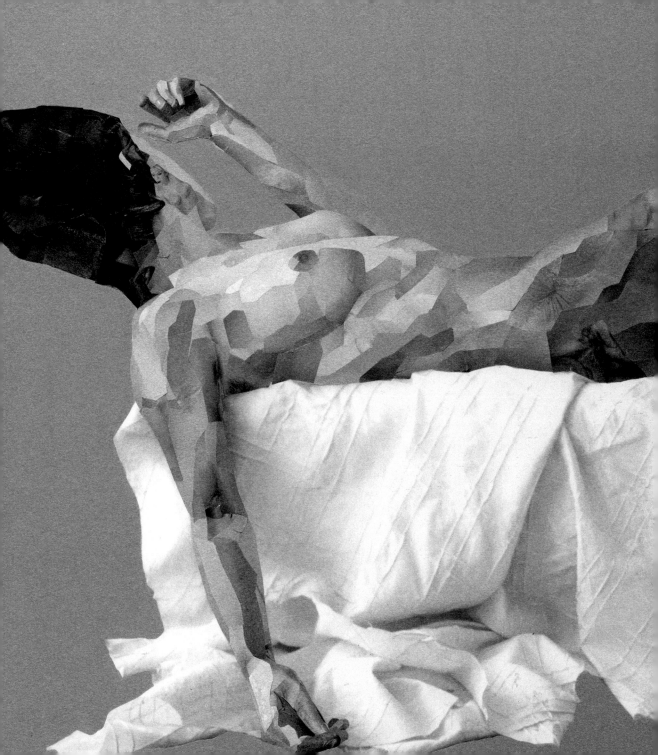

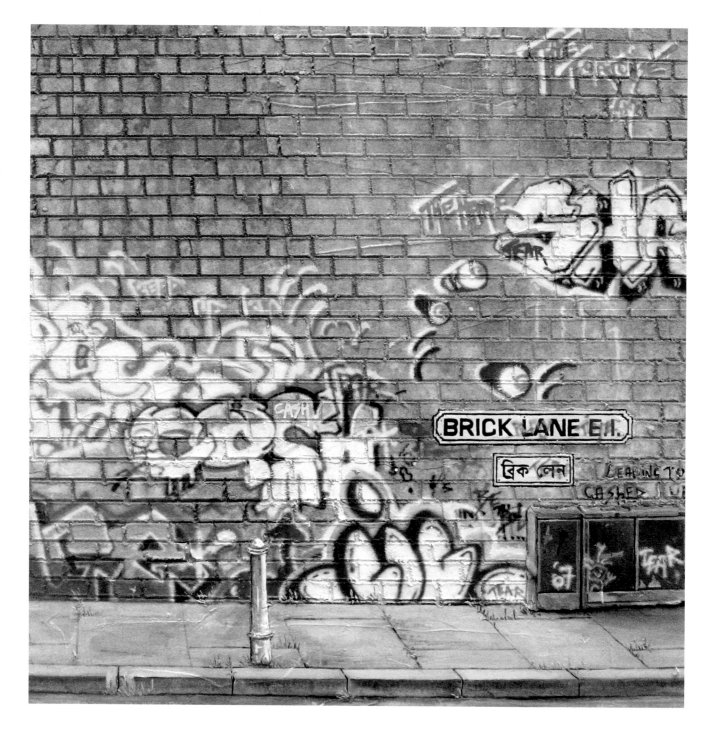

Above: Brick Lane
Opposite: Charing Cross Road

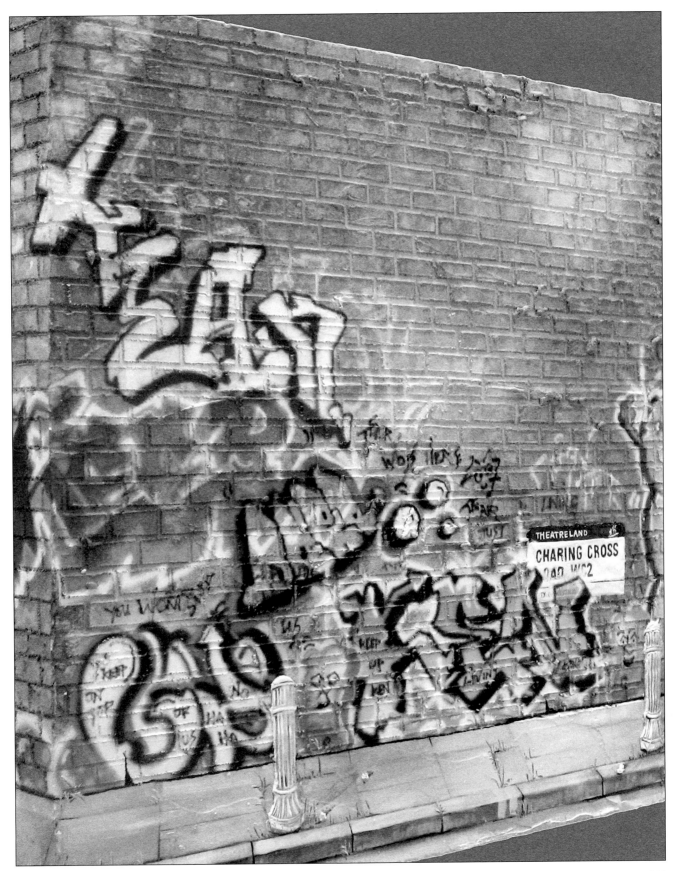

161

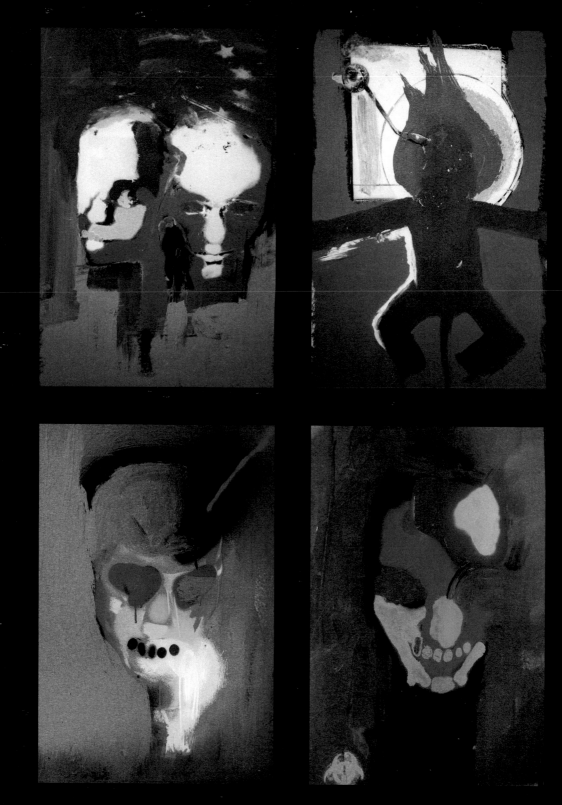

Above (clockwise from top left): Two Heads; Blue Lines Board; Adrian; James
Opposite: Twilight Bright

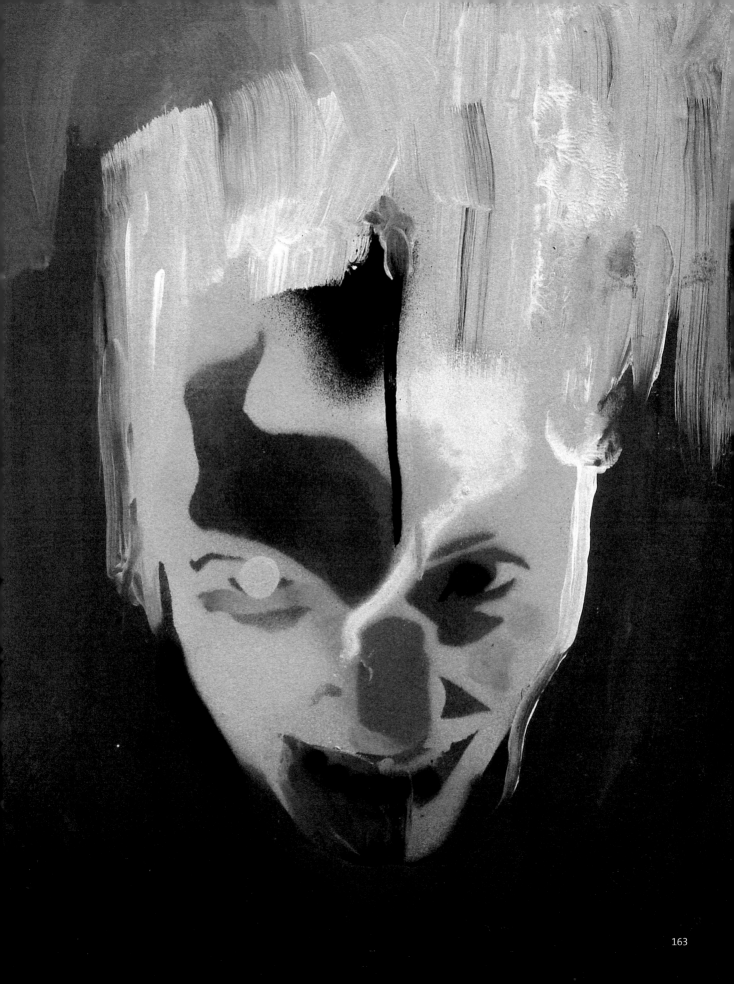

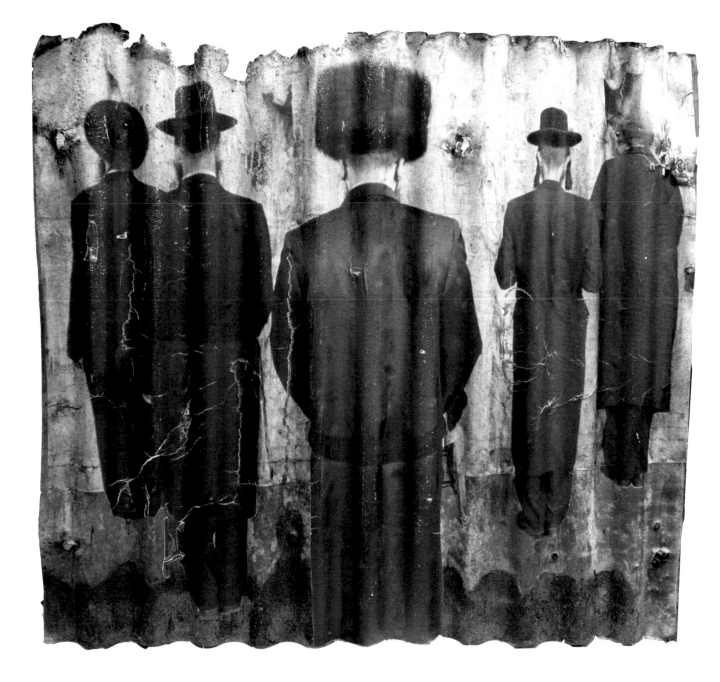

Above: Kotell, Jerusalem
Opposite: Ottis

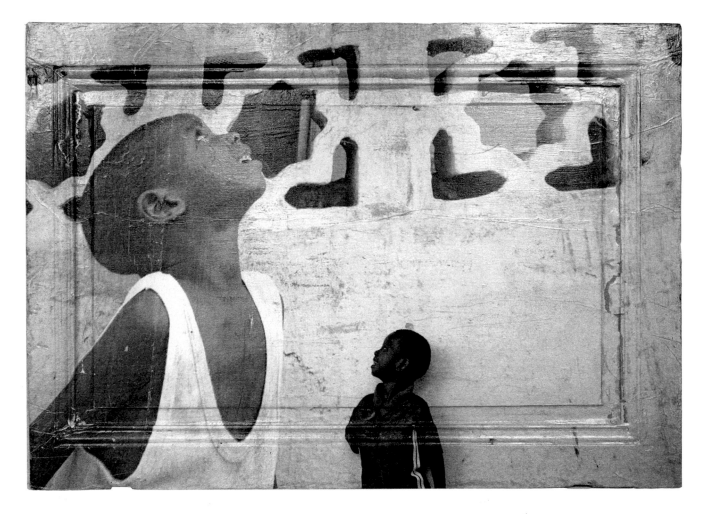

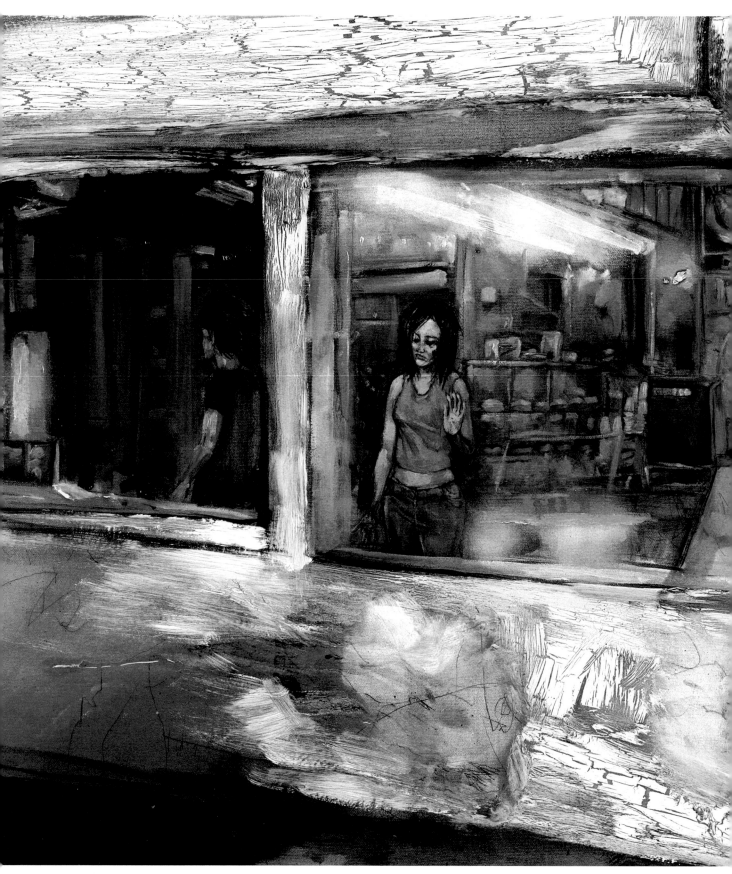

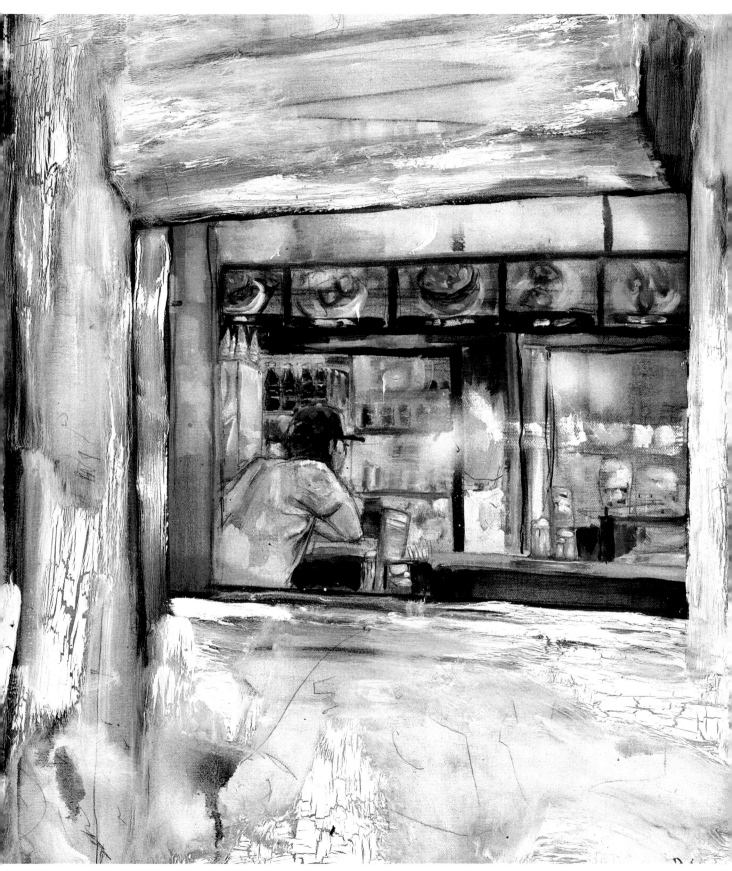

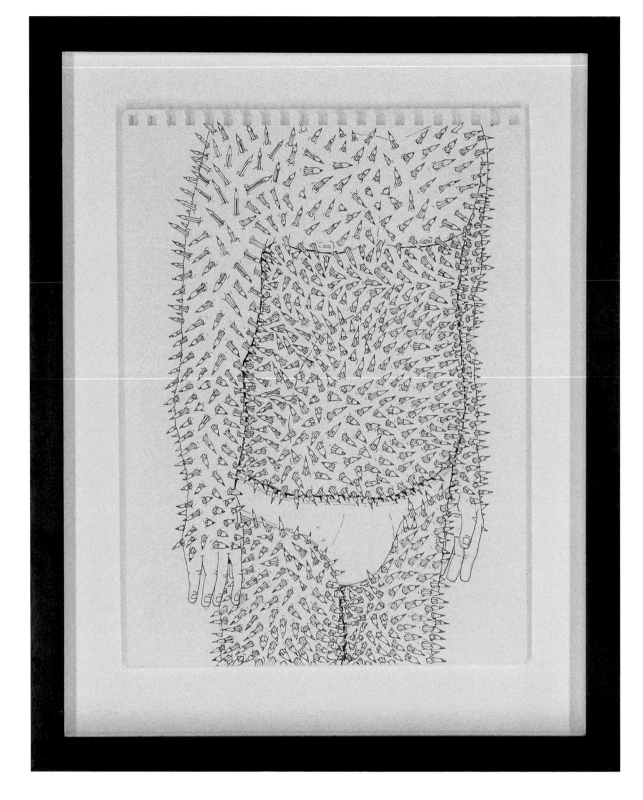

Above: Red Sketchbook 9
Opposite: Red Sketchbook 15

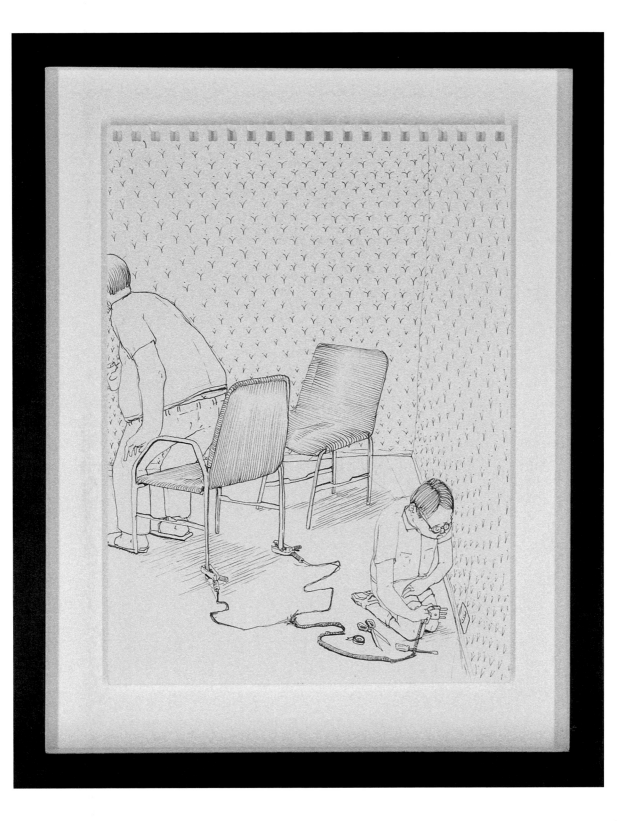

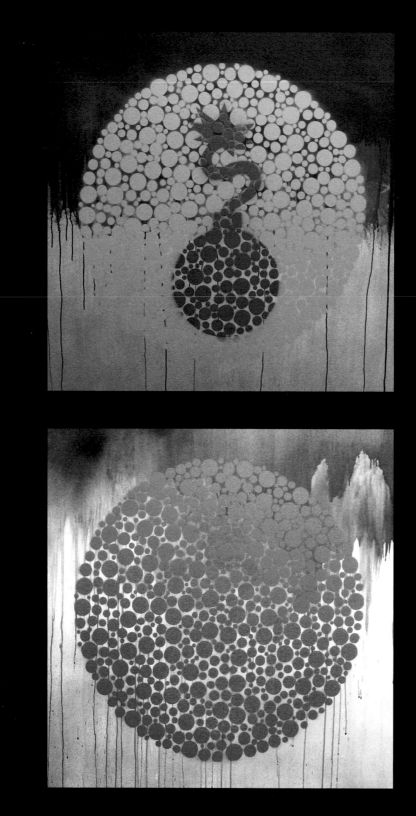

Above: Blind Spots and Bombs
Opposite (clockwise from top left): Neapolitan Martyrs; Lunch; Euro Ribs; Hand to Mouth

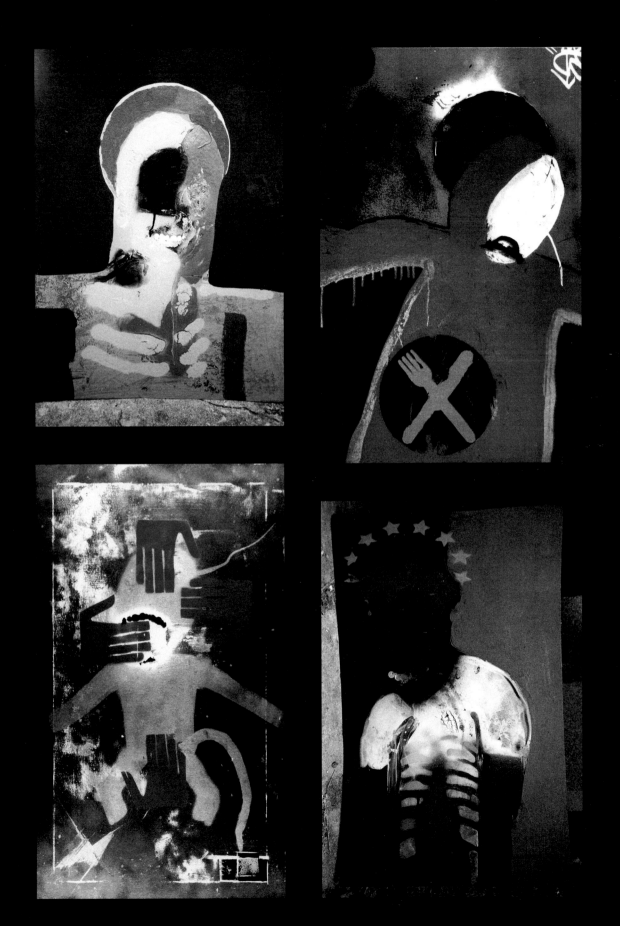

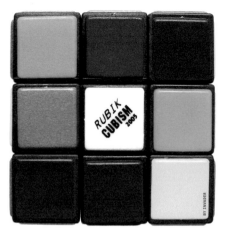 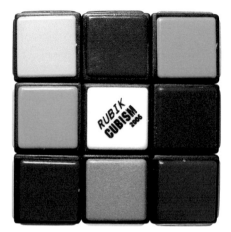

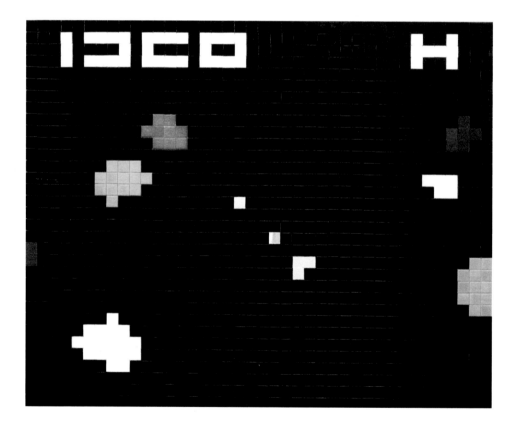

Above: Rubik Cubism, Sticker, 2005; Asteroid
Opposite: Blue and Black Duo

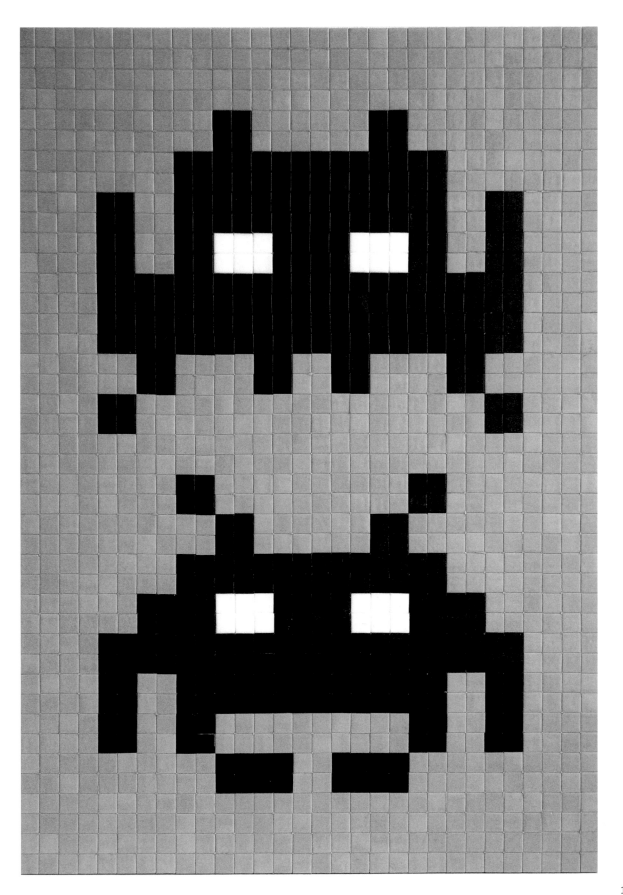

Antony Micallef

Despite being runner-up in the National Portrait Gallery's BP/Amaco Portrait of the Year prize in 2000, Antony has always turned down portrait commissions insisting not only that he's not a figurative painter, but that he could never see himself "inflicting brutal emotions on somebody I didn't know". At once colourfully beautiful and deeply troubling, Antony's work examines our dichotomous relationship with consumerism, examining how we can maintain to despise multi-national brands yet still allow ourselves to be seduced by them. "The trouble with pop imagery is that it doesn't really go deeper than the surface," he says. "You have to drag it down and challenge it to make it interesting. When you put two contrasting images together, it causes friction, and that is the bit I'm interested in – the union of two opposites make an intriguing and strange chemistry." Described as 'Caravaggio meets Manga' and 'Bacon in Disneyland' this strong cocktail has already seen Antony become enormously popular.

Mode 2

The thinking man of the British graffiti movement recently returned home from a long self-exile in Paris. Mode's work is instantly refreshing due to its lack of posturing and antagonism, concentrating instead on human themes (friendship! Dancing! The latter stages of pregnancy!). He has collaborated closely with the clothing label Maharishi and Coco de Mer, the peerless London erotic emporium founded by Body Shop founder Anita Roddick's daughter Sam. Mode's projects for the latter include a major exhibition on Trafalgar Square highlighting the plight of Eastern European girls trafficked into the West to become prostitutes. He is also the boutique's artist-in-residence, a role in which he has developed an offshoot style mixing street art influences with 'traditional' portraiture. Mode paints customers from his vantage point of a cubby-hole in the changing rooms. And yes, he is available for private commission.

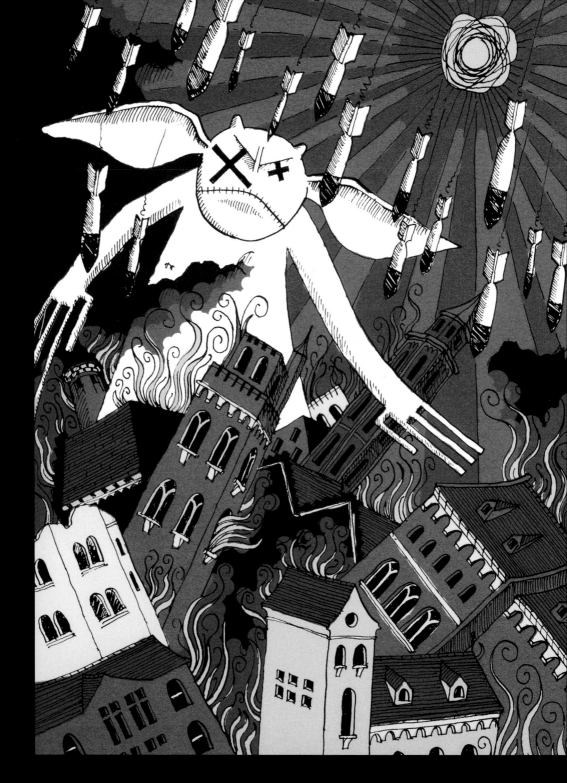

Above: Operation Phantom Fury
Opposite: Suburban Fire; Happy Family

Protect

Above: Bella-Gerant-Alii
Opposite: Audio Hostem

Above: Deckchair
Opposite: Deckchair (detail)

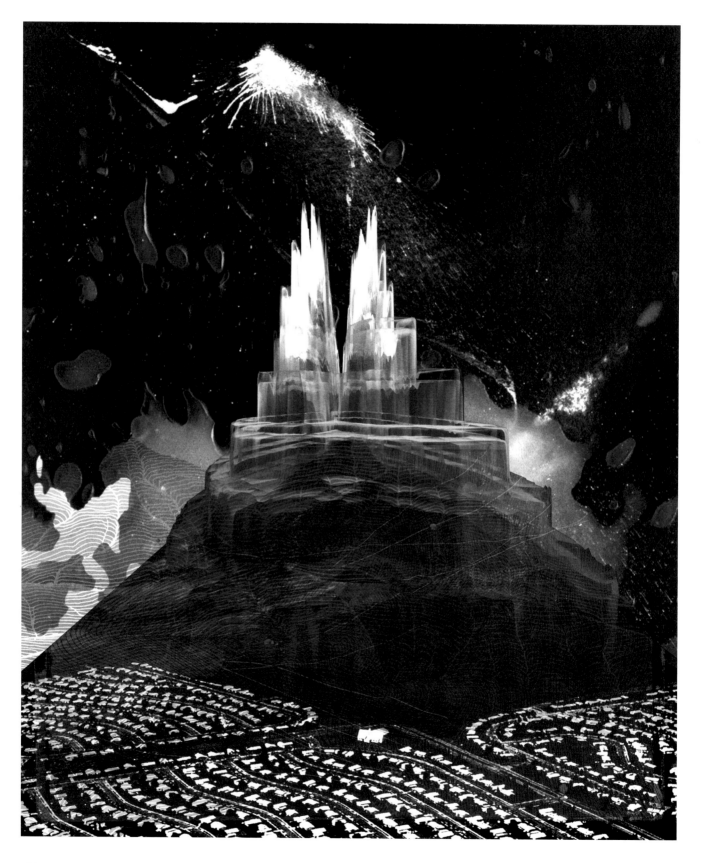

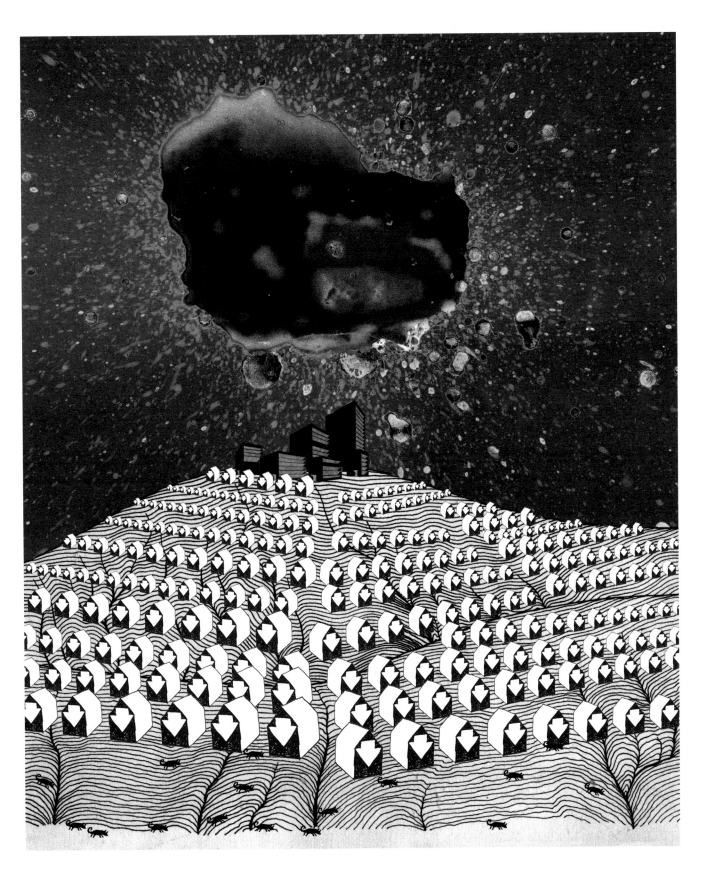

Polly Morgan

Traditionally taxidermists place their preserved animal corpses in scenes considered to be their natural surroundings. Polly Morgan elevates the craft to an art form by creating vignettes that emphasise the romantic beauty of nature – a dead rat, for example, loses its association with disease and strife when placed inside a champagne glass.

Polly, unsurprisingly a country girl, grew up on a specialist farm surrounded by angora goats, ostriches and llamas. Among her chores as a teenager was driving dead goats to the abattoir to be minced into dog food. The smell still lingers under her nose, but she's nonetheless a confirmed carnivore, her preferred delicacy being rare liver. She continues to be tutored in taxidermy by George Jameson, an expert stuffer for 38 years now, based in a thousand year-old tower by an estuary in Edinburgh where the majority of her work is made.

Ben Turnbull

In an age when sneering at the USA is a popular if mediocre pastime amongst the chattering classes and beyond, Ben Turnbull admits "I actually love America, and want to be there".

Ben's love isn't just a fascination – he cares. "I'm not trying to Bush-bash, although I do see it as a duty to create satire from the outrageous. My work is more emotional than political – I'm haunted by the lack of superheroes, for instance."

Ben has never actually visited America. To him the continent only exists in its popular culture, an adrenalised dimension where the populace speaks in wisecracks and every helicopter eventually explodes. But even there time passes – thrills and spills are no longer provided by the A Team, but Fox News. Ben's recent work has therefore explored "America's violent, paranoid side and the crimes committed on the American people by its media". His concerns are grave, and the pieces brutal. But Ben's messages are comforting and compassionate. Don't be afraid. Rise to the occasion. Or as they'd say in the states: be the best.

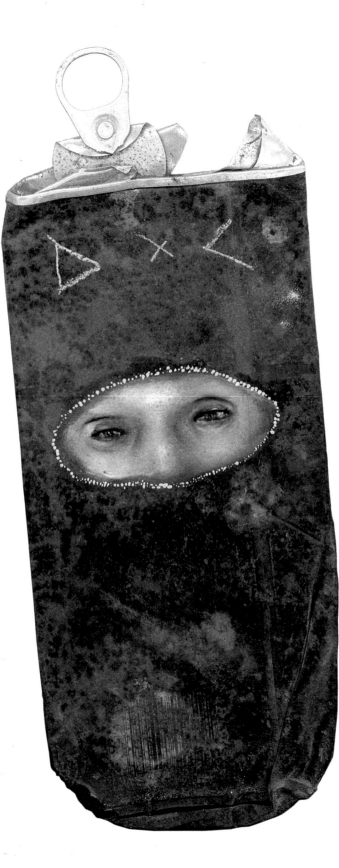

Above: Rusty Beer
Opposite: Scrilla

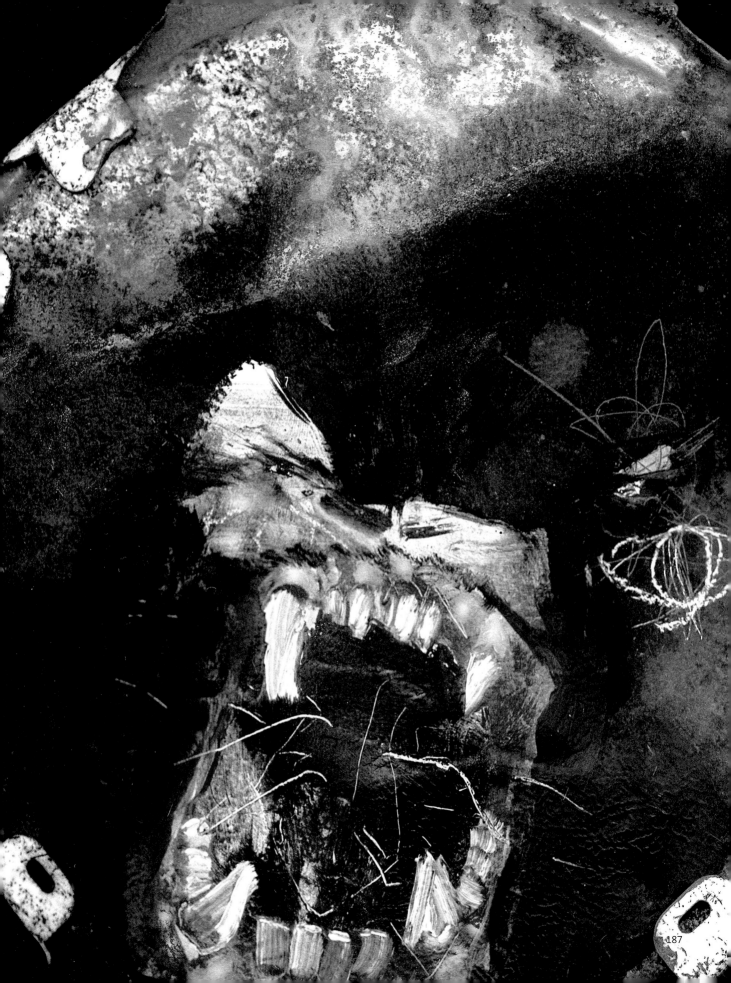

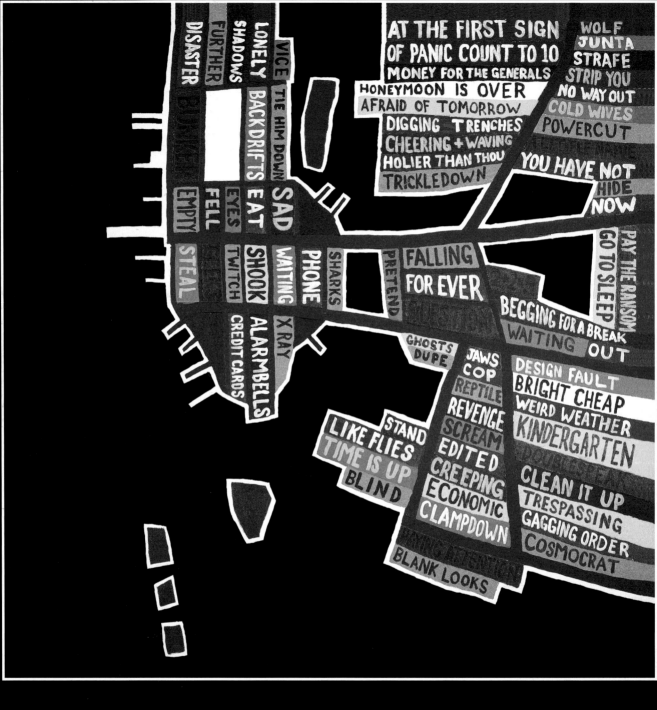

Above: Manhattan
Opposite: Haunted; Special Sauce

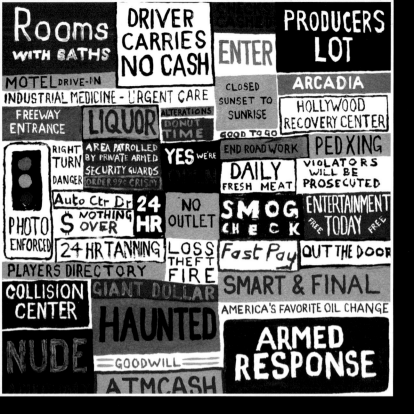

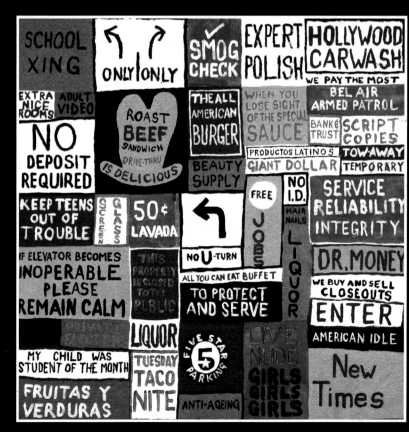

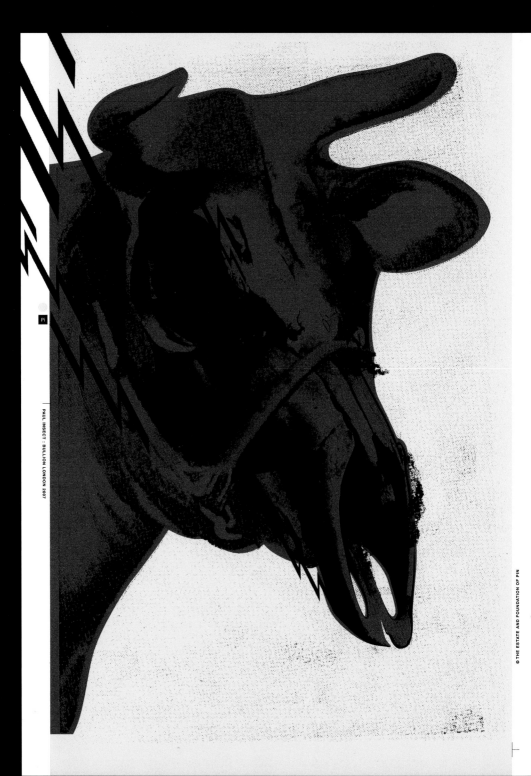

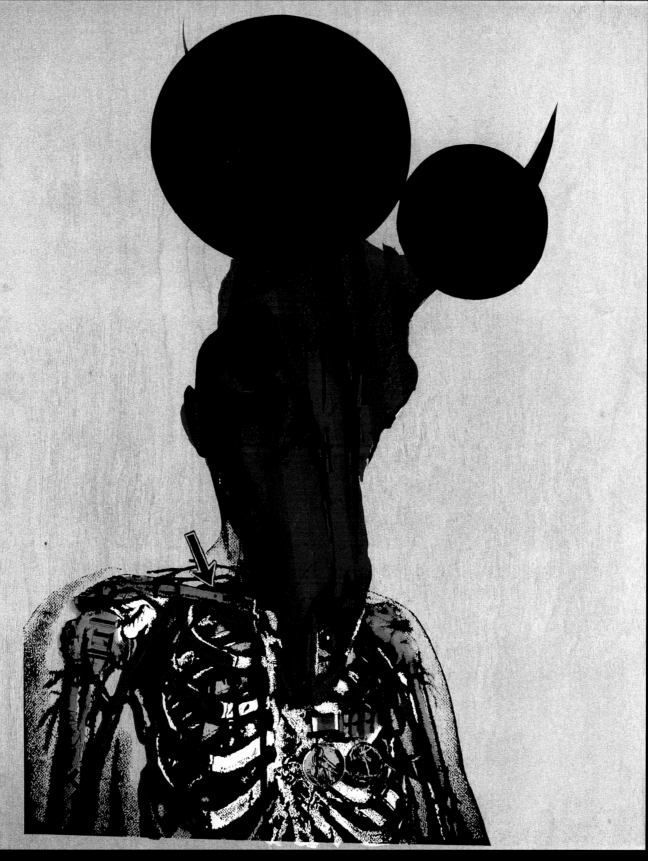

Gee Vaucher

As an artist dealing with political subjects in a visceral manner whose medium was popular culture, Gee Vaucher (along with other off-the-radar influences like CND marketer Peter Kennard and science fiction comic 2000AD) is a huge influence on many Outsiders artists. Working in an age when you could judge a record by the quality of its cover Gee provided sleeve art for the infamous anarchist band Crass under the name G Sus, for which their record company was prosecuted under British obscenity laws. Surrealism met agit-prop in a series of parent-spooking covers for LPs such as Penis Envy and Best Before 1984.

Whilst not quite as prolific, the decades have not dulled her sensitivities, and Gee's work remains radical and poignant. A major retrospective of her work toured California in 2007-8.

Sage Vaughn

California-based Sage Vaughn boasts an approach that's unconventional even in the context of Outsiders. Whilst his pictures use motifs familiar to the milieu – animals in Vaughn's Wildlife series, superheroics in his Wildlives project – they are handled with considerable sensitivity and intelligence. In Wildlife the less-than-straightforward co-existence of nature and technology is portrayed in the most subtle of ways, via highly contemporary illustration. A seemingly simple picture of a bird perching on a branch, as a helicopter approaches, instantly bathes the viewer in all the mixed feelings one should experience at seeing such a scene – but rarely stops to consider. In Wildlives, children in jury-rigged costumes and battle armour prepare for action, and a young worker, a frustrated shop clerk perhaps, dons a cape.

All this warmth and consideration flows from a moustachioed gun nut. There are more surprises to Vaughn: "He thinks of art as a privilege, not a gift... Vaughn approaches his studio at 9am and leaves at 6am unless he's preparing for a show, when he never leaves. He is the only artist with a blue-collar mentality," said *Malibu* magazine. And they should know.

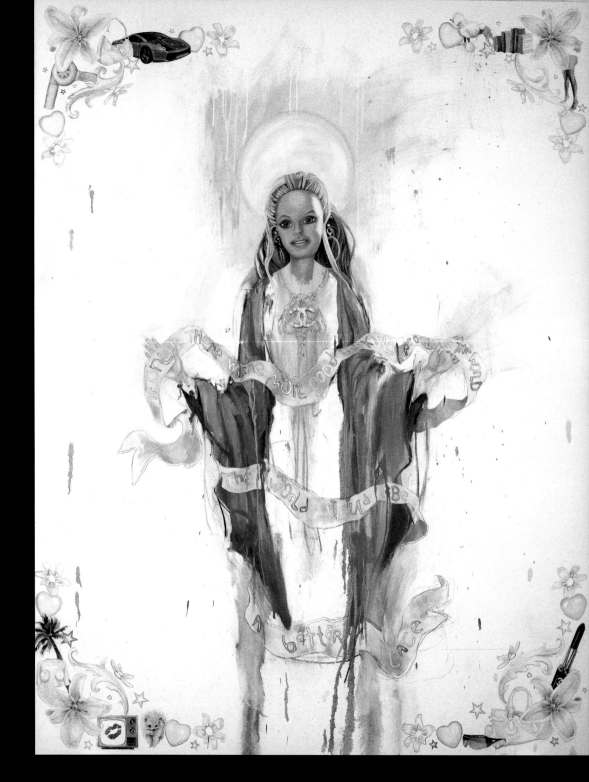

Above: Appearance is Everything
Opposite: Peacekeeper

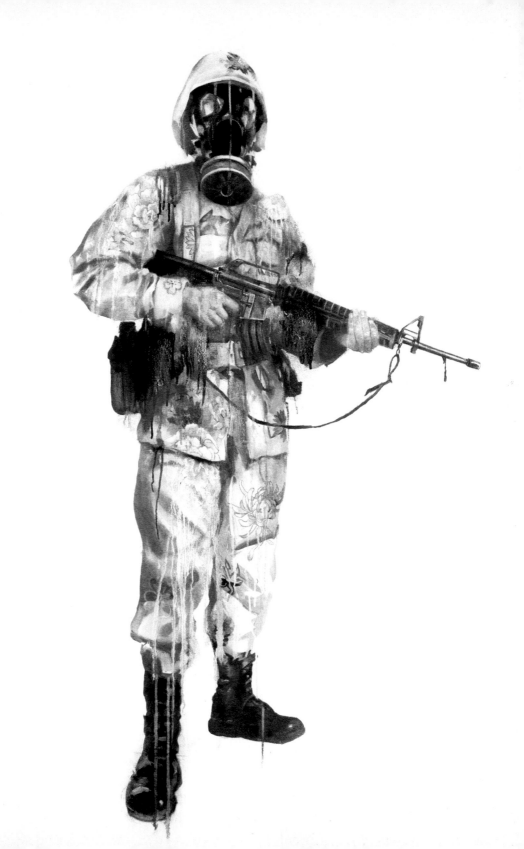

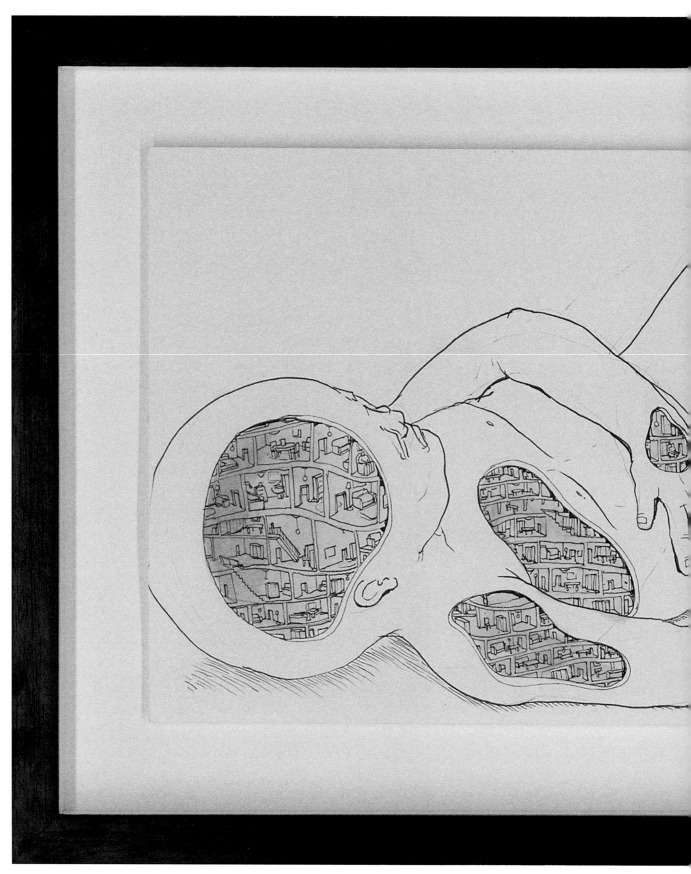

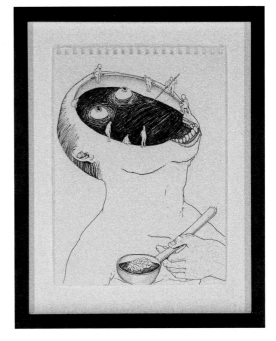

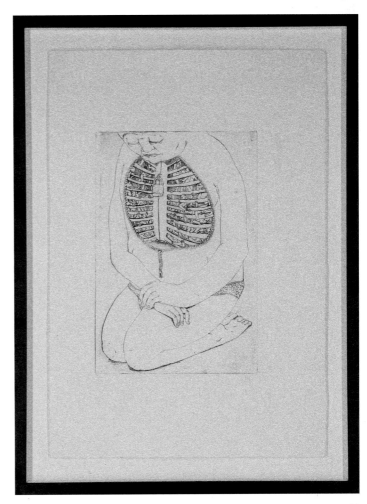

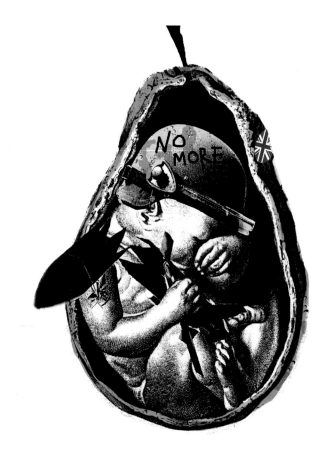

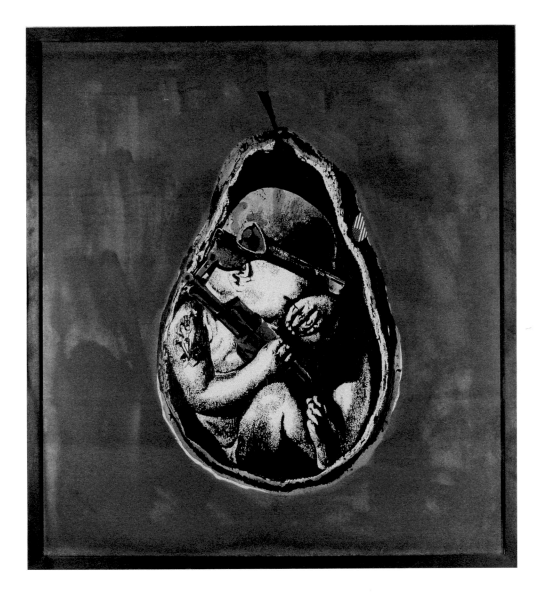

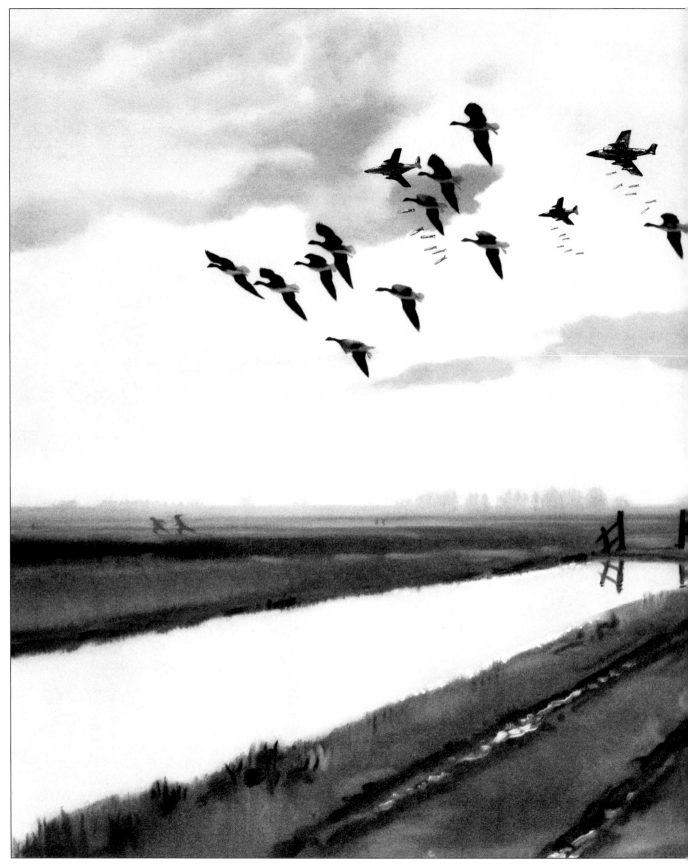

Great Scott

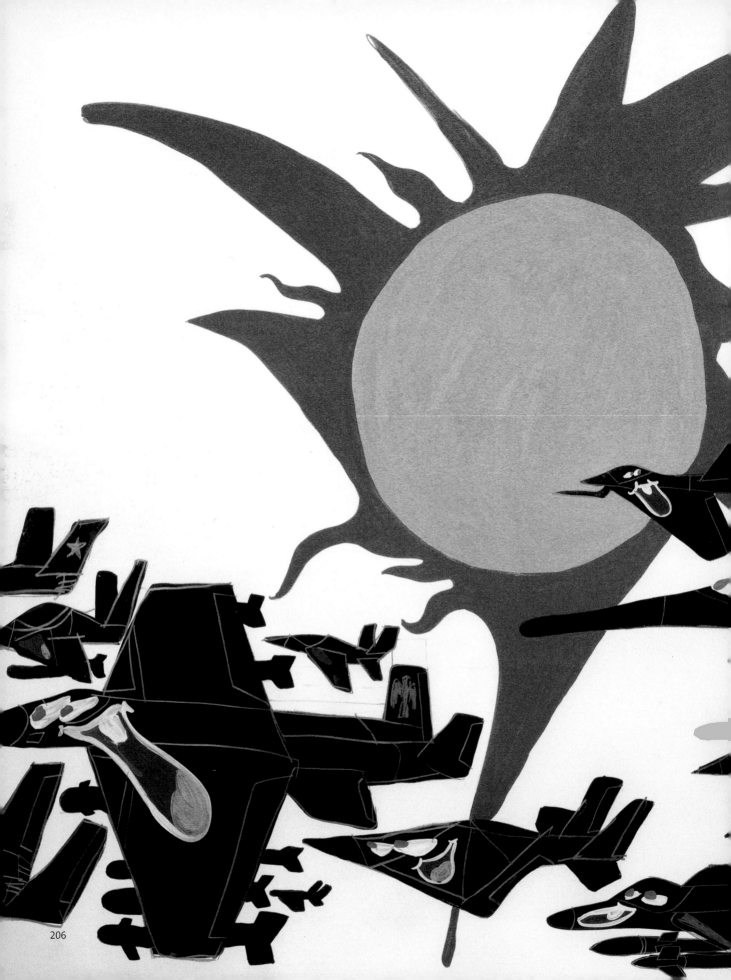

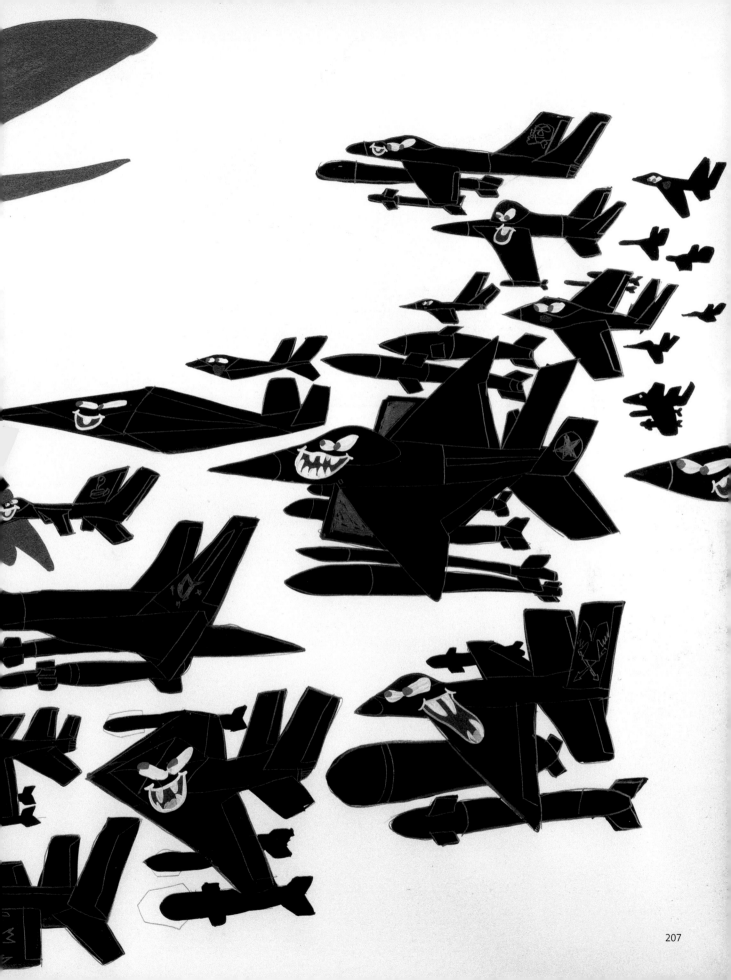

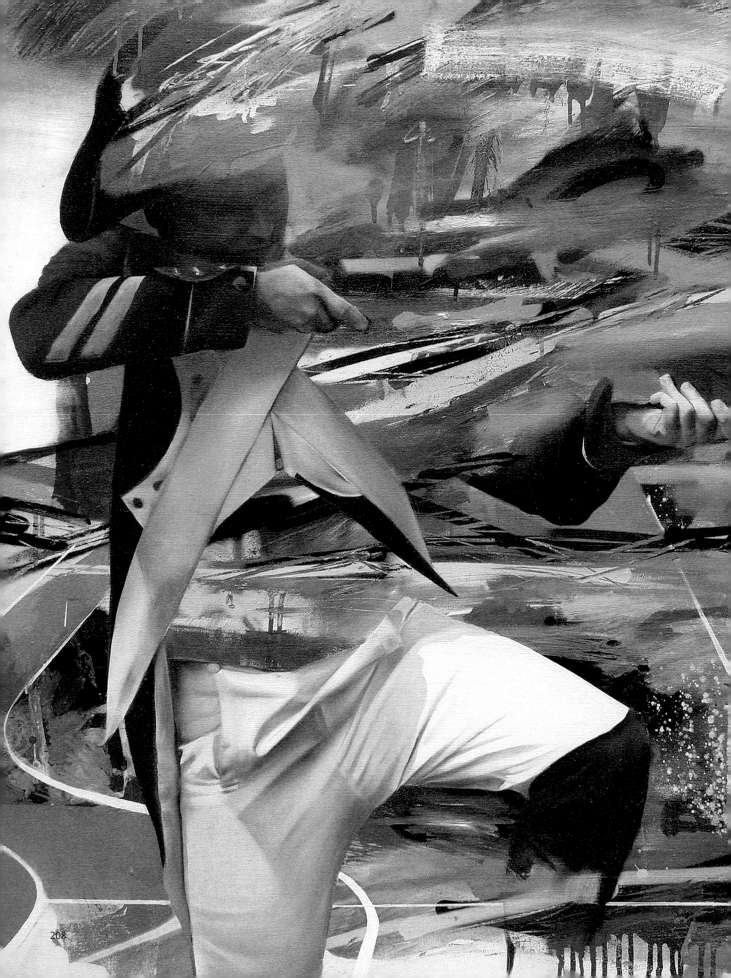

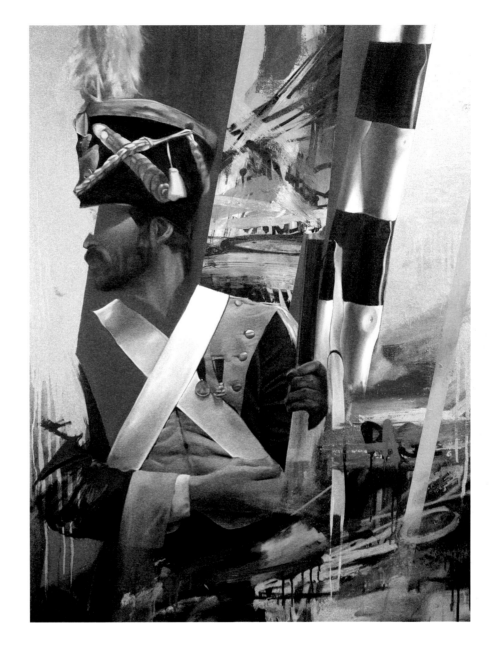

Above: Dislodge the General
Left: Make me a Superhero

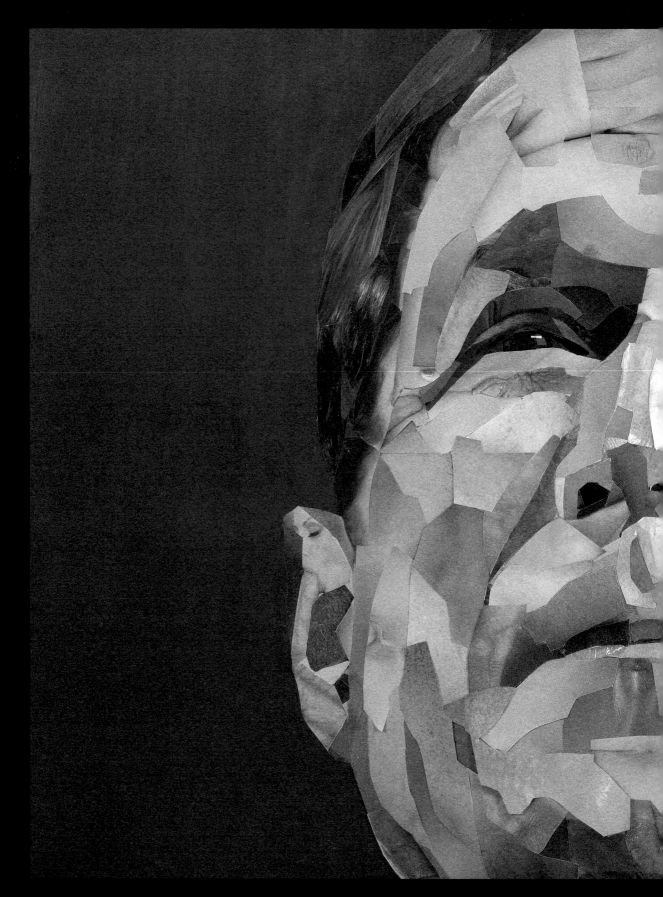

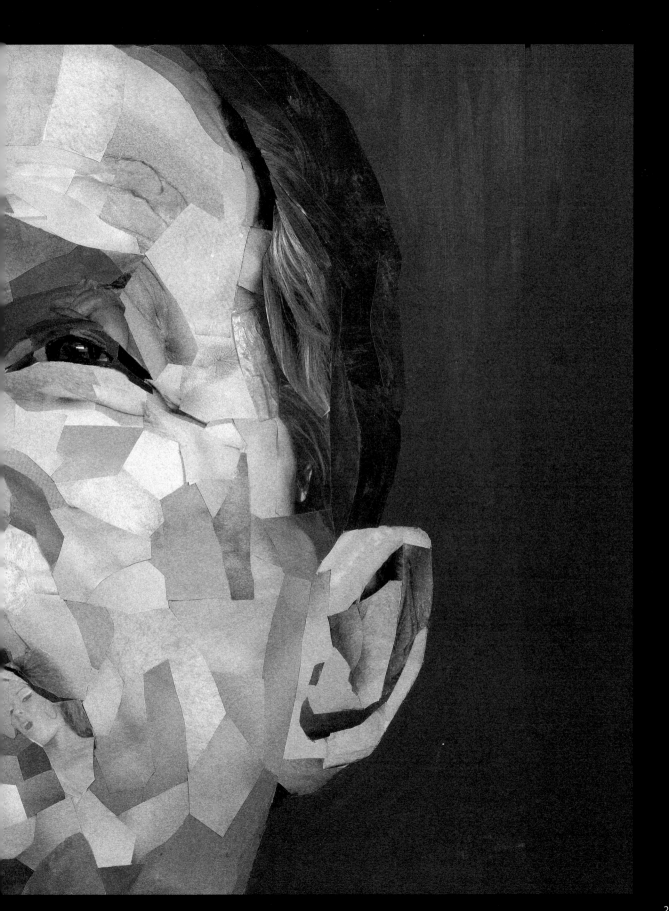

Other

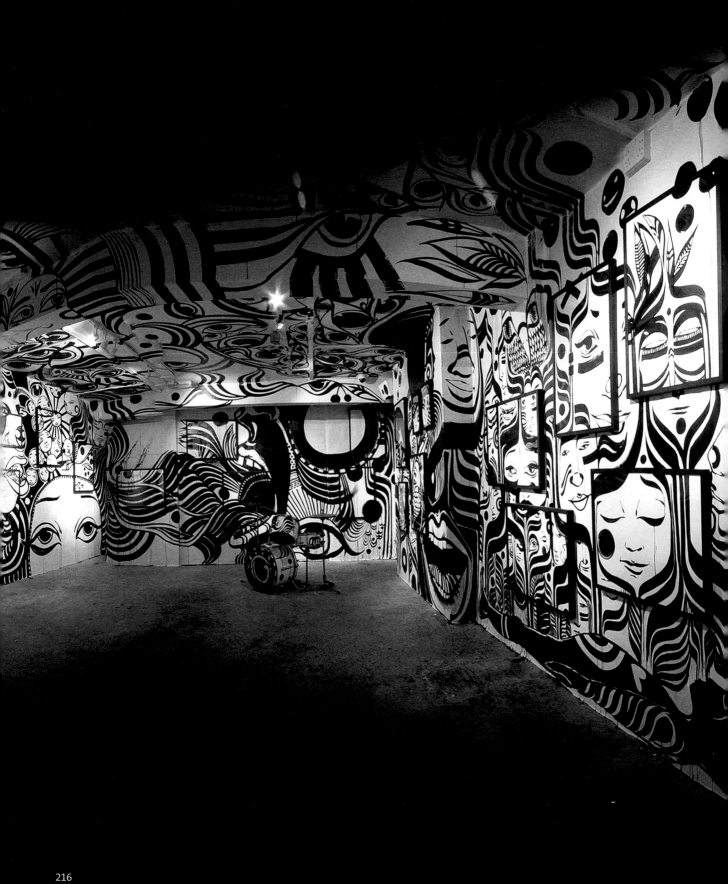

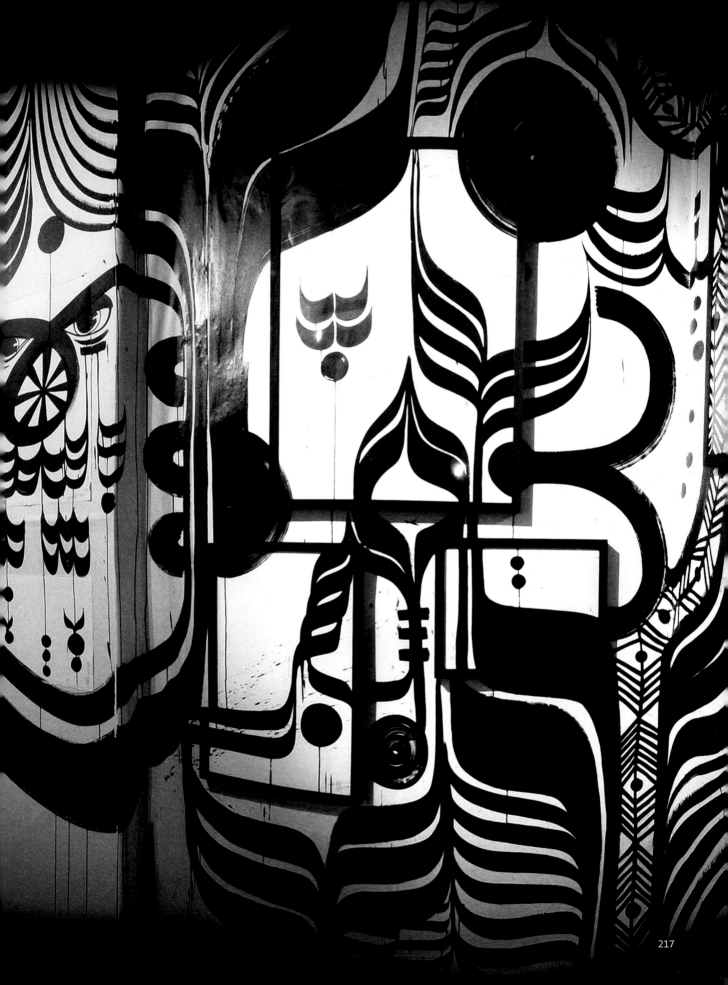

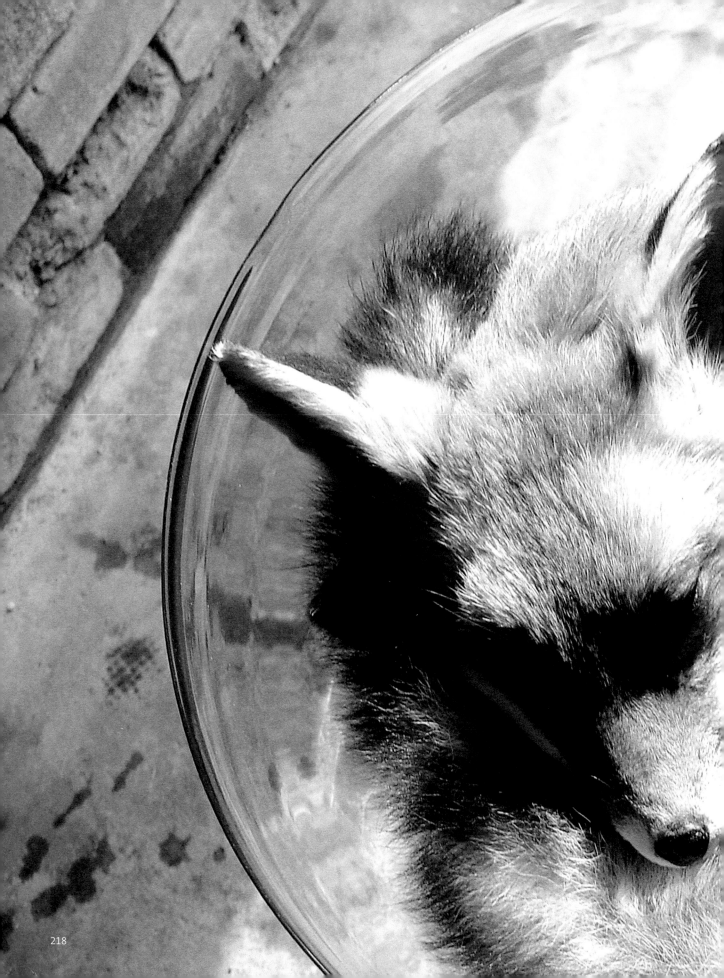

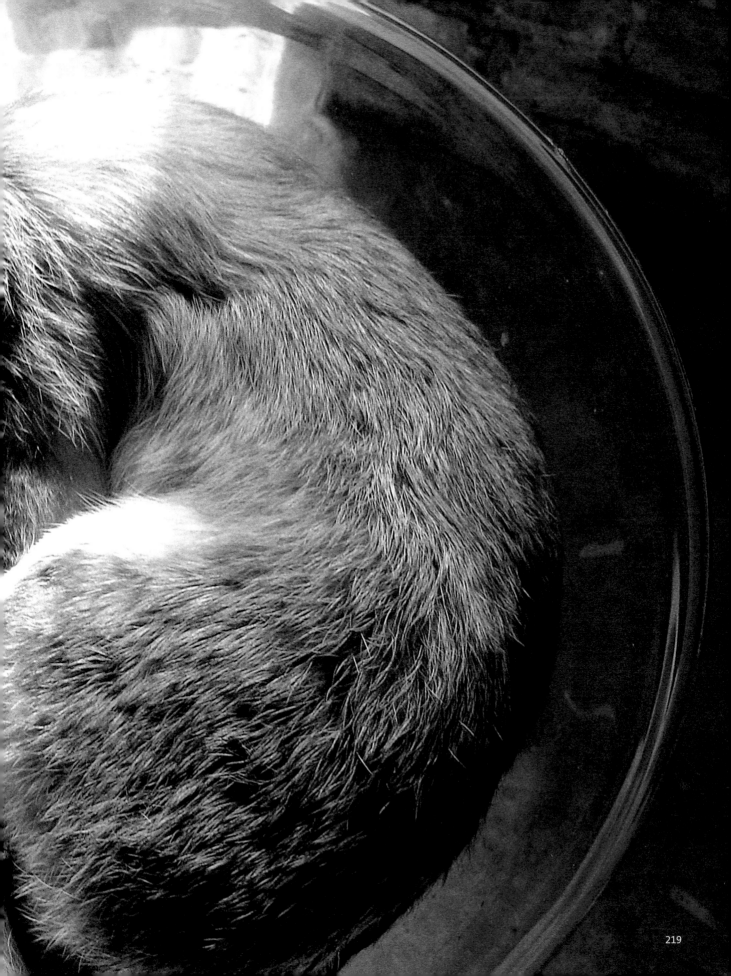

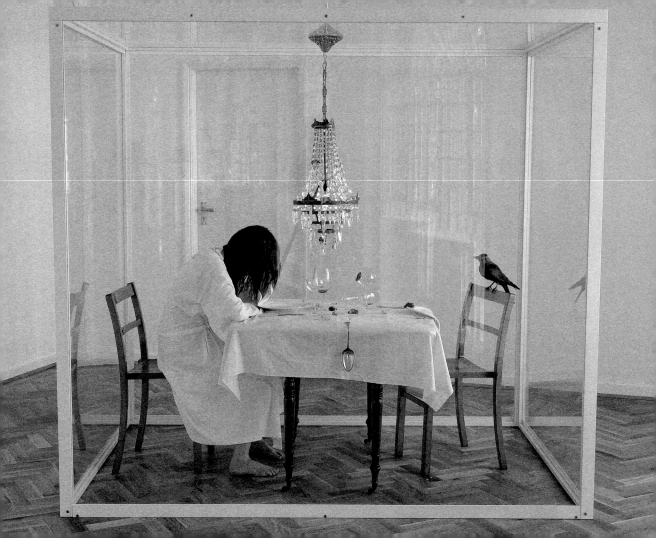

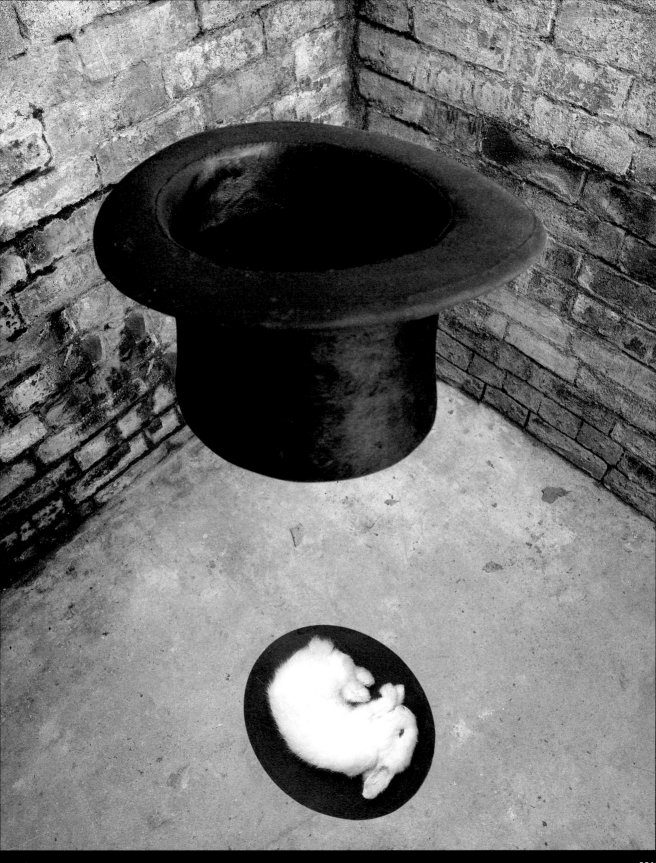

Jonathan Yeo

Jonathan Yeo is the eminent portrait painter of his generation. His use of oil painting may be traditional – he is the first official 'Election Artist' to use oils since Hogarth – but his content is youthful and praised for its realism whilst retaining the emotive quality of the format. Like any portrait painter his work is subjective, but rarely is it entirely irreverent.

Self-taught, Yeo has painted subjects ranging from the Russian Mafia to royalty: both celebrities and the genuinely blue-blooded. It's fair to say he's no stranger to controversy. The three paintings in a 2001 triptych of Tony Blair, William Hague and Charles Kennedy were sized according to the subjects' popularity. In 2003 he unveiled a full-frontal nude of Ivan Massow the notoriously gay Conservative party chairman and vocal patron of the arts. His most infamous work though is *Bush Porn*, a picture of George Dubya made from a collage of pornographic clippings. Equally Yeo has rarely been glib or judgemental in his treatment of potentate subjects. Rupert Murdoch, says Yeo, possessed an "electrifying analytical intelligence" whilst Tony Blair exuded a "tigger-like enthusiasm".

Vhils

The youngest artist to appear in this book, the already prolific Portuguese-born Alexandre Farto's range spans from collage to portraiture. Of late he's taken to creating works purely from in situ materials, taking Vandalism as art to its logico ad absurdum conclusion. Advertising hoardings are torn to make fresh images, and plaster drilled away at until the remaining relief forms the work. He is, at the time of writing, experimenting with a cocktail of Quink ink and household bleach. But this is a long way from brutalism; Vhils' art is poetic, complex, and ambitious, often focussing on the needs we have abandoned in favour of our wants, and the realisation that trading pleasure back in for happiness will be a less than straightforward exchange.

Above: The Idol Kids of Today – Burger Boy; The Idol Kids of Today – Weapon Face Girl
Opposite: Beginning of the End

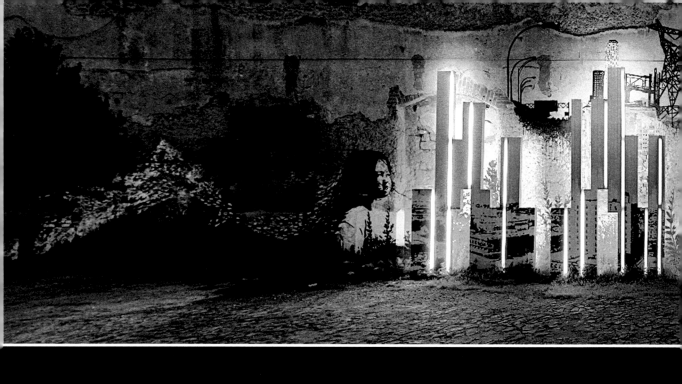

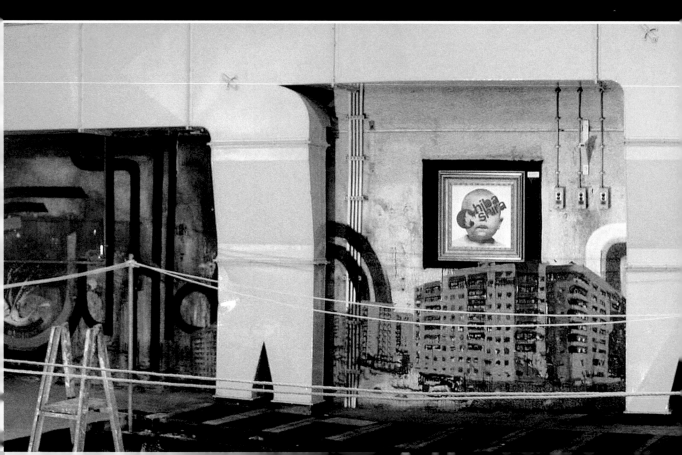

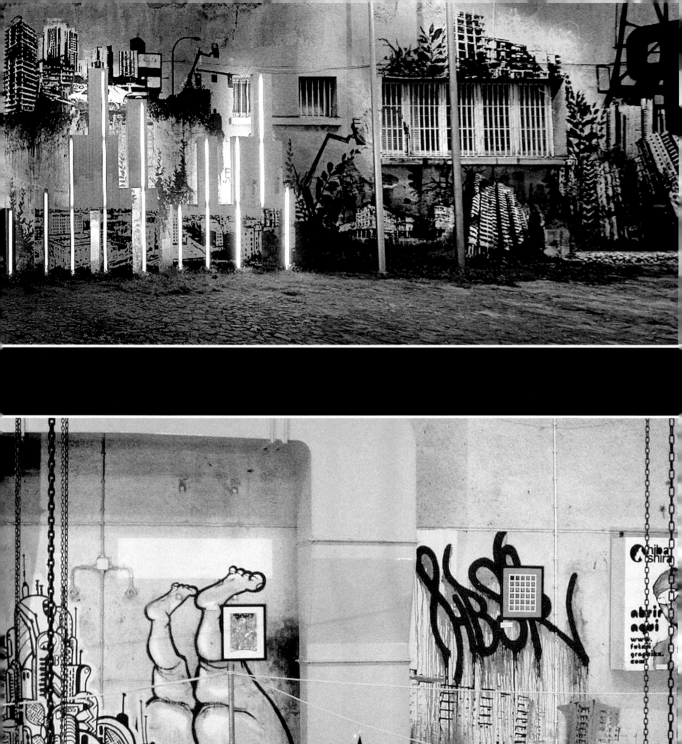

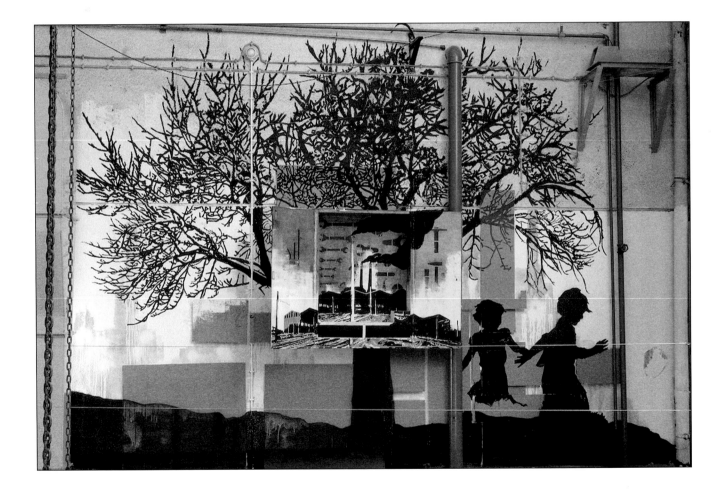

Above: Beyond the Urban Space
Opposite: Building 3 steps *(Collaboration with Miguel Maurício)*

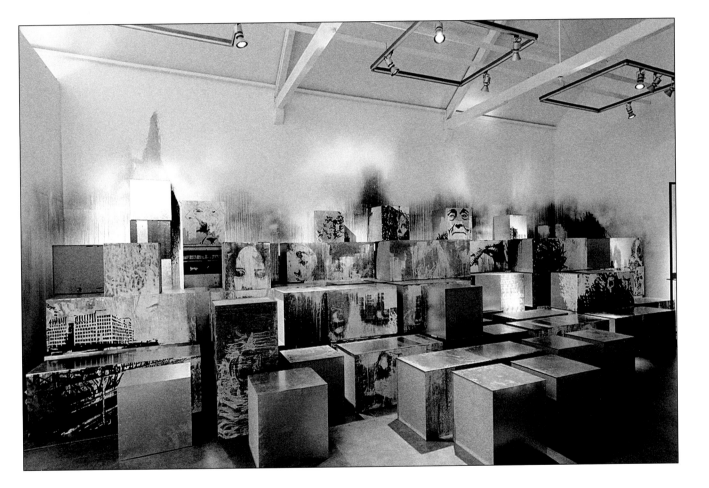

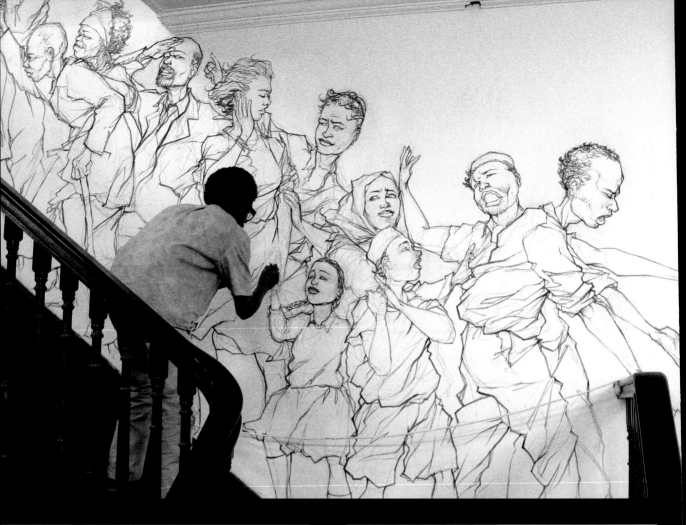

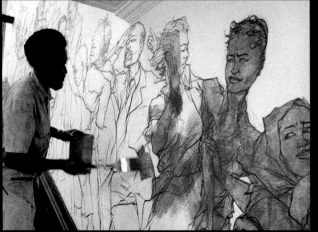

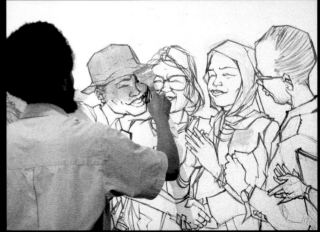

District 6 Homecoming Centre

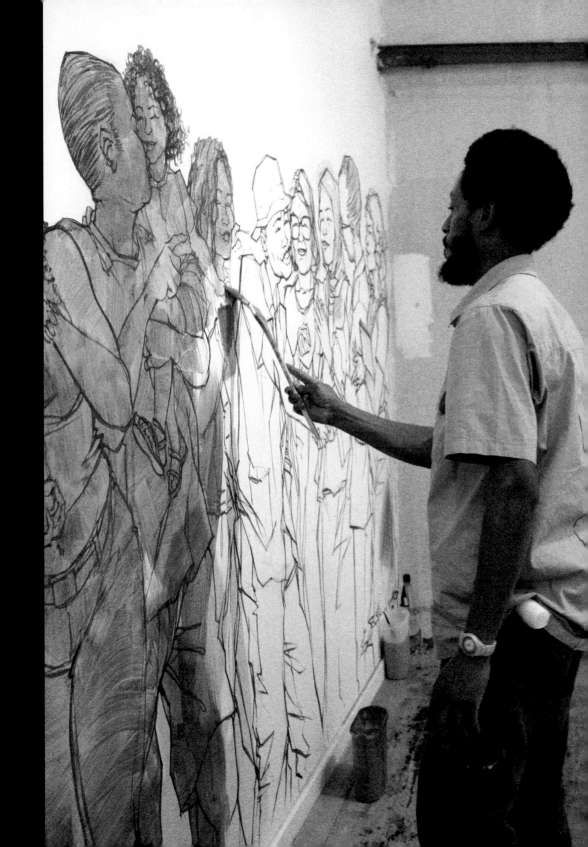

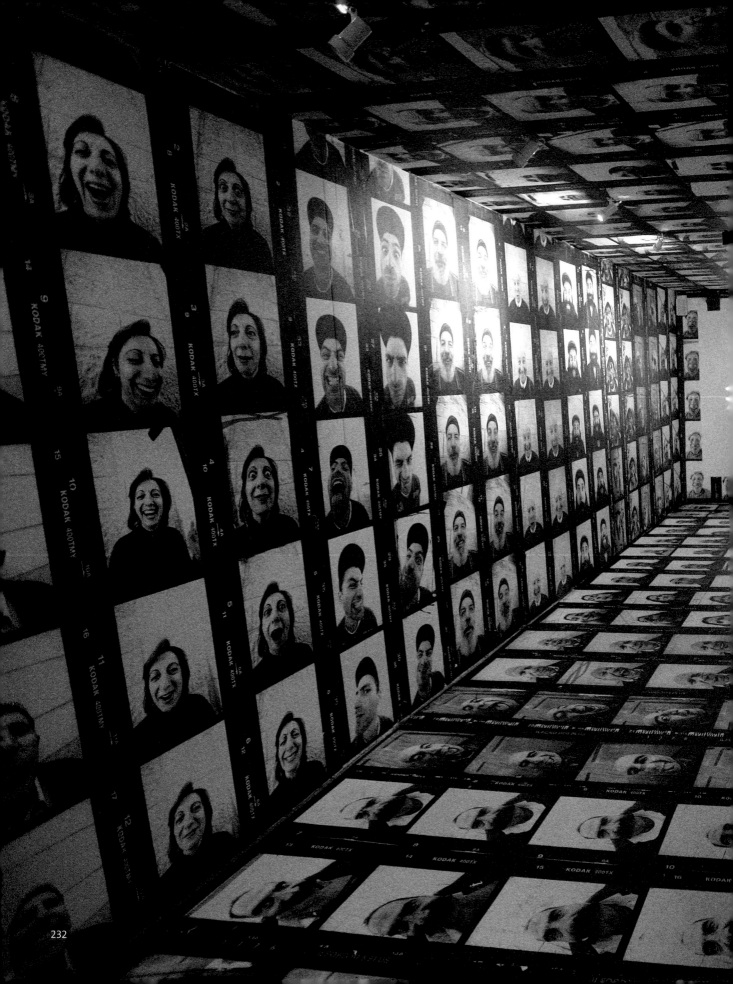

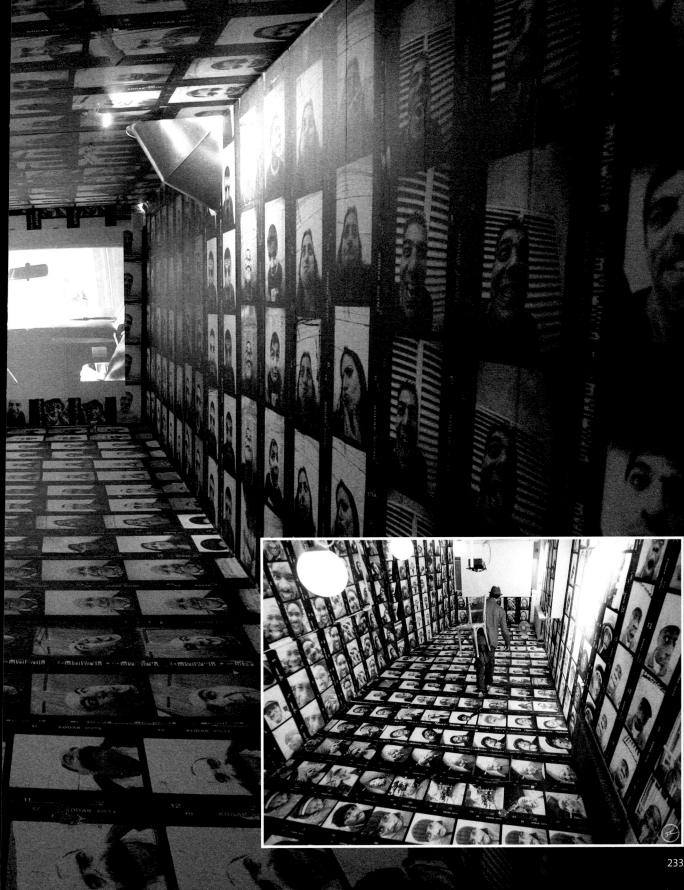

Above: Someone on the Phone
Opposite: Mind over Matter

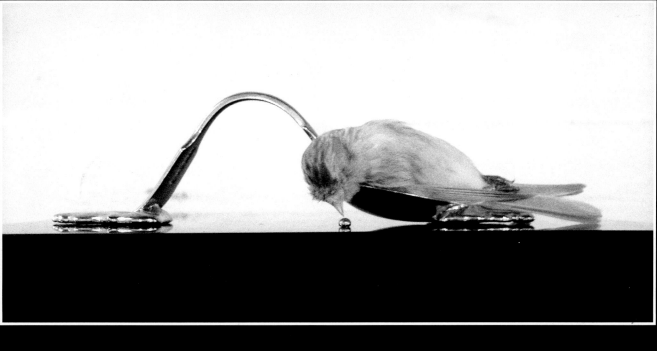
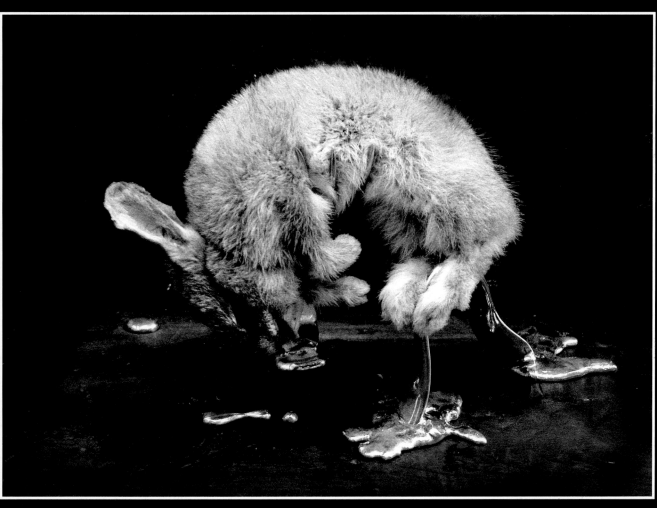

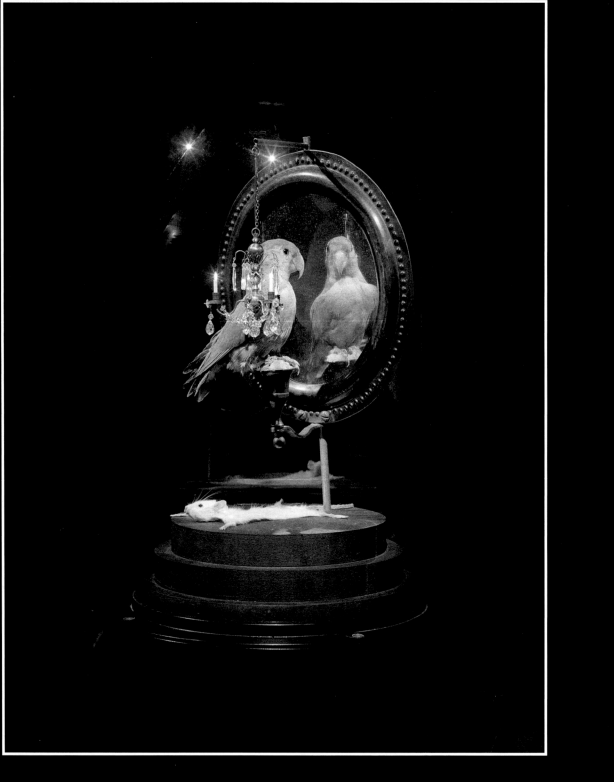

Above: Lovebird
Opposite: To Every Seed His Own Body; Still Life After Death (Pigeon)

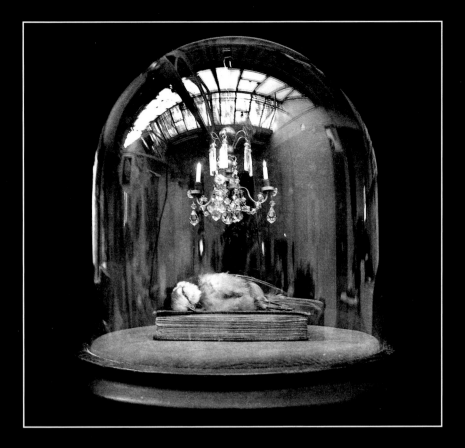

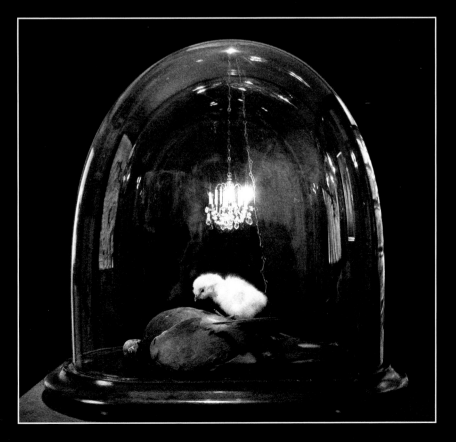

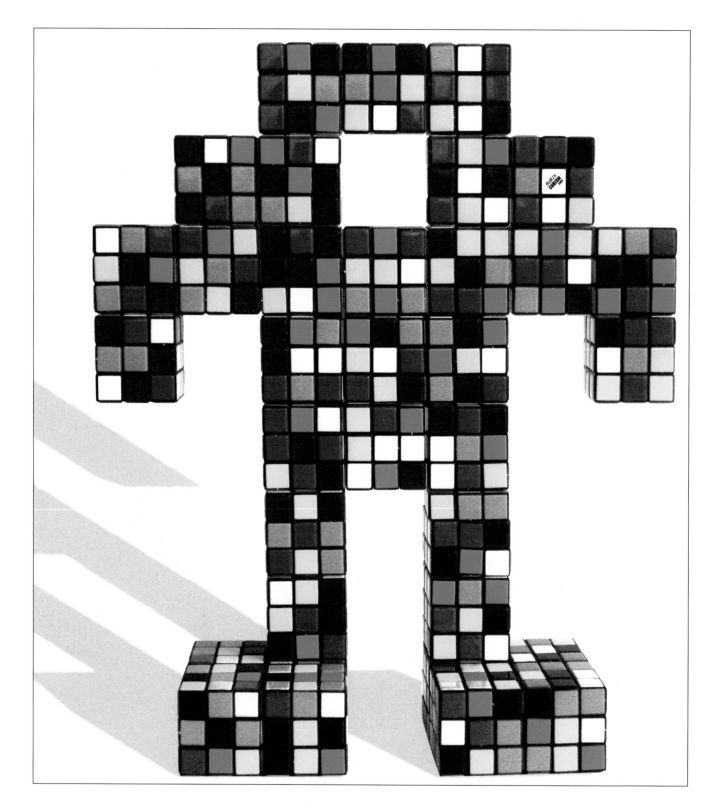

Above: OiFi2
Opposite: Detail of Exhibition 'Rubik Space', P Dorfmann; Pixelplosion

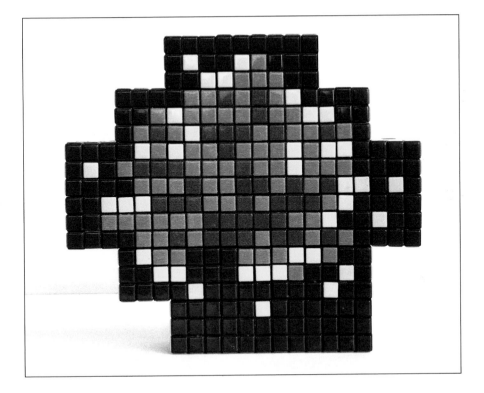

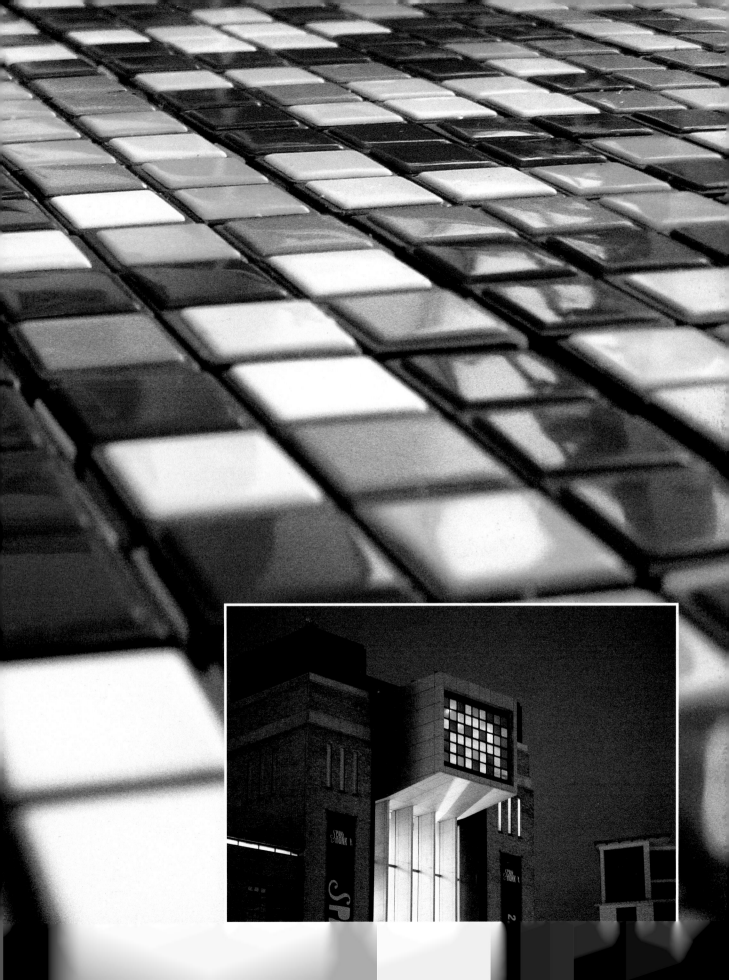

Zevs

Zevs is not only one of the most political artists within this often partisan tome, he is becoming seen as one of the more inspired practitioners of mischievous street work. His Liquidated Logos series, first displayed at the Soho gallery in November 2007, are arguably the most direct and recognisable examples of the oeuvre.

His activity on the street has drawn much controversy and attention from the 'high art' world, blurring as it does the line between 'street pieces', conceptual art, and plain old-fashioned angry vandalism. Most notorious were his examples of 'visual kidnapping' where Zevs removed entire figures from over-sized adverts. At Berlin Alexanderplatz a vast, garish, hanging billboard for Lavazza coffee found itself without its female lead. Zevs 'demanded' a 500,000 Euro donation to the Palais de Tokyo art gallery in Paris for her return. Other techniques have included simply 'cleaning' a picture onto a dirty wall using high pressure steam cleaners, obviously toying with the notion of whether graffiti is a blight upon the landscape or a complement to it.

Massive Attack Tour

```
( H  F
( I
( 0 )        ACAD.POBRESITO
( 0 )▊       ACCEPT.3618
( 0-)        ACCEPT.3773
( 0--<       ACCEPT.3773 (GEN1)
( OO )       ACCOUNT_AVENGER.87
( G_G)       ACDC.494
( (Y))       ACDC.499
( )          ACE.1872
( )          ACG
( _ )        ACG.B
( )
(*Y )▊
```

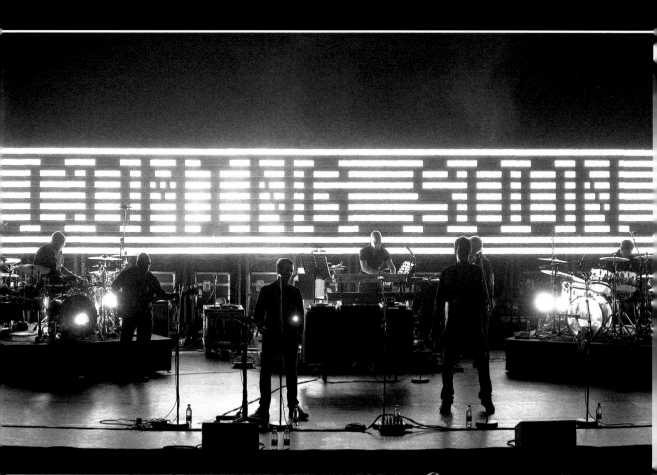

Above: Favoured Nations
Opposite: Meltdown Composite

With Laura Raynsford, Meltdown Festival 2008, Southbank Centre

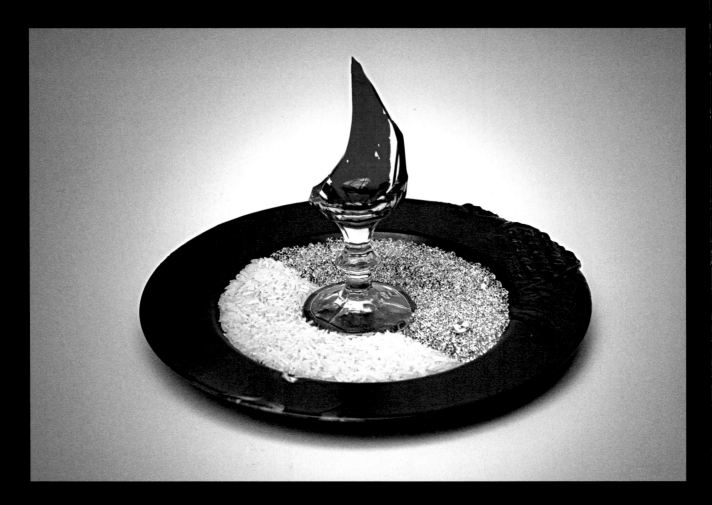

Above: Regime Africain 2007 (tar, rice, crystal, blood)
Opposite: Liquidated Logo

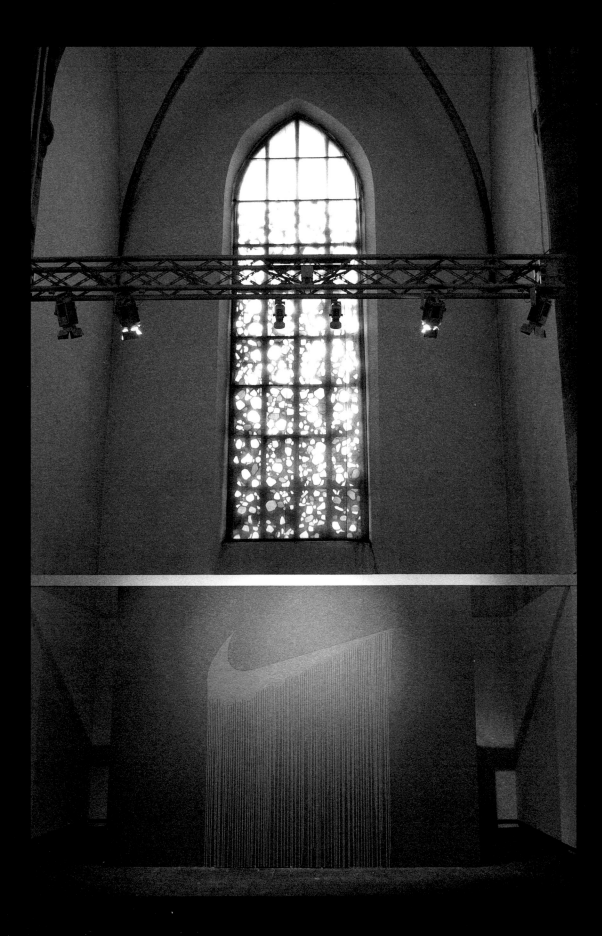

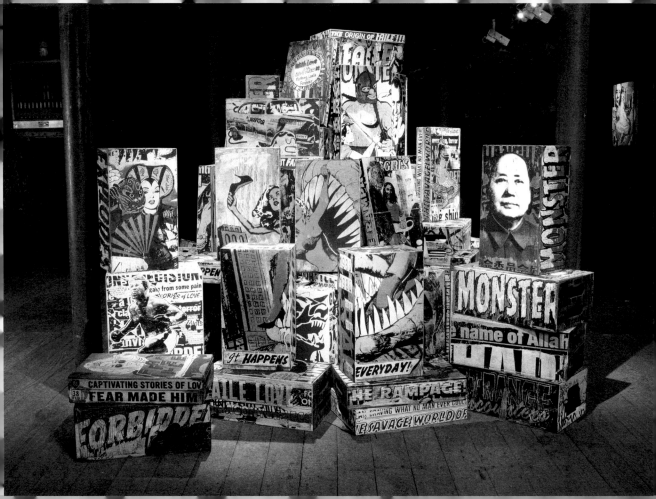

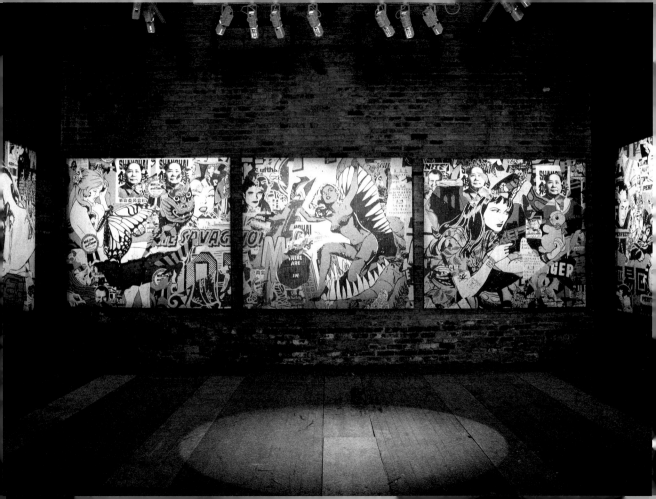

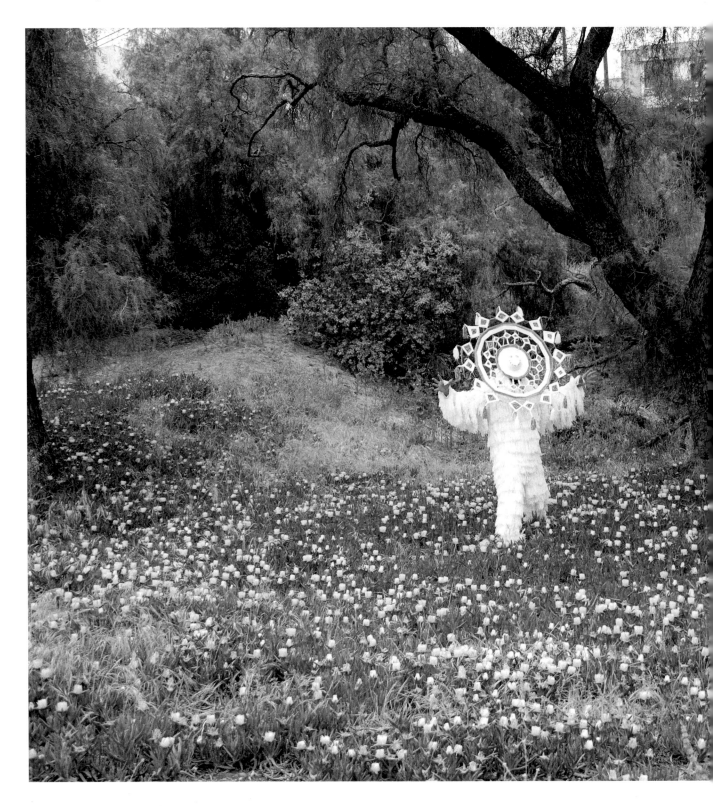

Cosmic Kid

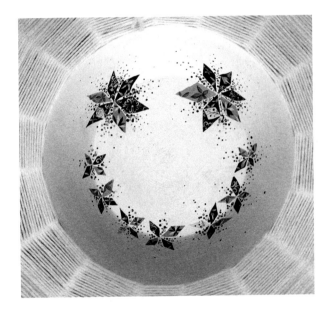

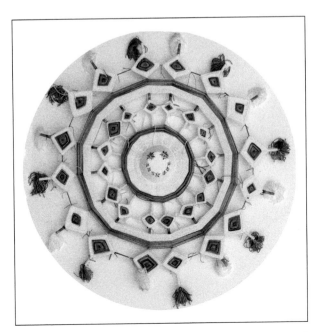

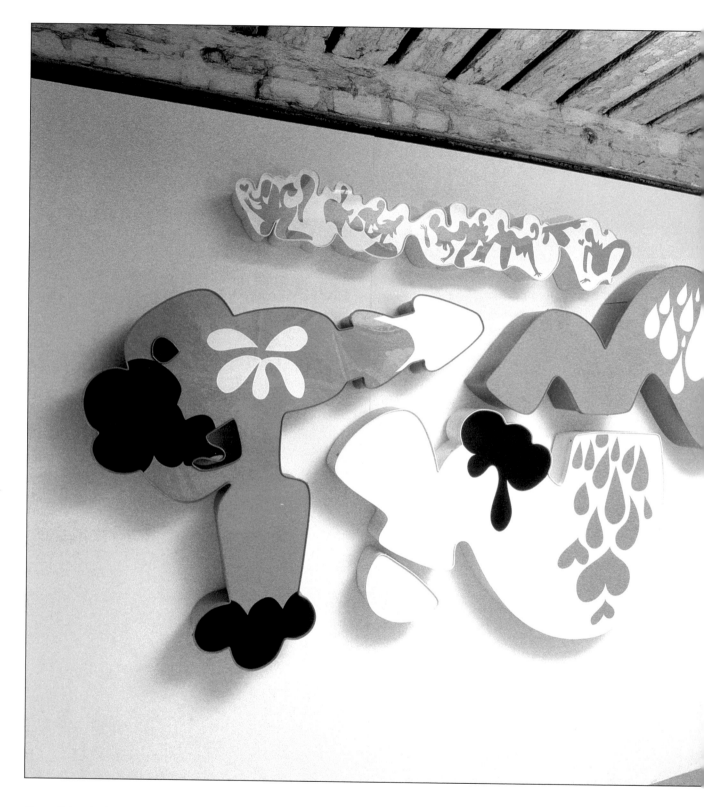

Above: Pink and White Girls
Opposite: Cry Baby and Boogaloo Cat

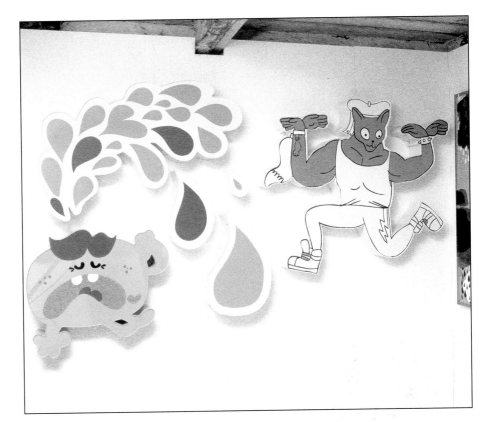

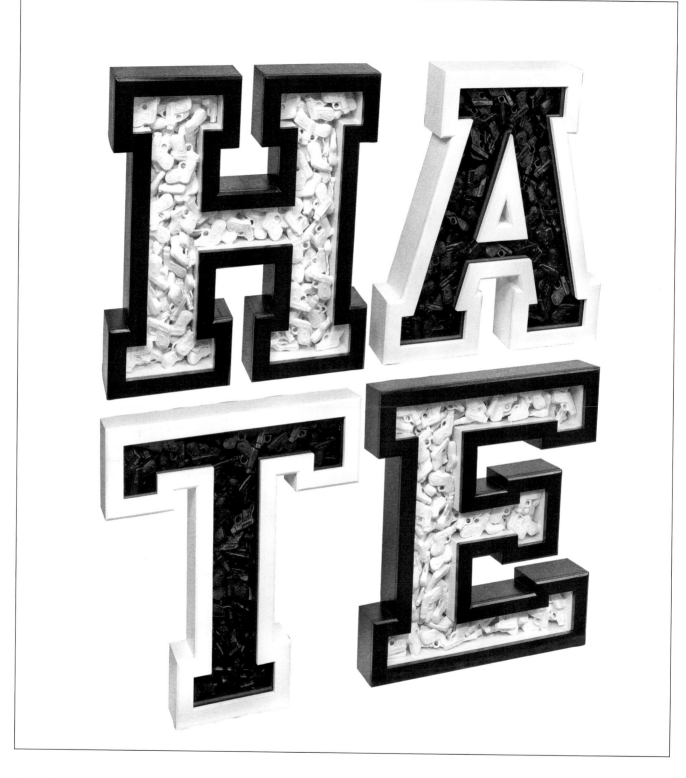

Above: Give me an H
Opposite: Protection Complete

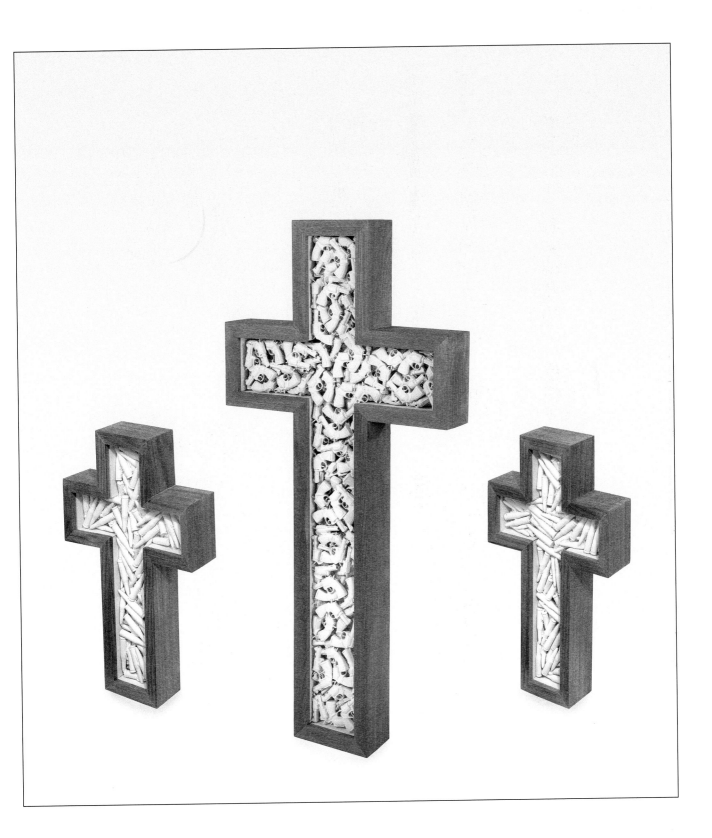

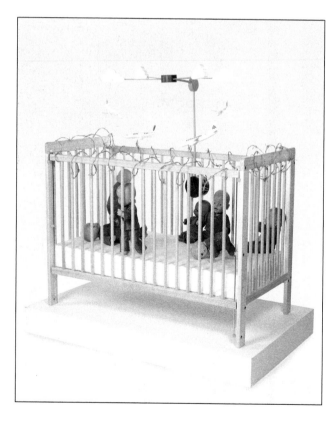

Breeding Terrorism

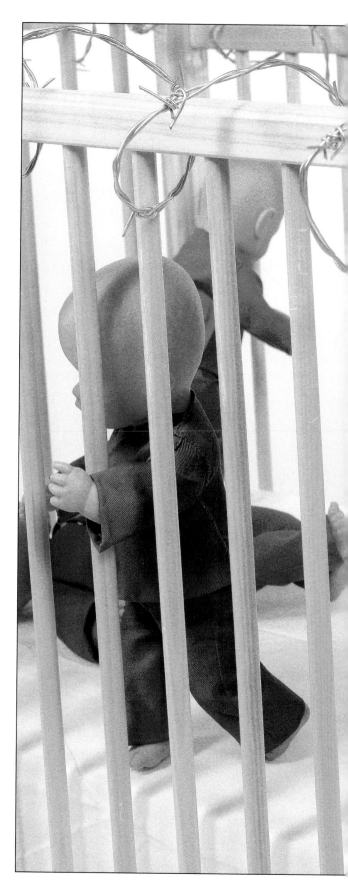

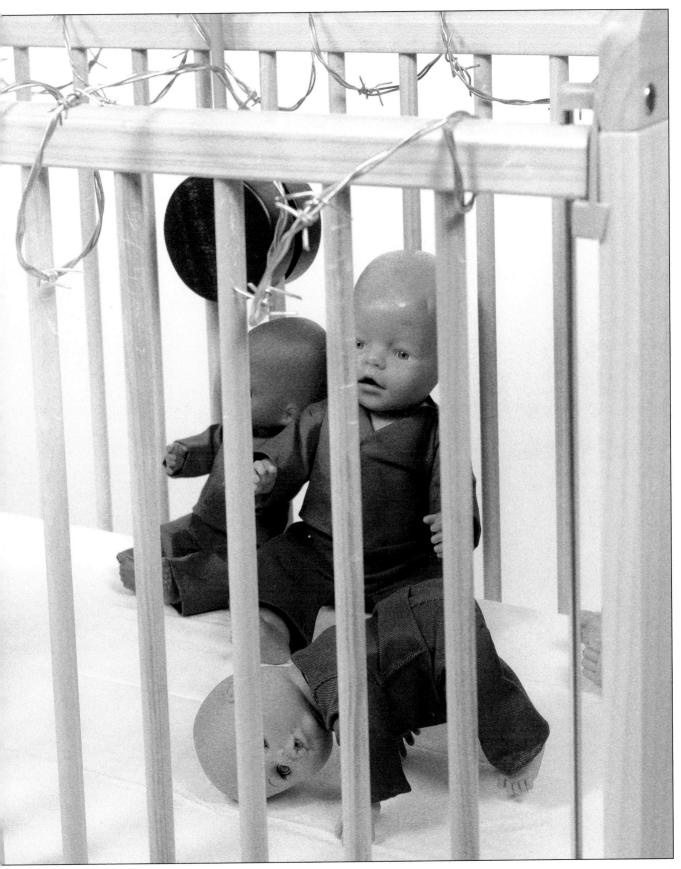

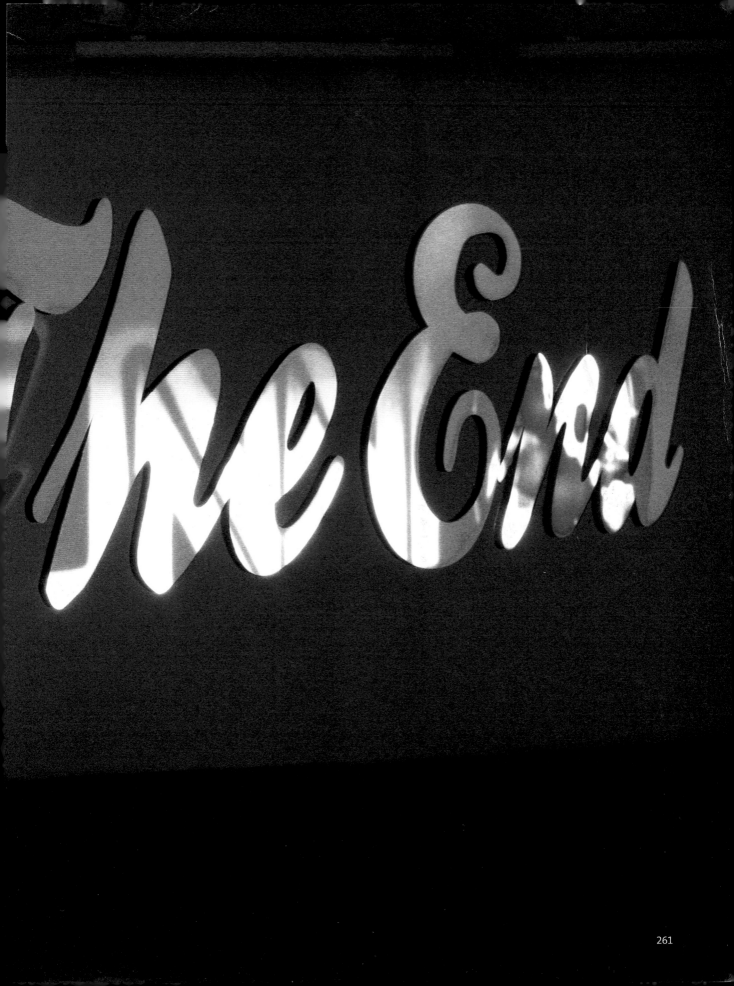

Outsiders – index and information

The artists

Further reading

**Books published and
available via Lazarides:**

Miranda Donovan
Lost World of Innocence
ISBN: 978-0955672644

Stanley Donwood
If You Lived Here You'd Be Home By Now
ISBN: 978-0955417856

Faile *From Brooklyn With Love*
ISBN: 978-0955417832

Conor Harrington
Weekend Warriors
ISBN: 978-0955672620

See-Saw
ISBN: 978-0955417818

Paul Insect *Bullion*
ISBN: 978-0955417870

Invader
Invasion London/Bad Men II
ISBN: 978-0955417894

Todd James/Reas
Blood and Treasure
ISBN: 978-0955672675

Mark Jenkins *Outcasts*
ISBN: 978-0955417849

Lucy McLauchlan
Expressive Deviant Phonology
ISBN: 978-0955672613

Antony Micallef
ISBN: 978-0955417863

Antony Micallef
ISBN: 978-0955417801

Mode 2 *Never Too Late*
ISBN: 978-0955672637

Ben Turnbull
Nightmare on Greek Street
ISBN: 978-0955672668

U.S. vs THEM
ISBN: 978-0955417825

Jonathan Yeo *Blue Period*
ISBN: 978-0955672651

Zevs
ISBN: 978-09955672606

Outsiders – index and information

Further reading

Banksy

Wall and Piece
Century, 2005
ISBN: 1844137864

David Choe

SLOWJAMS
Xeric grant, 1999

Bruised Fruit: The Art of David Choe
Self published, 2002

CURSIV
Giant robot publishing, 2003

The Vice Guide to Sex and Drugs and Rock and Roll
Grand Central Publishing, 2003

Blk/Mrkt One
Die Gestalten, 2006
ISBN: 978-3899551532

Faile

Spank the Monkey
Die Gestalten Verlag, 2006
ISBN: 978-3899551747

Urban Illustration
Gingko Press, 2007
ISBN: 978-1584232919

Street Art
Tate Publishing, 2008
ISBN: 978-1854377678

Jamie Hewlett

Gorillaz, Rise of the Ogre
Penguin, 2006
ISBN: 978-1594482717

Invader

Invasion in the UK,
Trans-Atlantic Publications, 2007
ISBN: 978-2952019972

Street Art
Tate Publishing, 2008
ISBN : 978-1854377678

Street Renegades
Laurence King, 2007
ISBN : 978-1856695299

Art of Rebellion
Gingko Press, 2004
ISBN: 15842-2099

Street Logos
Thames & Hudson, 2004
ISBN: 0500284695

DPM Disruptive Pattern Material: An Encyclopaedia Of Camouflage
Lincoln Frnces, 2004
ISBN: 978-0954340407

Polly Morgan

All Tomorrow's Pictures
ICA, 2007
ISBN: 978-1900300537

Reas

The Art of Getting Over
1999, St. Martins Press
ISBN: 978-0312206307

Street Market
2000, Little More

Attitude Dancer 1 and 2
2000 and 2008, self published

Todd James
2002, Testify Books & the Henry Moore Foundation
ISBN: 978-0972592000

Beautiful Losers
2005, Iconoclast
ISBN: 978-1933045306

Mascots & Mugs
2008, Testify Books
ISBN: 978-0972592048

Gee Vaucher

Animal Rites
Exitstencil Books, 2004

Crass Art and other Pre Post Modernist Monsters
AK Press, 1999
ISBN: 978-1873176108

Vhils

Visual Street Performance 2007
ISBN: 978-9892009261

Jonathan Yeo

BP Portrait Award 2004, by Blake Morrison
National Portrait Gallery
ISBN: 1855143445

BP Potrait Award 2005, by Philip Hensher
National Portrait Gallery
ISBN :1855143658

Figurations
Eleven Gallery

The Portrait Now, by Sandy Nairne and Sarah Howgate
National Portrait Gallery
ISBN: 1855143585

The Naked Portrait
National Galleries of Scotland
ISBN: 978-1903278956

Websites

massiveattack.com	3D
blublu.org	Blu
kelseybrookes.com	Kelsey Brookes
davechoe.blogspot.com	David Choe
mirandadonovan.com	Miranda Donovan
slowlydownward.com	Stanley Donwood
faile.net	Faile
ifrancis.co.uk	Ian Francis
conorharrington.com	Conor Harrington
gorillaz.com	Jamie Hewlett
paulinsect.com	Paul Insect
space-invaders.com	Invader
jr-art.net	JR
xmarkjenkinsx.com	Mark Jenkins
BEAT13.co.uk	Lucy McLauchlan
antonymicallef.com	Antony Micallef
mode2.org	Mode 2
pollymorgan.co.uk	Polly Morgan
reasinternational.com	Reas/Todd James
benturnbull.com	Ben Turnbull
sagevaughn.com	Sage Vaughn
alexandrefarto.com	Vhils
jonathanyeo.com	Jonathan Yeo
lazinc.com	Lazarides
picturesonwalls.com	Pictures on Walls
woostercollective.com	Wooster Collective

Steve would like to thank:

Firstly the artists who made this book possible, Susie, Cassius, Xavier, and Che for keeping me sane, Yvette, Ralph, Jess, Remi, Tom, Alex, Emily, Ben, Sam, Coralie, Kim, Stevie P, Alice, Flavia and Claire, for putting up with my madness, awkward Dave. Steve Beale for the words. Jez Tucker for making it look great. Holly, Simon, Damien, Cheyenne, Calum, Harry and Graham, Eddie, Jason, and everyone who has supported the Lazarides gallery of which there are too many to mention.

All Photography © Lazarides Gallery, except: Polly Morgan – 'Rabbit and Hat' by Matthew Leighton; Vhils – *Scratching the Surface* © Michael Greenwood; Vhils – *Unknown Faces Edition* © Matilde Meireles; Vhils – *Beyond the Urban Space* © Luis Colaço.

All Text © Steve Beale